The Business of Graphic Design: a sensible approach to marketing and managing a graphic design firm

Ed Gold

Watson-Guptill Publications
New York

Dedicated to Bobbye
May 9, 1933–June 9, 1992
Compassion, Beauty, Style, Grace

Copyright © 1995 by Ed Gold
This edition published in 1995 in the United States
by Watson-Guptill Publications, a division of BPI
Communications, Inc., 1515 Broadway, New York,
NY 10036-8986

Library of Congress Cataloging-in-Publication Data
for this title is available from the Library of Congress,
Washington, D.C.

ISBN 0-8230-0546-1

Manufactured in Singapore

Senior Editor: Candace Raney
Associate Editor: Dale Ramsey
Designer: Ed Gold
Production Manager: Hector Campbell

1 2 3 4 5 / 99 98 97 96 95

ACKNOWLEDGMENTS

First of all, I would like to thank the dozens of design-
ers who were gracious enough to give me a couple of
hours of their precious time. Without their willingness
to share information and experiences, there would be
no book.

Second, I have to mention some special people who
have been immensely valuable to me during the three
years it took to put this revision together:

Mary Suffudy, of Watson-Guptill, who worked with me
on the first edition of this book and who got me started
on this second edition. Without her incredible patience
and understanding during the most difficult time of my
life, I probably would never have had the desire or will-
ingness to get back to work on the book at all.

Candace Raney, who picked up where Mary left off and
has been a wonderful source of help and support.

Craig Ziegler, David Patschke, Max Boam, and Jerry
Greenberg, who, between them, know more than every-
thing a person would ever want to know about com-
puters.

Don Akchin, who took all the rough edges off the chap-
ter, "Managing Technology."

Greg Schlimm, who, because of my earlier ignorance
of technology, was forced to retype the entire text of
this book.

Finally, there is a special place in my heart for Denise
Knobloch, a wonderfully talented designer who put this
whole book together for me. She has been my right
and left arms during the entire process.

If there are any people who I have forgotten to include
here, I beg their forgiveness and can only plead tem-
porary insanity.

Contents

Introduction

In 1985, when the first edition of this book was published, the graphic design business as we had known it had been around for approximately 50 years and had not changed in any significant way. Some of the tools had changed, of course, but few had had any real impact on the relationships between designers and their clients or on the way the businesses themselves functioned. Even in periods of economic recession, few designers were affected very strongly.

The reason for this was simple. Like it or not, anyone who needed a publication printed or produced had little choice but to hire a designer, either directly or indirectly, through agencies and printers.

As business became increasingly competitive, and as the fight for the attention of the consumer intensified, the need for the minds and eyes of graphic designers increased as well.

With minimal effort, and sometimes even with minimal talent, many designers found themselves in the happy position of getting as much work as they could handle. At the same time, due to exposure to more and more "good" design, clients were beginning to recognize the value of design as an important marketing tool.

The years from 1965 to 1985 were, for most graphic designers, golden years. During that period almost any design firm that followed reasonable business practices could count on a 10- to 20-percent yearly growth rate. Design firms grew and multiplied, and design as an industry was identified by many business analysts as one of the "hottest" careers to enter. Colleges and universities—responding to the twin demands of students needing preparation to enter the design profession and of the schools' own need to attract more and more students—hired faculty and began to offer design courses at all educational levels, from community colleges to graduate schools.

In the late 1970s and early '80s, many major advertising agencies, both in the U.S. and abroad, hoping to both broaden and deepen their services, began to acquire major design firms the way kids today collect baseball cards. During those years any major design firm that hadn't received at least one buyout offer had to feel a little like a wallflower at a high school dance. In the mid-1980s, with the double whammy of another worldwide recession and the introduction of the Macintosh computer, all this changed.

In the beginning, few professional designers and even fewer clients embraced the Mac. Most designers either couldn't afford to buy a computer or just didn't feel the need for one. Clients, by that time, had already committed themselves to the IBM technology, which was incompatible with that used by Apple, so they felt no desire to move to a new platform.

Gradually, through a combination of aggressive marketing by Apple and the influx of hundreds of Mac-literate young designers into design offices, what had been a trickle became a flood. Within just a few short years, computers, especially Macintosh computers, became not just another important tool for designers, but an absolute necessity. Printers, responding to the needs of their design clients, began to accommodate themselves to dealing with Macintosh hardware and software.

Pandora's box had been opened and the design profession would never be the same again.

As the effects of the recession spread, putting more and more pressure on clients to cut their budgets and costs, design firms found themselves competing first with small desktop publishing operations and, later, with in-house departments set up by printers and other suppliers and by the clients themselves.

Soon, a domino effect began to transform the entire graphics industry.

The first to feel the full effects of technical change were the typesetters. In the short space of only seven or eight years, most typesetters were forced out of the traditional typesetting business, becoming instead "service bureaus" providing high-resolution output from disks furnished by their clients.

The next to be hit were the design firms themselves. Clients had already brought many of their jobs in-house, reducing the number of available projects for designers. At the same time, since almost anyone who could turn on a Mac could, and often did, purport to be a graphic designer, design firms found themselves facing more competition for fewer projects.

Added to this was the increased overhead already taken on by design firms to buy the technology they needed to compete. Inevitably, design firms were forced to reduce their staffs. The majority of designers who were let go, finding no jobs, turned to free-lance work, further swelling the ranks of competitors.

Managing and marketing a design firm has never been easy, and few design schools have tried to prepare students for the business demands they will meet when they graduate. In the past, because the design business had been relatively stable for so many years, this problem could easily be overcome by any designer willing to make the leap of faith I mentioned in the first edition of this book: *Being a business person does not mean making a pact with the Devil.*

Today, this leap of faith is not enough. Although much of the knowledge and skill needed to successfully manage a design business has remained the same, much more has changed. And the changes have come with such speed that few designers have had the time or experience to determine what works and what doesn't. Most designers had to learn the new survival techniques by trial and error. Unfortunately for many, one trial and one error was all they got before they were forced to close their doors.

This book builds on the premise of its first edition, to help graphic designers become as good at business as they are at design. Along with describing the same simple and basic business principles that all designers need to understand in order to make the most of their talent, it also describes the many ways that designers all over the country have adjusted to the confusing and complicated new demands forced on them by changes in technology and the economy.

This edition is the result of hundreds of interviews with designers in this country and in Europe, each conducted to satisfy my curiosity about how they have been dealing with their new challenges. What I discovered was almost as many creative approaches to the unique problems posed by change as there are creative designers.

Wherever possible, I have attempted to find similarities and present them in as clear and direct a way as possible. Where there have been differences, I have tried to explain the pros and cons of each approach and have left it to the reader to decide which direction or strategy to pursue.

Should You or Shouldn't You?

Until the late 1980s there was little doubt that the majority of designers I talked to would have preferred to work for themselves, if given the chance, rather than work for someone else. Even in those days, however, starting one's own design firm was a scary prospect. In today's even more uncertain design environment, going out on your own looks like a downright "Kervorkian" move, akin to an assisted suicide.

Although the design profession has changed radically in the past nine or ten years, the reasons designers would prefer to work for themselves haven't changed:

1. They feel frustrated artistically.

2. In many cases, they feel they are underpaid.

3. They complain about being isolated from clients and from the problem-solving process, and

4. Some resent others' taking credit for their designs.

But, in addition to the fact that many designers still lack the kind of knowledge which would take the mystery out of operating a business and are still suspicious of the very people from whom they could learn sensible business procedures, today there are several new considerations that make it even more difficult for designers to make the decision to open their own businesses.

Designers contemplating going out on their own have always been troubled by the usual questions: "Where do I start?" "Will I be able to attract clients?" "How much money will I need?" "I know nothing about business. How do I keep track of costs?" Today they are faced with some new questions: "How much computer hardware and software will I need?", "IBM or Mac?", "Pentium or Power PC?", "Should I buy or lease?"

In the past most designers merely needed a T-square, some triangles, a few pencils and pens, and some layout pads. Today, in order to compete, the same designers are convinced they will need to buy or lease enough electronic widgets to run a small missile base (come to think of it, since the breakup of the Soviet Union, a small missile base is probably less expensive).

Another problem facing designers contemplating going into business for themselves is the fact that so many of the ground rules seem to have changed, and no one knows what the new rules are.

Opening a design firm today is a bit like walking into a dark room without knowing where the light switch is, or even how to turn it on. The profession is going through an amazing transition, and most designers are still trying to figure out where it is going and what strategies will be needed to get through the transition in one piece.

THE CONSPIRACY

It isn't too difficult to understand the various reasons that for years, young designers have feared opening and running their own businesses. From the day young people begin to take a serious interest in art, there is almost a conspiracy to keep them in their place—there always has been.

First they learn that artists aren't supposed to be concerned with making a living. The romantic nineteenth-century image of the poet-artist concerned only with Art is the one we all carry in our heads.

At some point in their lives, however, the young artists-to-be become the young graphic designers-to-be. They then come smack up against the contradictory nature of graphic design as a profession. Graphic design is at one and the same time an art and a business. But art schools do little to foster in student designers a healthy respect for business and business people. They almost seem to go out of their way to encourage suspicion and mistrust of the marketplace and merchants.

This problem is perpetuated by a system in which student designers are taught by designers, lectured to by designers, judged by designers, and spend practically all their waking and working moments in the company of designers.

By the time they have managed to get out into the world of commerce, most of them are barely prepared to understand a client's language and needs, much less to run their own business.

Another factor which seems to work against designers starting their own businesses is the master–apprentice tradition of the graphic design industry. Graphic design is one of those professions which happens to develop superstars. The dream of most student designers is not to replace these chosen few but to work for one of them. These superstar designers are their gods, and they don't want to kill their gods. They want to become *disciples*.

Add to this the need for more capital and what appears to be the collapse of the design firm system as we have always known it. Is it any wonder that few designers go out of their way to quit their jobs and open their own businesses in spite of the fact that most of them so badly want to? This is not to say that owning and operating a graphic design studio is something that should be entered into lightly or that all designers should do.

Clearly, there are many designers and "wannabe" designers who will find that, in the new, more competitive and more complex business of graphic design, there is no room for them. There are also many designers who would be far better off working for someone else. Perhaps they haven't learned enough to run their own businesses, or maybe their personalities are such that they could never feel comfortable as their own boss. It could also be that they are lucky enough to have a terrific employer who appreciates them and lets them know it. For these designers, it obviously makes more sense to continue working for others than to open their own firms. The good news for these designers is that in the next ten or so years, there promises to be a lot more design jobs opening up, not in the traditional design firms, but in in-house corporate and institutional departments, where more and more well-trained and well-educated designers will be needed to produce an increased amount of communications materials, both in print and in electronic form. They will be needed to help compete for the attention of audiences exposed to the barrage of information and messages coming to them on the "information super-highway" everyone is hearing about.

In spite of all appearances, there has never been a more exciting time for graphic design. Furthermore, for designers with talent, energy, good business sense, and a recognition that the days have long since passed when a design firm could survive merely by providing good service and doing good-looking work, the prospects for success have never looked better.

These designers could, and perhaps should, begin to think about opening and running their own studios. To help make this venture a success, they need to consider carefully their motives and their aspirations.

The fact is that there have always been good reasons for designers to start their own businesses and there have always been bad reasons. If you want to open your own business for all the wrong reasons (page 8), you're asking for trouble. On the other hand, if your reasons are solid, and you're well-prepared to deal with the responsibilities and problems that owning a business involves, then starting your own company makes perfect sense.

SOME BAD REASONS

1. "I WANT TO BE A GREAT DESIGNER."

Being a great designer has little to do with whether or not a person owns his or her own business. That particular goal has far more to do with talent and experience. Having too little of either is more likely to prevent designers from being inducted into that rarefied domain reserved for the great designers than whether or not they own their own businesses.

For many designers, in fact, the kinds of pressures that are created by the need to administer and manage a business can actually go a long way towards preventing the development and flowering of whatever potential for greatness they might otherwise have. When the choice comes down to compromising a daring and imaginative design or not eating or meeting a payroll, you'd be amazed how quickly art flies out the door.

2. "I WANT TO BE FAMOUS."

Although we can certainly point to many designers, such as Lou Dorfsman and McRay Magleby, who achieved great fame while working for others, it is true nevertheless that the chances of one's name becoming a household word (at least in the households of other designers) is far greater for those whose names are on the doors than for those who merely work for others. However, reality tells us that the nature and size of a business or institution play more of a role in affecting the exposure that your designs get than whether or not they were done for your own business. This exposure, plus the necessary talent, ability, and experience, makes designers famous. Merely owning a studio of your own will not do it.

The opportunity for national recognition is dependent upon the wide circulation, exhibition, and/or exposure of the designer's works. One avenue for this exposure for designers is the annual design exhibitions, of which there are about 50 different national examples. But entering many of these exhibitions can get expensive, and only the larger firms or institutions can usually afford the expense. Furthermore, the criteria for award-winning design projects have little to do with profitable or successful assignments. Unfortunately, due to the nature of the judging process, dictated by time limitations, they have more to do with what a design looks like, which means that, very often, a design firm has to be willing and able to forego some of profits in order to do the kind of design work that helps them become famous. It is no accident that so many award-winning designs are pro-bono or self-marketing projects.

National recognition can also come from working on large and complex programs for major clients. Small design firms used to find it difficult to get large corporations to give them extensive and complicated assignments. This is no longer true. More and more corporations and institutions are seeking new and more innovative designers and care little about sheer size.

But, if fame is your goal, then you probably have two choices: Work for a firm or institution that offers you the opportunity for national exposure, or open your own firm and accept the fact that, to do the kind of work that might win design awards, you will probably have to spend a lot of time working on projects that pay no money.

3. "I WANT TO BE FREE TO DESIGN MY WAY."

Fine artists please themselves; graphic designers please others. If you're already having trouble convincing your bosses or their clients that your solutions are the right ones, what makes you so sure that in your own business you'll be any more successful persuading your clients that your way is the right way?

4. "I WANT TO MAKE MORE MONEY."

Some designers make a lot of money. The majority just make a living. The only way to make any money at all in graphic design is to find clients who are willing to pay for your work. It stands to reason that, if it's money you're after, you'll have to go out and get clients and make them happy.

Clients are usually happy only when their needs are satisfied, but often the client doesn't agree that the solution designers have proposed will satisfy those needs.

In such cases the designers face the choice of changing their design, changing the client's mind, or changing their client.

If it's money you're after, deciding to work with only those clients who offer the best opportunities for excellent work is a reasonable choice, but one that will require a lot of patience and willpower. It's possible that by producing superior work over a long period of time, you will attract enough clients who desire your kind of work. You then begin to make a living, but you might have to go through many lean years first. I'm not suggesting that this would be a wrong choice for some designers. I'm merely saying that, if this is your choice, you should recognize the price to be paid.

Think about all those times when some client will be asking you to make changes in your design that you don't want to make. The design, you think, will be something less than it should be. How will you deal with this situation? How have you dealt with it in the past? Is there any reason to expect your behavior to change when there is more at stake?

The answer to these questions might be a good indicator of your ability to satisfy clients and keep yourself happy and financially successful.

5. "I WANT MORE SECURITY."

The truth is that there's practically nothing as insecure as owning your own business. And a service business such as a graphic design firm, which is based on the talents of the owner, is the most difficult of all businesses to make secure. Anything that interferes with its ability to serve can jeopardize the business, whether the owner has control over the problem or not: illness, suppliers that don't produce, the mail, the weather, a surly receptionist. And this doesn't even take into consideration the owner's ups and downs.

But, while there are many bad reasons to start your own business, there are also some excellent reasons why many designers should open their own businesses.

SOME GOOD REASONS

1. "I AM NEEDED."

You are certain that you have something of genuine value to offer clients but you find you're unable to supply it in your present circumstances. There is no precise way to know that what you have to offer has real value to a client. You just have to feel it.

2. "I CAN MAKE A GOOD CASE FOR DESIGN."

You clearly understand the role that design plays in meeting business objectives and are convinced that you can persuasively state that case to clients.

3. "I CAN PERFORM."

You think you're a better designer than your boss, who's doing quite well.

Sometimes you find this out from your peers. Michael Vanderbyl did. In describing the events that led to his opening his own design firm, he told me of the time when he was working for another firm and doing some free-lancing on his own. He entered some of the free-lance work he had done in a San Francisco design competition. When he found out that more of his free-lance work had been accepted into the competition than that of the firm for which he was working, he realized that he was ready to go out on his own.

4. "I UNDERSTAND BUSINESS AND BUSINESS PEOPLE."

You have enough knowledge of business, either by personal education or by taking formal business courses, to keep track of and manage your own business as well as to understand what a client's prime business concerns are.

5. " I AM READY TO MARKET MYSELF."

You have taken a few sales and marketing courses or seminars. There are many colleges and universities offering night courses in business, which are relatively inexpensive and accessible. In addition, such organizations as The Graphic Artists Guild sponsor many seminars in business for designers.

6. "I FEEL COMFORTABLE AS A LEADER."

As the owner of your own business, you will have to be a manager and motivator of others, not only for employees, but for clients as well. If this role is one you have difficulty dealing with, you may not be cut out to run your own firm.

7. "I AM DECISIVE."

You are not afraid to take responsibility. As the owner of your own business, you will have to make decisions each and every day which affect the futures of you and your staff. There will seldom be anyone to tell you which decision is the right one. Most of the time the clues that tell you what to do will be ambiguous. Yet decide you must, all by yourself.

8. "I AM A WELL-ORGANIZED PERSON."

If there's one thing that sets the good manager apart from the bad one, it is that the good one is well organized and logical. You can't run a business, which is a complex of many diverse parts, if you aren't well organized.

9. "I LIKE PEOPLE."

As the owner of your own business, you will not only have to deal with many more people than you had to when you worked for others, but you will also have to sell them on your ideas or motivate them to perform at their best for you. If you really don't get a kick out of dealing with people, this will be very difficult for you.

10. "I AM A SELF-STARTER."

If you don't need anyone to push you to do a job, that's good—because there won't be anyone there to push you.

11. "I'M COOL."

You don't easily get rattled under pressure. If you've been in the business for any length of time, you probably think you'll have no problems dealing with the pressures of deadlines. But you have to remember that there will be the added responsibilities and pressures not only of getting the work out with quality, but also of trying to get the work in as well, at a profit.

12. "MY HEALTH IS GOOD."

This is no minor concern. In a one-person business, there won't be much happening if you're the type who spends a lot of time in bed nursing colds and viruses.

GOING AHEAD WITH IT

If you can't give an enthusiastic "yes" to all of the above, but you have no other choice, then you have to forget everything and just go for it.

Primo Angeli, who owns a very fine design firm in San Francisco, told me of being asked once to describe the first firm he worked for. He replied that he hadn't found it yet. The truth was that no one would hire him when he graduated from art school.

In these difficult times, for many designers, both inexperienced and experienced, the choice is no choice at all. They are beginners and can't find a job at all, or, for one reason or another, have lost their jobs. If they want to work as graphic designers, they will have to open their own businesses.

Unfortunately, graphic design isn't one of those professions that can be learned easily merely by doing it. It really does help to spend some time working in a professional environment with more experienced colleagues. Thus, for designers right out of art school, being forced to sink or swim often means sinking.

On the other hand, more experienced designers who find themselves suddenly out of work are hardly in the frame of mind to take a risk confidently. No matter how quickly or slowly a separation occurs, it always comes at the wrong time. A panicky feeling that they will never be able to find a job is always on the mind of the out-of-work.

Designers are, by training, somewhat more compulsive about working in the first place. For a designer, there is probably nothing more difficult to deal with than not having a job. Out-of-work designers, then, will do everything possible to work for someone else rather than for themselves. Only when it becomes obvious that they really have no other choice do they begin to seriously consider the possibility of self-employment.

But we then come back to the central problem: Never having actually run a business of their own, they are overwhelmed with doubts and fears. Where will they get clients? How will they pay their bills? What do they know about bookkeeping?

A SIMPLE START-UP

Sooner or later these would-be studio principals find themselves in a bookstore trying to get a quick education in starting a small business. The books usually only add to their fears. The message contained within them is clear: "Starting a small business is risky, tough, and can be costly." Unfortunately, this message is all too true. Designers thinking about starting their own businesses have every right to be hesitant before putting out their shingles.

There are, however, some important differences between the start-up needs of most small businesses and those of a graphic design studio. Although the need for computer equipment has driven the cost of starting a design business up, in many ways, it is still a lot easier to open a graphic design studio than most other businesses.

At the risk of oversimplifying, let's examine the needs of a typical business. Almost every business can be broken down into four basic parts: buying, selling, paying, and pleasing.

The typical business transaction is to buy goods at one price, ideally low, and sell them at another, ideally high. A delicate balance must be maintained between having enough stock to keep the business going and not so much that needed capital is sitting in inventory too long.

For the graphic designer, the situation is quite different. Since the only inventory the graphic designer has to worry about is ideas and practical skill, one of the biggest drawbacks to opening a business is eliminated: the need to find and buy material at a good price for resale and, hence, the continuous need for large and sometimes risky capital outlays.

While other professionals, such as dentists, physicians, lawyers, and architects, may not have to worry about the need to lay in a large supply of widgets and find ways to unload them at a profit, they nevertheless have to deal with a number of other very real problems that graphic designers don't have to face. Although the gap has narrowed somewhat, it still costs a lot more to minimally outfit a small dentist's office than it does to buy a few computers and peripherals. A physician's office could easily cost just as much, depending on the type of practice and where it is located.

In addition, lawyers and architects, together with their fellow professionals, dentists and physicians, have much greater restrictions on how they can be licensed and certified, how they can market themselves and how much they can charge for their services.

Designers are somewhat better off. Their need for equipment, although greater than it had been for years, is still relatively minimal and inexpensive compared to most start-up businesses, and it requires little room. Large out-of-pocket costs on jobs can usually be billed directly to their clients, so there is little demand for cash beyond what is needed to pay the rent and their own salaries.

SELLING AND PLEASING

Of the four parts that make up the equation for most business and professional practices—buying, selling, paying, and pleasing—only two demand a designer's serious attention: selling and pleasing, neither of which involve a lot of capital.

Retailers accept the fact that, in order to survive in business, they must find a way to sell their product inventory as quickly as possible for the highest possible profit that demand will allow. So, too, designers have to be prepared to sell their products—their brains and talent—actively, aggressively, and intelligently.

Few designers have been trained for sales, and fewer have a talent for it. In later chapters we will discuss specific sales and marketing techniques. For now, one of your first considerations in contemplating whether to open a design business should be how well-prepared you are to sell your own graphic design solutions.

Pleasing, the other half of the two essential ingredients to a successful design practice, involves a number of issues. You need to please clients, please the government, please employees, please your peers, and finally, please yourself.

Clients must be pleased, because you won't keep them if they are not.

The government has to be pleased in the form of taxes paid and papers filed. If they aren't, designers might find themselves facing not only some costly legal fees, but the very real possibility of spending some time in the slammer.

Employees, if any, will have to be pleased if the designer ever expects to get to the point, which most designers aspire to, where he or she is mostly getting the benefit of employees' minds instead of their hands.

Peers will have to be pleased, not because their opinion of a designer's work is more important than the designer's own or the clients', but simply because it's good business to be held in high esteem by one's peers.

Designers will have to be pleased with themselves, because graphic design is a tough and demanding profession that's hard enough to practice day after day when one likes doing it. It's practically impossible to run a successful graphic design practice when one can't stand to go to work every day.

If designers can get these two vital elements of their business under control, selling and pleasing, they are well on their way to operating a successful design firm of their own.

Planning Ahead

When should you begin thinking about starting your own graphic design business? Here's the answer from Bob Rytter, one of the most successful graphic designers in the country: "The first day you show up for work at your first design job."

If the day ever comes when you decide to stop just thinking about it and start doing it, if you have prepared yourself properly, it should not be difficult to begin.

In the preceding chapter we outlined some good reasons (and bad reasons) to start your own business. If your decision is to *go* ahead, then by all means *plan* ahead.

If you don't have a deliberate plan, four things could happen:

1. You might never start your own business.

2. You might start your own business, but not at the right time.

3. When the right time comes, you won't be prepared to seize the opportunity.

4. You might start a business, only to find very quickly that the business is in serious trouble and that you are overworked, underpaid, and unhappy.

Planning is not mysterious. It means thinking through what you need and when you need it and then doggedly going out to get it.

WHAT YOU NEED TO GET STARTED

To get a graphic design business started successfully, you need these essential elements:

1. Adequate training and experience.

2. A business plan.

3. Working capital: At least one major client and/or enough money to buy equipment, pay bills and stay alive for several months.

4. Four dependable, trustworthy professionals: a lawyer, accountant, banker, and insurance agent.

5. A place to work.

ON-THE-JOB TRAINING

Bob Rytter's advice is sound. From the first day on the first job, observe with the eyes of one who plans to own your own business someday. Even if you change your mind later, nothing has been lost by learning how it's done.

No young designer has to be told to use a first job to get experience in solving design problems and developing the hand and head skills of the craft. Yet few realize the equal importance of learning to run a business intelligently.

Regardless of where you work, you can learn something about good and bad ways to manage a business. You can learn how jobs are estimated, costed, and billed; how projects are scheduled and coordinated; how to maintain cash flow. You can take some business courses at night. In short, view the early working years as years of apprenticeship not only as a designer, but as a business person.

Designers can get clients only if they are able to help clients and can prove it. So before you try to start your own business, you must have an excellent portfolio of your own completed work to show. Clients will want to see completed projects that indicate that the designer can get approvals and can supervise a job to its completion. Clients tend to dismiss work in which the designer played only a minor role.

This suggests that a designer should concentrate on working on his or her own projects and supervising the production, dealing with clients, and managing complete projects. Designers have to learn as quickly as possibly to make themselves answerable and responsible. They must also measure where they stand in these areas and document their abilities.

Clients will want to hire a designer who will produce the best possible work within certain givens; one who will deliver it on time and will keep within the agreed-upon budget. Clients are much more interested in results than in procedures. Designers have to learn to understand what results a client is looking for and how to help the clients achieve these results. They have to learn how to work with clients and how to direct projects.

To begin thinking in these terms, analyze projects you have worked on. What role did you play? How did the job turn out? What was done well? What might have been done better? What lessons were learned? Were there any awards won? Who was the client? What was the problem? What was the approach taken? What were the tangible or quantifiable results?

Furthermore, designers have to learn how to determine their fees so that they can compete with other designers. They have to learn how to make a profit so that they can stay in business at all.

They have to learn how to manage their money so they can build a secure future. The surest road to creative freedom is having the least amount to risk. So designers who have built good bank accounts have the most creative freedom. They can afford to turn down jobs or clients that don't offer them the most creative possibilities.

Designers have to learn how to manage their office and their employees. These, perhaps, are the most difficult parts of running a business, and the tasks designers are generally the least prepared for. Seldom do designers learn in school what other college graduates learn—salesmanship techniques, accounting techniques, some business procedures.

THE BUSINESS PLAN

Here's the foolish way to go into business: Just hang out your shingle and charge anyone who walks in your door the most you can get.

It's easy. Hundreds of designers do it each year. But only a handful survive as independent businesses.

The fatal flaw of this approach is that it brings you into the marketplace without a clear definition—in your mind, or in the minds of clients—of where your business fits. Are you charging the highest prices in town and offering the most complete services? Are you charging the lowest prices and doing quick-and-dirty work or are you acquiring a reputation as somebody who will always bend on price?

The wiser approach is to enter the marketplace with a business plan. That plan addresses your strategy—where your firm is positioned relative to other firms and what other firms charge, where you want it to be positioned, and what you intend to do to get it there. It involves conscious decisions about the size of the firm, its legal structure, and its pricing strategy.

To reach these decisions, these are some of the questions that must be answered:

1. Is the service your firm can offer in great demand locally?

According to the law of supply and demand, high demand tends to increase prices, while low demand depresses prices. If the service you offer is in low demand at the moment, you can assume that high prices probably will not be competitive. In that case you must decide whether to charge low, competitive prices, expand into markets of higher demand, or maintain high prices and wait for the demand to increase.

In describing his early years, Stan Richards, of The Richards Group in Dallas, tells how, while passing through Dallas on the way to Los Angeles, he talked to Marvin Krieger, a senior art director for a Dallas advertising agency. Krieger was greatly impressed by Stan's work, but warned that there was little need for work of that quality in Dallas at that particular time. He said Stan would probably have a difficult time finding work, but if he could survive without compromising either his standards or his sense of self-esteem, sooner or later the demand for a high-quality product would rise, and Stan would be the only one in the area who could provide it. Stan took Krieger's advice and toughed it out through some very lean years. Krieger's counsel proved to be absolutely accurate.

You also must distinguish between demand for a service and demand for your individual firm. The service you offer might be in great demand, but the perceived value of your firm might be low for a variety of reasons—a primary one being that you're the new arrival and without established credentials. Such a situation might call for setting lower prices initially to build a body of published work.

2. Is there much competition in the market you serve?

The number and caliber of competitors also affects prices. It pays to pay attention. Too often, design firms ignore the signs of tougher competition, only to find out too late that they have lost their competitive edge. When that happens they are facing a double problem: 1) They can't reduce their prices without appearing to be conceding the perceived loss in reputation; and 2) they can't continue to charge the high prices without losing more and more work. They could tighten their belts, cut back their staff and reduce overhead, in order to survive on a lower volume; they can step up their efforts to recapture their reputation in their traditional market; or they can seek new markets and add new services. All these remedies are costly and painful. It's far better to be sensitive to your competitive environment and more willing to add some long-range planning to your firm's arsenal.

If you find yourself competing with many other firms offering similar quality and service, you can assume that price will be a strong factor in the final selections. It is in your interest to shift your clients' focus from price to less quantitative areas—in particular, those where you can claim a decisive advantage.

3. How badly do you want certain kinds of jobs?

If your overall strategy calls for expansion into a new market area (telecommunications company annual reports, for example), a project that will bolster your experience in that area may be important enough to you to justify a price discount. But be careful. Information has a way of circulating throughout the marketplace. If your firm acquires a reputation for being low-priced, it will be very hard to quote higher prices to other clients. If the word gets around that your prices vary too much, you will be under constant pressure to justify or reduce them.

Furthermore, it will be very hard to pursue the kinds of jobs reserved for those firms who are perceived by the marketplace as providing high quality at high prices. Most clients, like most ordinary consumers, tend to associate higher prices with higher quality. In a business which is as subjective as the graphic design business, there often is no other measurement for unsophisticated clients to use.

HOW MUCH MONEY WILL YOU NEED?

Figuring a reasonably accurate budget for your first year in business is terribly important. It will be difficult enough to get going, considering all the things you have to do, without adding to it the considerable burden of financial surprises.

In order to create a budget, you will have to put together the figures which tell you how much money you will need in three areas:

A. You.

How much you need to live on.

B. Initial start-up expenses.

Most of these would be one-time expenses, such as certain computer equipment, furnishings, telephone installation, putting up signs, legal fees, and so on.

C. Continuing expenses or overhead.

Such things as ongoing computer costs, rent, gas and electricity, cleaning services, stationery, materials, and so on.

Assume that you plan to set up an office somewhere other than your own home. If your final figures show you will need more money than you can raise, compute it again on the basis of an office in your home. Don't lie to yourself about the figures. You have no one to fool but yourself. Remember, there are no norms. You must figure out your own costs as they apply to your personal situation.

(A) Personal Budget

This is a very difficult budget to try to work out, but it is probably the most important, since it affects you and your family directly. Identify a figure that will provide for your household's minimum living needs for no less than one year. Then add another 10 percent to that number, to cover all those things that cannot be planned for, but are virtually inevitable—the refrigerator that suddenly breaks down, braces for the twins (remember, in your own business you'll have to provide your own medical plan or pay the medical expenses yourself).

(B) One-Time Expenses

Below are listed some items that you may need to be concerned with. You may not need to plan for all of them, but they can serve as a guide. Once again, it would be a good idea to add a 10-percent contingency factor to the estimate of these costs.

Filing cabinets	Legal costs
Storage	Telephones, fax machine,
Shelving	photocopier
Chairs	Decorating
Light tables, drawing	Computer hardware and
boards and/or computer tables	software (see page 73)
puter tables	Opening announcements
T-squares, triangles, and	Slide projectors and trays
drawing instruments	Lamps and lighting
Markers, technical pens	Conference table
Waxer	Process and flat color
Reference books	charts

Make up your own list. Pin down as many of the figures as possible by making phone calls, writing for catalogs, or checking with friends or acquaintances already in business. Remember, too, that most of these expenses will be deductible items on your income tax.

(C) Overhead Expenses

These are continuous expenses. Some of them will be known in advance, or fixed, while some them can only be guessed at. Add a 10-percent contingency to all costs to cover yourself.

Salaries	Wax blocks
Rent	Spray/rubber cements
Insurance	Slide holders
Utilities	Cleaning services
Telephone bills	Mail
Taxes	Letterheads and
Accounting and book-	envelopes (business
keeping costs	and mailing)
Boards	Magazine subscriptions
Paper (photocopy and	Travel
laser)	Sales promotion
Miscellaneous office sup-	Advertising and public
plies (tapes, pencils,	relations
erasers, etc.)	Photography of samples
Computer disks, training,	
and upgrades	

SAMPLE BUDGET

	Yearly Subtotal	10% Contingency	Yearly Total
Personal expenses	$30,000	$3,000	$32,000
One-time expenses	$30,000	$3,000	$33,000
Overhead expenses	$20,000	$2,000	$22,000
TOTAL			$88,000

The $88,000 total in this hypothetical example represents what a designer will need to open and operate an office for a year. The money won't be needed all at once. In fact, not all of it absolutely must be in the bank, since there may be fee income during the year. But it would be more prudent to make plans without counting on that hoped-for income.

If you have some definite projects already under contract, of course, that's a different story. You might try to get your client to pay some of the bills in advance to help your cash flow. You could also use signed contracts as leverage in negotiating a loan. If you succeed, don't forget to include loan payments in your overhead expenses—and don't forget to make the payments on schedule.

By having adequate start-up capital, and thereby not struggling from week to week, you will be able to concentrate on doing the best job you can on each project, and on making lots of sales calls to let people know you're in business. You'll also be free to be more selective in your choice of jobs.

You know how much money you have in the bank. You know how much equipment you already own. Going through the exercise of figuring your first year's budget will give you a better idea of how close that brings you to being ready to start your own business. It also gives some direction to how you can afford to do it: whether from an office or from your home, by yourself or with the help of an assistant or a secretary.

And developing the budget is a valuable tool when the time comes to approach friends, family, investors, or lenders for funds. It doesn't predict whether you'll succeed in business or not, but it does help gauge the cost of trying and the amount of risk at stake.

There are three basic ways to come up with start-up capital. You can save it, you can raise it by selling stock, or you can borrow it.

Self-capitalization, or saving, has the decided advantage of putting you under no legal, ethical, financial, or psychological obligation to pay back someone else should you be less than a total success. Admittedly, saving enough to underwrite an entire year in business is hard and slow—perhaps impossibly slow. By the time you accomplish it, you may be retirement age.

But some of your own funds will certainly be part of any funding package. After all, can you expect others to risk money on your behalf if you haven't shown the commitment of risking your own?

A second source of capital is your family and friends. You might approach them either for business loans (to be treated as such and paid back with interest) or as investors in your firm, whose purchases of stock do not require immediate dividends. (Issues regarding how to structure your business are covered in detail in the next chapter, beginning on page 18.)

In either case, your business plan—showing how you have sized up the competitive situation, where you expect to find your niche, how you intend to win clients, and how much money you need to make it all work smoothly—can only help your efforts to secure capital.

The plan is an absolute prerequisite for calling on the third source of funds, your friendly banker. In truth, bankers are rarely friendly to graphic designers, at least in a business sense. Bankers tend to share a preconception of artists—unfortunately shared by many artists themselves—that they are too scatterbrained to run a business. Scatterbrains are not good credit risks. Breaking through this preconception will be an uphill struggle, but it is not impossible. It will require that you take the right approach and do your homework. What a banker wants to know is how you will generate the revenues to repay the loan. Show how. Explain your precise requirements, and have some well-documented forecasts of your earnings. Provide the evidence that you are capable of sound business management. And look the part—come dressed for success.

Perhaps the best way to secure the support of a banker is to approach one with whom you have had a long-standing relationship. A known quantity is always more bankable than a stranger.

THE GANG OF FOUR

Long-standing relationships are worth building not only with your banker, but with three other key professionals as well—your accountant, your lawyer, and your insurance agent. All four can be important advisers and supporters. It is worth the effort to find persons in each field with whom you feel rapport and trust.

Referrals are easy enough. But don't take someone else's word. Get to know the professionals personally. Have lunch. Ask lots of questions. Be satisfied that they understand the graphic design business or want to be educated about it. It is important, long before you take the plunge into business ownership, that you have confidence in the professionals you'll be depending on for expert counsel. Test each relationship yourself on a small scale. Borrow a small sum from the bank, and pay it back on time or ahead of schedule. Buy a small piece of property and ask your lawyer to draw up the papers. Buy some insurance. Have your accountant handle your personal income taxes.

A PLACE TO WORK

The relative advantages and disadvantages of renting office space versus working from your home are covered in more detail in the next chapter.

The important considerations are expenses and professionalism. Expenses are self-explanatory. By professionalism, I mean making clients feel that they are dealing with a bona fide, professional business. Clients need to have the security of knowing they are working with a firm that can do the job. Consequently, if new clients visit your "office" and find themselves down the hall from your bedroom, and your two-year-old is throwing Spaghetti-O's at them, you are not, in their mind, a real business.

You *can* have a home office, as long as clients don't visit there and as long as a breathing human being at least 18 years old picks up the telephone most of the time. There are other alternatives, too. When Jack Summerford opened his own design firm in Dallas, he and two friends formed a corporation which purchased a small but attractive building near the central business district. Each of them then leased space in their building from their corporation. The corporation also rents space to two other designers, to whom Jack gives occasional free-lance work; these designers are also there to answer Jack's phone when Jack is out of the office. Result: many of the advantages of a medium-sized design firm, with very little attendant overhead.

Leases and Other Legalities

The business plan is completed, and the first-year budget looks good. Now it's time to get down to the nitty-gritty—to make commitments and sign papers.

OFFICE SPACE

The first thing you'll need to figure out is whether you have enough money in the bank to allow you to set up a separate office or whether you'll have to work out of your home.

Most beginning free-lance designers work out of their homes. The advantages are obvious. The cost for rent, utilities, and furnishings is minimal, and a home office provides a useful income tax deduction.

There are some obvious problems with a home office, however. The fact that so many designers begin this way and then quickly try to set up an office elsewhere speaks volumes for the difficulties. One frequent problem is distance. Your home may be located far from the places you have to visit to do business. With the help of fax machines and modems, much of the need for face-to-face meetings with clients has been eliminated, but it would be a mistake to underestimate the need for physically being in front of clients, especially potential clients. Traveling time, which takes up a major part of the day, affects scheduling and limits the number of jobs you can handle.

A bigger problem is distraction. It is a hardy soul who can concentrate on the work at hand in the face of crying infants, interruptions from neighbors and salespeople, or the tempting presence of the refrigerator. Michael Manwaring, one of the terrific "Michael" designers in San Francisco, brought up a different problem created by having an office at home. "The work is always there." Every time you walk by the office door, there's an urge to pop in and continue working on some problem you have put aside. This conflict can put a strain on you and on family relationships.

Another problem to be aware of before you choose to set up your business in your home is that of the image it creates for your business. Some clients can get very nervous if they get the idea that they are dealing with an amateur or a one-person company. But if you have no other choice and there are no zoning regulations that would prevent it, go ahead and set up shop in your own home. To eliminate some of the inherent problems, however, you should develop a business plan that will take you into your own office within a specified time frame.

WHERE?

When the time comes for you to set up an office elsewhere, there are a number of factors to consider. Most importantly, where should the office be located? This choice will be determined to a certain extent by zoning laws, but beyond complying with local law, here are things to consider in your decision about a location:

Access

You and your clients will have to get together regularly, so don't make it too difficult for these meetings to happen. You also don't want to spend too much time traveling, because it simply leaves too little time for doing. Make sure that the office is located close to major access routes.

Services

You will be needing the services of various suppliers—service bureaus, pre-press houses, paper merchants, delivery services, secretarial services, etc. If you're located too far from these services, it will cost you more and may cause delays in the completion of your jobs, which might jeopardize them.

Address

It is not necessary to have an expensive address, since there won't be too many clients coming to your office in your early years, but you should pay some attention to how the address sounds to a client. If the address sounds as if it's in one of the better areas of the city, that raises the prestige of your business a notch or two in the client's mind. The reverse is also true, and you don't want clients to perceive you as less than professional.

Lighting

Make sure that the offices you're interested in have good natural lighting. Not only is it easier on your eyes, but it might also save you a little money on your electric bills.

Storage Space

A successful business accumulates an incredible amount of material over the years. Most of it will have to be kept neat, clean, orderly, and easily accessible. If generous storage space isn't already available in the office, try to imagine how you might add it.

Accessibility

Make sure that you'll be able to use the office 24 hours a day, seven days a week. If you're like most graphic designers, the 40-hour work week is just the beginning. You'll have some serious problems with your business if you can't get into your offices when you have to.

Improvements

A space in need of considerable renovation might be obtained at a lower rent. On the other hand, if it costs too much to make the necessary improvements, or if you're not the kind of a person who can do most of the work yourself, you might find yourself tight for cash. Furthermore, it might be a better use of your time to be out looking for jobs to work on than staying in your new offices plastering walls.

WORKING OUT A LEASE

Once you settle on office space you'd like, you have a legal hurdle to get over, the lease. More than likely, you'll be given a standard lease form to sign, but you don't have to accept it the way it is written. First, make certain "your" lawyer, "your" accountant, "your" banker, and "your" insurance agent read it over very carefully. Strike out anything you don't like and anything they don't like. Make any additions or changes you want to the lease. Be prepared to negotiate. Don't make concessions without expecting concessions in return.

A key question to be answered is how long the lease should run. Since we're talking about your first design office, a short lease—one or two years at the most—would help protect you from getting in over your head, in case the business should turn sour. On the other hand, if the business were to be wildly successful, you would probably be looking for new and larger space anyway after a few years.

If, by luck, you happen to find an office which in every way would satisfy all your present and future needs, the best thing to do would be to take a short lease with an option to renew it for a time.

DESIGN DECOR

A design firm's offices play a major sales role, especially if the firm is trying to attract large corporations. The more prosperous the clients you seek, the larger the appropriate investment in rental space and furnishings.

In any case, the offices should be clean, neat, and bright. Dirty, dreary, and sloppy offices are not conducive either to dealing with clients or doing the work itself.

The major items that will be needed are a desk to work on, a fax machine, printers, computers, a scanner, a countertop on which large pieces can be laid out for viewing; shelves to file any large items; file cabinets; drawing materials; spare chairs for visitors; lamps for the tables and desks. You will also need large wastebaskets, coat hooks, filing trays, a first-aid box, a cash box, and a Rolodex file or address file. Other items that may be needed are a bulletin board, a slide projector and screen, a photocopier. If cleaning services are not provided as part of the lease agreement, you'll need to arrange for them.

HOW TO STRUCTURE THE BUSINESS

Once you've found a place to do business, you need to give your business a structure. There are six legal frameworks to choose from, each with its advantages and disadvantages. I'll describe these in general here, but to make an intelligent decision on what is best for you, have a talk with your trusted lawyer and accountant.

THE SOLE PROPRIETORSHIP

"Sole proprietor" describes a business owned and operated by one person. Most free-lancers do business this way. Owners may use their own name or they may name the business anything they want, as long as the name doesn't imply that the business is incorporated or doesn't violate the restrictive laws of the state in which the business will be operating. These laws vary from state to state.

Advantages

1. It's easy to start one.
There are very few legal hoops you have to jump through, and it costs practically nothing in most states to establish a sole-proprietor business. If you're not going to hire any employees or give the business a name other than your own, about all you have to do is get a resale number in those states that have sales-tax laws. If you do hire employees, you also have to get an employer's number; applications can generally be found at any post office.

If you intend to use a name that might indicate that others are involved in the business (Joe Smith Design Studios, or The Joe Smith Company), then you will need to file a certificate with the County Clerk or other such local authority. You need this certificate to open an account and to deposit or cash checks made out to the company. People who might extend credit to you also may check on your certificate to find out who the principals of the Joe Smith Company are.

2. You're your own boss.
You can do whatever you please with your business. You have only yourself (and possibly your spouse) to answer to. You have only yourself to irritate.

3. You get to keep all the money.
Assuming there is any.

Disadvantages

1. Unlimited liability.

This is a biggie. You can lose everything—your stereo, your home, your cat. Everything. The law makes no distinction between your business debts and your personal debts, so if you buy too many things for your business and don't get paid fast enough by your clients to pay your bills—or, worse yet, don't get paid at all—you could be in big trouble. You're also vulnerable to lawsuits. Let's say a client happens to slip on a sheet of paper in your office and suffers a back injury, and your insurance doesn't cover the generous settlement a sympathetic jury awards. You can lose everything you have.

2. Lack of stability.

If you die or become disabled, your business does the same. Some people might say, if that happens, "Who cares? I won't be around anyhow." Aside from being a somewhat insensitive statement, it is also inaccurate. Your creditors will care. They might be more reluctant to extend you credit knowing that your business might not be around if you're not.

3. Taxes.

The income (or losses) of the business are treated as personal income, and taxed as personal income. Even in the current, less tiered tax system, tax rates grow steeper at higher income levels. Anyone who has a significant additional source of income, such as a spouse's salary, or dividends, will end up paying higher income taxes. In addition, there are certain tax advantages that are not extended to the sole-proprietor or partnership structures, but only to corporations. Your lawyer and accountant friends can tell you more about these.

4. The teeny-tiny syndrome.

Many potential clients are nervous about dealing with a one-person design firm. Generally, one-person design firms end up doing most of their work for advertising agencies. Few are able to deal directly at the client level, which limits their ability to grow beyond the mere hand-skills services.

THE PARTNERSHIP

Young designers who are not content merely to be freelancers and want to start a "real" design firm often decide to form partnerships. Under a partnership structure, all partners are equally liable for each other's actions, regardless of what their particular partnership agreement may be. Each partner is taxed as an individual (limited partnerships limit the amount of liability a partner is responsible for, but these are generally useful for real estate or tax-sheltering purposes, and are seldom used by design firms).

Advantages

The reasons so many young designers start out in partnerships with other young designers or writers are readily apparent.

1. It costs less.

Each partner only has to come up with a portion of the bucks.

2. It gives them access to more capital and credit.

3. It allows them to pool their labor and take on some larger jobs.

If two designers have slightly different skills and interests—perhaps one is a wonderful illustrator while the other is great at designing ads—they can expand each other's capabilities.

4. It's a morale booster.

There is a certain psychological lift in being able to share the many pleasures and burdens of a business. Just having someone with whom you can discuss a job or exchange points of view can be extremely helpful. Furthermore, there's security in being able to rely on someone who has a real stake in the business, who can cover for you in times of illness, or while you're on vacation. The strain of feeling that you alone are keeping the business going can quickly wear you out.

Disadvantages

The majority of designers I interviewed shared a similar history; at one time or another, early in their careers, they had formed a partnership with one or two other designers and had later dissolved the partnership to go into business for themselves. Partnerships can be intense relationships. Even the very best of friends and most compatible of designers can get to the point where the thought of packing a .357 Magnum when coming into the office begins to look very attractive.

If you intend to set yourself up in a partnership, my advice is to do it in a businesslike way. Don't believe the "It-can't-happen-to-us" stuff. It can, and it probably will. Each partner should get his or her own lawyer and draw up a legal, binding partnership agreement that spells out in as much detail as humanly possible what each partner's responsibilities and commitments will be. You wouldn't use the same lawyer to represent both you and your spouse in a divorce, so don't use the same lawyer for you and your partner or partners. You must protect your own interests. In the course of drawing up the agreement, you'll be amazed how many points of disagreement there are. If you can get through the process of drawing up the agreement without coming to blows, you might be well on your way to forming a very good partnership.

Remember, the problems partnerships run into are usually personal, but many of them have their roots in the basic legal structure of partnerships.

1. Liability.

Like the sole proprietorship, the partnership structure also has the problem of unlimited personal liability for business debts. Only this time, there's a kicker. In a partnership the actions of any one partner, or even of that partner's spouse, can affect the personal assets of all the other partners. This means that if one of the partners goes nuts and buys half of Manhattan, all the other partners will be held equally responsible for his or her actions. Even if their personal partnership agreement limited the liabilities of each of the partners, a creditor can still move to attach the assets of all or any members of the partnership, and even the assets of partners' spouses.

Regardless of how honest, fair, and well-meaning the partners may be with each other, the unlimited liability feature of a partnership structure is a very serious disadvantage. A bit of bad luck on the part of one partner could cost all the others their life savings.

Don't even *think* about entering into a partnership arrangement without first talking to your insurance agent to help reduce the potential risks.

2. Stability.

Like a sole proprietorship, a partnership is very unstable legally. The loss of any one of the partners automatically dissolves the entire partnership structure. In some states, such as California, where there are community property laws, even a divorce could spell the end of the business. Again, look to your insurance agent and your lawyer to help you deal with these potential problems.

3. Freedom of decision.

A partnership structure, by its very nature, restricts the ability of each partner to make decisions without regard to the wishes of other partners. This limitation of freedom of choice even extends to partners' spouses. Whether you like it or not, when your partners are married, their spouses are also your partners. Not only will you have to make sure you can tolerate your partners, you also have to make sure you can get along with your partners' spouses. Even if you manage to keep the personal lives of the partners separated from their business relationships, which you should, you may not be able to shield your business entirely from a spouse who is a determined and persistent meddler. Spouses can also create serious legal problems.

If either the partner or the partner's spouse dies, problems created by the disbursement of the estate and the estate taxes could completely wreck the financial structure of the firm and of all the surviving partners. Before you enter into a partnership agreement I strongly recommend extreme caution. Don't ever enter a partnership with family or close friends—if you value

their friendship. Before forming any partnership make certain you've asked yourself some tough questions, such as:

1. Are the partners capable of carrying their own weight, seeking as well as merely servicing design projects on their own, or will they be too dependent upon the reputation or abilities of one? If the latter is the case, you can be sure that problems will develop in short order.

2. Are the personalities of the partnership compatible? Have you worked together long enough to test this under all conditions?

3. Do the partners' spouses get along? Are the spouses the kind who might be a problem later?

4. Do the partners have similar long-range goals? Are their attitudes toward their work and their business goals similar?

5. How do the partners handle disagreements?

If the answers to all of these questions are encouraging and all the partners wish to go ahead with a partnership arrangement, then each should get a lawyer to begin drawing up a partnership agreement. The items that must be addressed and on which the partners must agree are:

1. How much money each of the partners is going to contribute to the establishment of the business, and when these contributions will be made.

2. What will be the name of the business.

3. How the profits or losses will be shared.

4. What the partners will be paid and how they will receive the money: by salary, draw, commission, etc. Whether or not there are to be any expense allowances, automobiles, health insurance, or other "perks."

5. What will be expected from each partner in the way of performance, degree of responsibility, managerial control, decision making, and employee management.

6. How long the partnership agreement will last.

7. How the partnership will handle the problems of death, retirement, disability, or merely the desire to dissolve.

8. How the partnership will handle disagreements. Will there be a stated arbitration policy?

9. What kind of behavior would be absolutely forbidden or absolutely required.

10. What the accounting method of record will be. How will the company administer the books? Which of the partners will be responsible for doing this?

11. How the partnership will deal with violations of the agreement.

These issues are just a few of the many problems that must be faced and settled. There will probably be many others that will surface as the matters are discussed and thought through. The partners should settle each issue one by one, put it on paper, sign it and put it away.

The knowledge that the agreement exists at all will go a long way toward making the partnership more secure.

CORPORATIONS

The corporation is a marvel of abstract thinking. In the eyes of the law, a corporation is a completely separate entity from the people who comprise it. What the corporation does and what each of the owners do personally have no relationship to each other. In most states, a corporation can consist of one person or an unlimited number.

While it is true that creating a corporation is a bit more complicated than creating a sole proprietorship or partnership, for a relatively inexpensive fee, a lawyer should be able to simplify the process. A fee in the $500 to $800 range is typical for drawing up the necessary papers. For this fee, your lawyer will check to see if the corporation name you have chosen can be used; help you issue the necessary stock and set a value on it; and write up a document of incorporation and file the necessary papers. In all likelihood, the lawyer will also advise you about how best to handle your corporate taxes. To reduce the costs, some of these things can be easily done by the individual.

Once the state grants you permission to incorporate, you are required to have regular stockholders' meetings, have your books audited every year, produce an annual balance sheet, pay taxes on corporate earnings, and generally do business in a formal manner.

Advantages

There are many distinct advantages to be gained by forming a corporation:

1. Liability.

The greatest advantage to the corporate structure is that it limits the liability of the individual owners—or stockholders, in this case. The investors will lose only the money invested. They do not have to worry about losing their personal belongings if the business goes belly up.

2. Performance.

The corporation can be set up to last indefinitely. Should one of the founders die, the corporation will not die with him or her. This is comforting not only to the surviving stockholders, but to potential creditors and lenders as well (although the latter may still require stockholders to pledge their personal assets as collateral for loans).

3. Taxes.

Corporations get many tax benefits that are not available to a sole proprietorship or partnership. Your accountant can give you advice on your specific situation. To give just one example, pension and profit-sharing options available to corporations are excellent ways for the stockholders of a corporation to put aside and accumulate tax-free income; they also provide excellent incentives to attract and keep employees in a firm.

4. Transferability.

If more capital is needed, the corporation merely has to issue more stock and find someone to buy it (which is not always easy).

Disadvantages

The main problem with the corporate form, other than the need for more paperwork, is that it must pay taxes on any profits before it can distribute them in the form of dividends; then the stockholders must pay personal income taxes on those same dividends. In other words, the same money is taxed twice. This is not a major difficulty for most small design offices, however, because practically all profits are paid to the stockholders in the form of salaries and bonuses.

S CORPORATIONS

This choice is available to stockholders before any stock is issued. By choosing to organize as an S corporation, the stockholders get all the advantages of incorporation—limitations to liability, pension and profit-sharing plans, etc.—while sidestepping the double taxation problem of the regular corporation. There are strict limits for organizing an S corporation, which differ from state to state. For example, in some states a maximum of ten shareholders is allowed, all of them residents of the state in which the business is incorporated; only one class of outstanding stock may be issued; and a specified portion of the corporation's income must be generated from the business itself rather than from investments. But these problems are relatively minor and easily accommodated. The bigger problem is that some states don't even recognize an S corporation.

LIMITED LIABILITY COMPANY

The Limited Liability Company (LLC) is a relatively new form of business entity that combines the benefits of a corporation and a partnership. An LLC is like a corporation in that it provides limited liability for the owners. However, for federal income tax purposes, it is treated as a partnership so that its income is taxed only once. As of the date of publication of this book, 46 states and the District of Columbia recognize LLCs, with Massachusetts and Pennsylvania on the verge of recognition. Only Vermont and Hawaii seem to be reluctant to recognize LLCs.

LIMITED LIABILITY PARTNERSHIP

The Limited Liability Partnership (LLP) is an even newer form of business entity that retains most of the tax benefits of a partnership while limiting the liability of the partners. As of the date of publication of this book, a majority of the states had not yet recognized LLPs.

Most small design firms will find that either an S corporation, an LLC, or an LLP structure will accommodate their needs very nicely. But, once again, they shouldn't even think about making a final decision without some long and serious discussions with their four best friends—their lawyer, their accountant, their insurance agent, and their banker.

Estimating Your Costs

Many design firms use a very simple formula for calculating the price to charge for their services: "Figure out what the client will pay, and say that's what it will cost." This is also known as getting "the going rate." While this system isn't a bad way to get business, it's not a very good way to stay in business.

The major problem with focusing completely on the going rate is that it is only part of the story. It may establish what a client will pay, but it doesn't tell you whether you can make any money at that selling price. Ideally, the price of a job should reflect both factors.

Simplistic though it may sound, if you intend to make money, you must set a price that brings in more than you spend. So the first step in setting your price is computing your actual costs. *This is the single most important tool in setting design fees.* When you know your costs for doing a job, you've established your "floor"—the minimum below which you cannot go and still make any money. At the other extreme, prices can reach a "ceiling," the point at which a firm has priced itself out of its market. It is vitally important that a design firm know where these points are at all times.

To arrive at your "floor," you have to calculate the true cost of an hour of your design firm's time. Once that cost is clearly established, it should be reviewed once or twice a year and adjusted (more likely, upward) to remain useful.

HOW TO CALCULATE THE HOURLY RATE

There is no universally accepted way to compute the hourly rate. The most often cited formula is three times salaries, a rough estimate based on about one-third for salary, one-third for overhead, and one-third for profit.

This formula, like certain methods of birth control, is simple but not very reliable, as many design firms have discovered to their regret.

A slightly more complex, but also more realistic, formula for the hourly fee is actual and anticipated total salaries, plus actual and anticipated total overhead cost, plus desired profit.

To illustrate how to apply the formula, we'll create a hypothetical design firm in a typical city in the South. We'll call it WGDF (which stands for The World's Greatest Design Firm, Inc.).

SALARIES

The first step in defining WGDF's proper hourly fee is to add up the cost of all salaries, which represents the largest expense in the design business—labor. For this illustration, let's give our hypothetical design firm five people: a principal, or owner, who is paid a salary of $50,000 a year; a senior designer, who is paid a salary of $30,000; two junior designers/production assistants, who are each paid salaries of $20,000 a year; and a bookkeeper/receptionist, earning $15,000 a year. The total combined salaries—$135,000.

Added to this should be all other costs associated with labor: taxes, benefits, FICA, insurance, bonuses (if predetermined), etc. As a rule of thumb, tack on about 25 percent, or about $35,000, for these. The total would then be $170,000:

Total salaries	$135,000
Total additional labor cost (25%)	35,000
	$170,000

Next, figure the total number of labor-hours that the firm could charge in a year. Assume 8 hours a day, times 5 days a week, times 52 weeks, times 4 people (the bookkeeper/receptionist represents nonchargeable time).

Total chargeable hours possible: $8 \times 5 \times 52 \times 4 =$ 8,320 hours. But, obviously, no designer can be expected to charge every hour of his or her time. Allowances have to be made for vacations, legal holidays, illness, and so on.

7 legal holidays	$8 \times 7 \times 4 =$	224 hours
2 weeks' vacation	$8 \times 10 \times 4 =$	320 hours
1 week's sick leave	$8 \times 5 \times 4 =$	160 hours
		704 hours

8,320 hours – 704 hours	= 7,616 hours

You must also make an allowance for nonbillable hours—time when the designer or principal might be cleaning up, filing, or going over the books. Allow approximately 25 percent for nonbillable hours.

7,616 hours × 25%	= 1,904 hours
7,616 hours – 1,904 hours	= 5,712 hours

Now divide the number of billable hours (5,712) into the annual cost of salaries ($170,000) to arrive at the per-hour cost of labor.

$170,000 ÷ 5,712	= $29.76 per hour
(We'll round it off to $30 per hour)	

OVERHEAD

Overhead represents what it costs to be in business, as opposed to labor, which is what it costs to do the work. Overhead costs include such things as rent, gas and electricity, insurance, telephone, electronic equipment, cleaning services, postage, stationery, art supplies, magazine subscriptions, accounting fees, advertising, and marketing costs. These are expenses that are passed on to a client indirectly by building an add-on percentage into billable time.

For the sake of this illustration let's assume these costs total $75,000 per year. That equals 44 percent of the total salary cost.

$75,000 ÷ $170,000	=	44%
$30 per hour (labor costs)		
× 44% (overhead percentage)	=	$13.20
$30 + $13.20	=	$43.20
(rounded to $43.50)		

This is the price per hour to recover the cost of salaries plus overhead expenses.

PROFIT

If the design firm sold every possible billable hour for this rate ($43.50), it would only be breaking even. It also needs to make a profit. Too many design firm principals operate on the shortsighted premise that anything left over after paying expenses is theirs to spend. But the firm needs profits too, as surely as do the principals. Profits get the firm through the rainy days, without firing employees; they replace old equipment or buy new furniture; they provide the funds for pay raises or bonuses; they can help secure a line of credit to finance growth. In short, profits simply make life easier for all so they can go about doing their jobs. They buy the freedom to say no, and the freedom to say yes, at the appropriate moments.

A minimum profit margin of 10 percent is desirable; 20 percent is preferable. To achieve a 20% profit margin, you have to multiply by 25 percent.

$43.50 × 25%	= $10.88
$43.50 + $10.88	= $54.38
(rounded out to $54.50)	

The hourly rate of $54.50 represents the minimum rate our hypothetical firm can charge to cover its cost of labor and overhead, with a profit margin of 20 percent. This is its floor price.

You can apply this formula to your own situation, substituting your own figures, to determine the "floor" price for an hour of your firm's time. This figure becomes your basic tool for calculating all estimates.

TIME VERSUS VALUE

The per-hour figure is not, however, the last word on pricing. True, it represents costs and profit. It accurately reflects the time involved in producing a job. But it does not reflect *value*.

Value is complex, and not as easily reduced to formula. It can be approached from several perspectives. *Value* is what the finished product means to your client's bottom line. Clients buy design services because they have a problem or a need; their ultimate concern is for how well you solve their problem. They will care, in other words, about the results, not about how you get there. It is critical that you try to define for your clients the value your work will represent to them. Designers must try to help clients understand the direct connection between design and increased sales or awareness of a product or service; to demonstrate how appropriate design will enable a client to charge higher prices; to translate a more defined and positive identity into dollars for a client.

Value is also what the finished product means to your own firm's bottom line. Finished samples are a design firm's primary sales tools. If handling a particular job represents an opportunity with long-term value to the firm—because of the prestige of the client, the potential to create a spectacular showpiece, or the chance to enter a new market or add a new type of service—then this value to you tomorrow may override the need for a healthy profit today.

Value is your firm's reputation for outstanding concepts and performance. It is easy to measure the time and ultimate value of "hand skills," such as mechanicals, paste-ups, or electronic files, but putting a real value on creative or conceptual work is more difficult. What a design firm sells, essentially, is its combined thinking, training, experience, and talents. The better a firm's track record for original solutions and quality work, as well as the more experience it can draw on, the greater its potential value to the client.

Not only is it difficult to put a value on creative efforts, it is also very difficult to predict with any degree of accuracy how long it will take to solve a design problem. And there is no direct relationship between value and time spent on a design problem.

The late Herb Lubalin would generate an enormous number of brilliant sketches in bursts of quick energy. Each idea would only take him a few minutes to come up with. If he merely charged for the time spent on each job, it would hardly be a reflection of the true value of his thinking. Yet there were times when even Herb would labor for days over a job, and when it was finally done, it still wasn't something he was really satisfied with. He once submitted something like 24 different sketches for a cover to a publisher. When asked which one he liked best, he replied, "None."

Value is the demand for your service, relative to the supply of competent competitors. If you're the only design firm in town, and if the client is desperate, your value is higher than if dozens of designers are swarming the business community begging for table scraps. The actual quoted price, then, is likely to be a combination of many complex factors. However it is actually computed, it should reflect the floor price plus a weighing of the various components of value.

As a rule, value is factored into the equation by adjusting your profit margin upward or downward.

PRICING STRATEGY GOALS

Regardless of how you arrive at a price, the final objectives of pricing are the same:

1. To establish a clear and definitive price that clients understand, can plug into their budget, and are willing to pay.

2. To place the design firm in a reasonable position relative to its competition.

3. To allow the design firm enough flexibility to adjust its fees, depending on the situation.

4. To pay the design firm a fair price relative to its talent, experience, and efficiency, and relative to its total contribution to the client's ultimate profits.

DETERMINING PRICE

There are five basic methods a design firm can use to determine a final quoted price.

1. Average hourly rate

2. Individual hourly rate

3. Per-page rate

4. Past results

5. Sales price

Each of these methods has advantages and disadvantages and is best applied in certain situations.

AVERAGE HOURLY RATE

With this method, you arrive at a budget and a price by breaking the job down into its component pieces, estimating the labor-hours needed for each piece, and multiplying the total hours by your per-hour rate (your "floor" price). Then out-of-pocket cost items are added on.

The key is answering one simple question: "How long will it take to do the work?" Getting the answer, unfortunately, is seldom that simple.

Many variables can affect the number of labor-hours spent on a job. Different individuals work at different speeds; one individual's performance may vary from day to day. The firm's prior experience with a similar project may make the work proceed faster. Jobs vary in their complexity.

But there is one thing you can almost always depend on: You will underestimate the time it takes. A good rule of thumb would be to always add 50 percent more to the total estimated time.

For example, your firm is asked to prepare an estimate for the design and mechanical of a small 6-page folder, all type, two colors, 4 × 9 inches folded size.

Broken down into its various tasks, the time spent on the job might look like this:

1.	Read the copy for content, point of view, style of writing, length, "feel":	1	hour
2.	Prepare thumbnail concepts:	4	hours
3.	Computer time for refining concepts:	6	hours
	Add 50 percent contingency:	5½	hours
4.	Call to service bureau for pickup:	¼	hour
5.	Mount color printouts:	4	hours
6.	Write covering letter:	¼	hour
7.	Telephone to set up appointment:	¼	hour
8.	Travel to client and back:	½	hour
9.	Meet with client, receive copy on disk:	1	hour
10.	Transfer copy to electronic files, define type styles, etc.:	2	hours
11.	Print out on laser printer, review, refine:	½	hour
12.	Write instructions to printer, covering letter:	¼	hour
13.	Call delivery service, prepare package to send to printer:	¼	hour

TOTAL TIME: 25¾ hours

HOURLY RATE: $54.50 × 25¾ = $1,403.38

To this hourly cost must be added any out-of-pocket costs, such as laser and color printouts and delivery charges. Most design firms add a 15- to 25-percent mark-up to their out-of-pocket costs. In this example we'll assume these costs include one delivery charge of $25 and color print charges of $30, for a total of $55:

$55 × 20%	= $	11.00
$55 + $11	= $	66.00
TOTAL ESTIMATE:		
$1,403.38 + $66	= $1,469.38	

You'll want to consider the following advantages and disadvantages to average hourly rate pricing.

Advantages
1. In organizing your estimate, you also create a plan for implementing the job once the estimate is approved.
2. This method breaks the job down into small budgets and schedules, which help in project management.
3. It identifies areas where changes may be negotiated. If the final estimate is too high, you might get the client to agree to approve the concept from rough thumbnails only, or to save on travel time by coming to your office.

Disadvantages
1. The more complex the job, the longer it takes to break it down into all its small tasks.
2. Since each task is estimated separately, there is great potential for bad guesses. Underestimating could make the job a money-loser. Overestimating could cost you the job at the outset if the client chooses a lower-priced competitor.

INDIVIDUAL HOURLY RATE
This method is a variation on the average hourly rate. The difference is that you use a different per-hour fee for each task, based on the salary of the individual who will actually perform the task. The $54.50 per hour figure (the "floor"), in other words, is replaced by one figure for a senior designer, another for a junior designer, and so on.

Advantages
1. The estimate tends to be more precise than the average per-hour method.
2. All the other advantages of the average hourly rate method also apply.

Disadvantages
1. It adds another layer of complexity, which makes estimating more time-consuming.
2. If, for any reason, the people who actually end up doing the work are not paid the same salaries as the people on whom the estimate was based, actual costs could be far above or below the quoted price.

This type of estimating forces a choice between accurate pricing and flexibility in using personnel. If salaries are not interchangeable, then personnel become locked in by the way the job is priced.

PER-PAGE RATE
This method uses the firm's own historical data plus a knowledge of what competitors are charging to arrive at a price per page that should cover costs plus a fair profit.
If the firm has carefully tracked its costs per project and the number of total pages it has designed, it merely has to divide the total labor-hours by the total pages to reach an average figure that reflects labor-hours per page.

Total labor-hours billed per year	5,712
Total pages designed for year	1,345
5,712 ÷ 1,345	= 4.25 hours per page
4.25 hours × $54.50 per hour =	$232 per page

Different design firms contract their per-page fee proposals in different ways. Many firms using this method tell the client that, as long as the criteria under which they are designing haven't changed, the total price paid by the client will not vary, regardless of how many design revisions are required. Other firms using this method will put a cap on the number of revisions they will do for the per-page price.

For purposes of estimating, all covers are regarded as pages. All illustrations, graphs, and the like are billed as additional items at specified costs.

Let's take the same example we used to illustrate the average hourly rate method.

6-page folder: 6 pages × $232 per page	= $1,392
Out-of-pocket costs:	66
Total price	$1,458

The per-page method has the following advantages and disadvantages.

Advantages
1. It is extremely simple, quick, and easy for a client to grasp. There are no hidden costs or contingencies. The entire process of negotiation is quickly disposed of, enabling you and your client to get on with the job.

2. Because you need not negotiate every project individually, this method encourages long-term client relationships.

3. Since it is based on average labor-hours per page for all the firm's projects, it automatically compensates for individual designers' variations in experience and speed.

Disadvantages
1. Regardless of similarities, each project is different. There will always be some that will require more design time than the average. Too many of these could get a firm in trouble financially.

2. While a per-page rate works well for publications, it is difficult to apply design assignments to projects such as posters, identity programs, environmental projects, or packaging.

3. This method, because it is based on past history, is slower to keep up with changing conditions, which might drastically affect the average per-page rate.

PAST RESULTS

Like the per-page rate, this method bases its price quote on actual historical costs for similar work. The difference is that this method attempts to break down its historical database more distinctly (computers have made this a relatively easy task).

A design firm using this method would look at its records and define jobs by category and subcategory. For example, you might have a category for folders, with subcategories for 6-page folders, 4-page folders, and so on.

In each category or subcategory, you would add up the total design charges and divide them by the number of jobs to get an average price.

Total number of 6-page folders	10
Total charges, 6-page folders	$14,500
$14,500 ÷ 10	= $1,450 average per folder

Consider the following regarding the past results method:

Advantages
1. It more precisely compensates for the differences in types of jobs than does the per-page method.

2. If properly tracked, it is self-adjusting as conditions and costs change.

3. It is quick and simple, enabling the design firm to respond to clients' requests for estimates quickly.

Disadvantages
1. Like the per-page rate, it assumes that all projects that are alike physically are also alike in the creative problems they represent. This assumption isn't true. The averaging factor helps to compensate somewhat, but it wouldn't take too many complex and more time-consuming assignments than usual to get the design firm in trouble.

2. It requires a computer and someone feeding the data in at regular intervals.

3. As with per-page pricing, basing prices on past averages means prices are likely to lag behind new costs.

SALES PRICE

This method involves what may be referred to as "going-rate pricing." First, the design firm identifies a sales price that seems to be what the client is willing to pay. Then it works backward, allocating labor-hours, overhead, and profit to bring the job in line with the budget.

For example, you determine that your client is willing to pay in the neighborhood of $1,400 for a simple all-type, 6-page folder. By subtracting the profit margin and operating expenses, you arrive at the budget for labor charges.

$1,400	Selling
– 280	(20% profit margin)
$1120	Total labor and overhead

Current overhead ratio: 44%
$1,120 ÷ 1.44 = 778 (labor)
$778 ÷ $30 per hour = 26 hours
(26 labor-hours that can be budgeted to the job)

The sales price method offers these advantages and disadvantages:

Advantages

1. If enough information is available from either the client (in the form of a budget) or from knowledge of competitors' prices, the highest priority is put on getting the most for the job.

2. It clearly identifies to the design staff the labor-hour goals for them to work toward. Most designers feel more comfortable working within clearly defined schedules and budgets, although they don't like to feel that these are the only goals to shoot for.

3. Since the firm's profit margin is the first item allocated, it is assured of this profit almost immediately—assuming labor charges stay within budget.

Disadvantages

1. The budgeted labor-hours may not be enough to do the job properly. Either the job is done poorly or not to the client's liking (unwise), or overtime is required to maintain the schedule and reduce the losses.

 Note: Overtime is the preferred method to make up underestimated jobs (if staff is paid on a straight time basis, rather than 1.5 × salary) because, while it increases the salaries paid to staff, it maintains approximately the same overhead costs. The effect is a reduction in the percentage of overhead, which absorbs some of the extra labor costs.

For some examples, we'll work with the same $75,000 overhead figure and $170,000 total salary figure from our previous example (page 26). With overtime, both increase.

With No Overtime	With Overtime
100 × $75,000	100 × $76,000
divided by	divided by
$170,000 = 44%	$185,000 = 41%

$1,400	Selling price
– 280	(20% profit margin)
$1,120	Total labor and overhead

Adjusted overhead ratio: 41%
$1,120 ÷ 1.41 = $794 (labor)
$794 ÷ $30 per hour = 26.5

The effect is that an additional half-hour can be allocated to the job without affecting the profit of the firm.

2. The design firm is not forced to plan the various steps involved in the production of a job and, hence, runs the risk of encouraging loose project-management controls.

3. It puts the emphasis on giving clients what they want, rather than what they may need—on projects, rather than programs.

WHICH METHOD TO USE?

Each of these methods has its advantages and disadvantages. You must use your judgment in deciding which method applies best in a specific situation. You may feel more comfortable with one method than another. Still, there is no requirement that you use one method exclusively. No method will be perfect for all situations.

It is important to remember that any of these methods, if followed properly and if based on accurate per-hour and overhead costs, can allow you to create an estimate that will assure your firm an operating profit.

Proposals, Contracts, Letters of Agreement

By figuring out what your cost per labor-hour is and by determining your overhead percentage and desired profit, you have given yourself some basic tools for estimating the cost of design projects.

In the preceding chapter, I outlined five ways of calculating prices. Regardless of which method you choose, you should view the resulting sales price as only a starting point. There are still several decisions yet to be made before you are ready to present a price to a prospective client.

Now that you know how much you *should* charge a client for your services, you must figure out what you *want* to charge, *how* you want to charge for the work you will perform and, finally, how best to inform your prospective client of your decisions.

Unlike advertising agencies, which have managed to establish a "fair" percentage clients expect to pay for their services—currently 17.65 percent of the price paid for media placement—design firms have no agreed-upon formula for compensation that clients can refer to. Therefore, deciding how much to charge a client for work becomes more an art than a science. A design firm has to balance its desire for getting the highest possible price for its work against the realities of what it reasonably *can* expect to be paid for its work. Again, it has to assess the factors that determine *value*. These are the same questions you had to confront in developing your business plans. They have to do with demand for your services, competition, and the kinds of jobs you seek. (For a complete discussion of these factors, refer to "The Business Plan" in the section "Planning Ahead," beginning on page 12.)

HOW TO CHARGE

Once you've decided *what* to charge, you must select the *form* in which you will present your price to the client.

There are two decisions to be made.

1. Should the price be quoted as an hourly rate, a flat, fixed fee for the project, or as some combination of the two?

2. Should the price be presented in a letter of agreement, in a formal, printed contract, or in some other form? The basis for a price can—and should—take many forms, but the form it takes should always be consistent with the specific requirements and circumstances of the client.

HOURLY RATE OR TOTAL PRICE?

Many clients will ask a design firm to provide them with an hourly billing rate. Don't be misled. Regardless of what clients may tell you, in almost every case they are really looking for a total, lump-sum price. If they ask you for an "estimate" of costs, they do not regard your reply as an "estimate" or "best guess"; they consider it a "final quote." If you are asked for and quote an hourly rate, more often than not a client will want you to put a "not-to-exceed" figure in your proposal. This amounts to a no-win situation for you: If the job requires more work than you expected, you won't be paid for it; if it takes less, the client expects you to bill them less.

In addition, by putting the emphasis in the wrong place—on individual units of time, rather than on solving a problem—you encourage a client to see the design firm's contributions as hand skills rather than creative thinking. Furthermore, clients can get very nervous when faced with hourly rate proposals. They view them as open checkbooks. But, if the problem to be solved is so vague that it's impossible to predict creative time accurately (or if the number and kind of applications or adaptations can't be specified), an hourly rate basis for payment is often the only way the design firm can sensibly submit its proposal.

In today's more competitive design atmosphere, design firms must not lose sight of their real objective when they submit a proposed estimate to a client, which is not just to make a profit on each design project they

are hired for, but to lay the foundation for, or to further cement, a longstanding relationship between the client and the design firm.

What a client really wants is to get the job done superbly, quickly, at an agreed-upon cost, with no unexpected, unpleasant surprises. This means that what they would love the designer to provide them with is a simple bottom-line price and schedule that can be plugged into their spreadsheets and forgotten. Designers would love this also, because all they would have to do is decide about how long it will take to do the job and what the job is worth to them. They wouldn't have to worry about keeping time sheets, because, since they can't get paid any more for the job, regardless of how it changes or who was responsible for the changes, the time they spend doing the work is irrelevant, as far as income to the design firm is concerned. It would be a simple, perhaps even elegant, arrangement between design firms and clients.

So why not merely quote all jobs on a fixed-fee basis and leave it at that? Because we don't live in a perfect world. A fixed-fee quote has some drawbacks that have to be recognized and addressed in advance:

1. If the scope of the work that the design firm is being asked to do is too vague, the firm could end up doing far more work than it expected to, with no way to get paid for the additional work.

2. When clients know that there is no meter running, they have a tendency to ask for a lot more adaptations and alternatives than they would if they knew they had to pay for each one.

3. Designers are just as subject to wishful thinking and lying to themselves as anyone else. Most of the time, little allowance is made for slip-ups. And more often than not, mistakes and slip-ups do happen. Unless the job has been extremely well planned, the estimates carefully prepared, the project well managed, and the team of designers efficient in their handling of the job, the firm stands to lose money on the job.

The system that seems to work best is to quote a lump sum price for a project while breaking the job down into phases, with each phase clearly and precisely described in great detail. A kicker paragraph inserted into the letter of agreement should spell out that any additional work not specified, described, or outlined already would be charged at a specific hourly rate. If your client balks at this last item and insists on a flat fee for everything, try to quote a flat fee per application. Work out the flat fee by figuring out how much time it would take for an average application times your basic hourly rate plus a 20-percent to 50-percent contingency, depending on the client history.

CONTRACTS AND LETTERS OF AGREEMENT

Perhaps no subject sparks more disagreement among design firm principals than the matter of contracts. Many designers insist that contracts are an absolute necessity, the single most important thing a design studio should incorporate into its method of doing business. On the other hand, just as many designers have no use for contracts. They insist that contracts scare the hell out of clients, bring clients' lawyers into the picture (and with them more delays), and are totally useless because even signed contracts cannot be enforced.

So the question is, "Should graphic designers rely on contracts, and what should a contract say?" A contract does not have to rival a Russian novel in length or density. It doesn't even have to be written, although any designer who runs a business based entirely on verbal contracts must also still believe in the Tooth Fairy.

A contract is an agreement between two or more parties that something will be done by one or both. The key word is *agreement*. Until both or all parties *agree* to the terms of the contract, *there is no contract*—only what might be called a first offer.

Furthermore, until there is some *evidence* to suggest that both parties willingly agreed to the terms of the contract, the law must assume that there was no contract. Suppose, for example, that you and your client agree that you are to design a brochure for them for X dollars, and you go ahead and do it and send it to them

with a bill. Within a few days, you get an angry call from the client saying, "Not only is this nothing like what we asked for, but your bill is outrageous. We're not going to pay you a penny!" If you can't resolve the problem between the two of you, you might find yourself standing in front of a judge with little defense except your word against the client's. Without any signed letters of confirmation to spell out the terms of the assignment, documented meetings in which the job was discussed (implying understanding and acceptance), or previous bills upon which the terms were restated, what can a judge conclude except that the parties never came to any agreement?

Many designers will say that if clients really want to get out of paying a bill, they will, contract or no contract. Even if you do take them to court and win, it will cost you more than it's worth. And by then the client is history anyway.

Other designers say that the mere presentation of a contract to a client appears to be insulting their honesty. According to them, some clients claim that they have always done business on a handshake and always will.

These are weak arguments against the hard evidence. Many designers have, unfortunately, been stung by clients with highly selective memories, executors acting on behalf of widows or widowers (who view the designer as just another creditor trying to take money with no proof the deceased spouse even hired the designer), or new executives at the client firm who find no record in the files that their predecessors ever made a deal for a design job.

If a client refuses to sign some kind of document that describes in detail what they are buying and for how much, you have every reason to wonder, "Why not?" If they really intend for you to do the work for the price you are asking, what do they have to lose by putting it in writing?

One explanation for all the suspicion of contracts is poor contracting. Too many designers structure a process and/or a document that is either confusing, intimidating, or simply too one-sided.

Contracts or letters of agreement do not have to be ponderous or full of technical language. Quite the contrary, the shorter and simpler, the better. If the proper foundation has been laid, most jobs can be handled in very simple forms and short letters of agreement.

The important things to remember are:

1. The letter should contain no surprises for the client.

2. It should serve as a means of continuing the process of closing the sale, not shutting it off.

3. It should leave absolutely no margin for misunderstanding. Any reference that could in any way be considered vague should be rewritten.

The contract or letter of agreement should serve the purposes of both client and design firm. The client primarily wants to feel secure. They want the reassurance that the design firm has understood the problem, that the price is within their budget, and that the work will be completed on time. The contract or letter should reinforce the client's feelings that they made the right choice in selecting your firm.

The tone of the letter should be professionally enthusiastic, not dry and dull. If the designers aren't excited about the prospects of working on the job, how can they be expected to bring any fire to the job?

The letter should be logical and organized, indicating a well run and disciplined firm—one that won't miss deadlines or drop the ball during the course of the job. There should be absolutely no spelling errors, corrections, incorrect names or titles, or any other indications of sloppiness or lack of control and supervision.

NEGOTIABLE ITEMS

The design firm obviously would like to sell the job for a profit. If the firm has properly estimated the time the job will take, it should have a good idea of what it will need to be paid to show a profit on the job. However, selling the job at that price might take some negotiating. So, some of the most important things to build into a letter of agreement are items that are negotiable. If the client is quoted a simple flat price, the individual basis for this price should be spelled out in such detail that the price will look low. Even more important, by describing the scope of the job in such detail, the design firm will have given itself a negotiating tool should the client balk at the price.

By giving itself the flexibility to reduce the amount of work to be done, the design firm is able to reduce the final cost of the job without reducing either the quality of its work or the profit in the job.

For example, by suggesting to the client that the price could be reduced by doing only roughs, instead of comps, by doing fewer alternative solutions, or by eliminating some items altogether, the design firm demonstrates to the client that it really wants to do the work, and that it is willing to make some concessions to do it. But the firm should never indicate to the client that it will make concessions that place a lower value either on itself or on the quality of the job. As soon as a client learns that a design firm can be pushed about so easily, it's only a matter of time before the relationship will turn sour.

It's far better, if the design firm can afford it, to lose the job. Even in losing, the firm will win the respect of the client. The client may continue to ask for proposals from the design firm, or at the very least, refer the firm to others.

THE IDEAL CONTRACTING PROCESS

Obviously, there is no single best way to contract with clients, since all clients are different and all contractual arrangements should be tailored as precisely as possible to the specific situation.

Nevertheless, there are certain items that should be included in all contracts and letters of agreement and a certain procedure to be followed which seems to work best for graphic design firms. We'll examine these, beginning with new client–firm relationships.

THE NEW CLIENT

The first time a design firm is asked to submit a proposal for a new client is by far the most critical time for the design firm. If handled sensibly, it could serve not only to get the firm hired at a price that's right for both sides, but it could serve as a strong base for all future assignments.

In the flush of the possibility of new work from a new client, the design firm mustn't be tempted to abandon sensible business practices. Doing so could mean a lot of wasted time, not to mention a sizable loss of income to the firm.

There will be two kinds of clients—those you've heard of and those you haven't. Just because you've heard of them doesn't make them any less a business risk. Conversely, just because you personally haven't heard of them doesn't mean they can't or won't be able to pay their bills.

Before accepting an assignment to do any work for a new client, make certain you run a credit check. This can be done discreetly by checking with your local credit bureau. If the information received is too incomplete, it doesn't hurt to ask for references and begin the assignment only after these references have been checked out. You must be very careful to treat any new client very delicately, but you also should be completely satisfied that they will not be a credit risk before you start doing any work for them.

If There Are Danger Signs

For some reason, brand-new firms without a lot of capital seem to feel that everybody they deal with should share their risks. I haven't the faintest clue why this is so, but an awful lot of design firms that should know better play Santa Claus to these new businesses. Perhaps the design firms believe that they'll be allowed the freedom to do exciting work because they've agreed to accept the job at bargain rates. It's an interesting theory, which has proven wrong 95 percent of the time. Cheap rates do not make a client any less demanding. If anything, new businesses are even more involved because their emotional stake in their enterprise is intense.

If you just can't resist taking an assignment from a brand-new company or any client that may be unreliable about paying its bills, try at least to adhere to some basic, sensible ground rules in dealing with them.

1. Get everything in writing and have all agreements signed by the client. If the client is a corporation, you will need a personal guarantee of payment, not from the business but from the owner, to have a chance of getting paid should the business declare bankruptcy.

2. Make certain that you get some money up front (try for 50 percent) and the balance in scheduled payments. This way you can deposit the money and get the cash working for you in case the client is slow in paying the second invoice. If any of the payments aren't paid according to the terms of the contract or signed letter of agreement, simply stop doing any more work and politely let the client know you've done so. Chances are very good that, if you haven't been paid yet, you won't be. Don't throw good money (your time) after bad.

3. Never go into debt for the client. Have suppliers bill the client directly, or get the cash in advance to pay them. Don't risk ruining your relationship with a good supplier because of a bad debt.

4. If the client absolutely can't pay now, but you have great hopes for a bonanza in the future, don't be afraid to spell out this bonanza in writing. If, for instance, you decide to accept an identity program for a new business (because you feel it would add something worthwhile to your portfolio, and the client can't afford your normal rates at the moment), you can structure a contract that pays you x now and x times x in the future, should the program still be in use. You might even decide to accept some stock in the firm in lieu of cash. Remember, a contract can be anything you would like it to be as long as two consenting adults are involved.

5. If the client can't pay now and you don't have much hope for future jackpots, but for some reason you still want to do the project, try to work out a reasonable barter arrangement (I'm still getting some free meals for design work I did for some restaurants years ago).

If the Signs Look Good

When the feedback indicates that the new client is definitely one you wish to work for, it is even more important that you proceed carefully. Most design firms only have to be burned once before they learn to stay away from bad credit risks, but some firms never do develop sensible procedures for dealing with the firms that will form the backbone of their business.

CONTRACT OR LETTER OF AGREEMENT?

Many designers never use a formal contract, but the weight of the evidence suggests that formal contracts should be an integral part of client relationships. The best time to send the client a contract is the first time you do a job for that client. At that point in the relationship, the client is most likely to view it as a perfectly normal business procedure and will not be intimidated by it. A suggested approach: A contract that refers to terms globally, not specifically for any one project, a letter of agreement covering the specific assignment you are estimating on, and a cover letter explaining that it is your normal procedure to send clients a contract only once, when you're starting to work on their first project. On future assignments you will use only a letter of agreement, or even just a purchase order.

Ask the client to sign one copy of the contract, return it to you as quickly as possible, and keep another copy on file. Recognize that it is very likely that the client will want some time to review the terms of the contract with its attorneys. While they are doing this, proceed as if the contract had already been signed. If, as is quite likely, the date for the signed contract passes without the signed contract arriving, call the client and gently remind them that, without the signed contract, your attorneys won't allow you to deliver any of the work you've already done. This usually works.

Don't worry if the client objects to some of the terms and refuses to sign the contract as is. It's better that these problems be faced early on, rather than later. Try to get each problem solved by negotiation as best you can, so that all the legal questions can be behind you. The important thing is that documents have clearly been exchanged, and that these documents indicate that work was requested by the client and that the design firm had begun to do the work. This is a strong basis for collecting fees later, if that becomes necessary.

Of even more significance is that the very act of negotiation and trust that this process demands creates a basis for the best kind of mutually respectful relationship needed by both client and design firm.

The contents of both the letter of agreement, as well as the first (and only) contract, should not come as a surprise to a client. In the very first meeting with the client, all points should be covered, with the exception of the final price. That will come in the letter of agreement.

Many design firms feel the need for several contracts, since the nature of the work can vary so much. Certainly the problems a designer confronts when estimating on environmental projects—which might require enormous subcontracting fees and totally unpredictable numbers of signing applications—are nothing like those faced by the designer estimating a simple two-color letterhead.

But basic terms that can apply to all design jobs can be covered by printed attachments to the letter of agreement. These attachments should also be sent just once, to be held in the client's files. (This will require keeping a file of all contracts that have been sent to each client and checking it when you are asked to estimate on new projects for that client.)

Items to Include

In addition to simple, direct language without errors and a tone that conveys enthusiasm (on stationery that looks good), every letter and/or contract must contain certain basic elements to serve its purpose—to sell the job at an agreed-upon price according to terms that are right for both the client and the design firm. Every letter and/or contract should:

1. Spell out as precisely as possible exactly what you are going to do.

2. Tell the client how long you expect it to take you to do this.

3. Clarify who's going to do what at your firm and at the client's.

4. State how much it's going to cost and how you expect to be paid for the work.

5. Have a place for the client sign it.

Even if clients do not sign the letter, if they behave in a manner that appears to be in accordance with accepting the terms of the letter (such as approving designs in writing), the client will have a hard time proving they never accepted the terms of the letter.

Somewhere in either the overall contract or the letter of agreement these points should be addressed:

1. You want to protect yourself from getting too far into a job without getting paid. You also want to set up what amounts to a kill fee, should the job get sidetracked permanently. Start with a paragraph that describes your general working relationship. It should say that you intend to do your work in phases, which you will describe in detail, and that these phases will be billed as they get done or in monthly billings measured against the total for each phase.

2. You want to protect yourself against nonpayment, so include a sentence that gives you the right to stop all work or not deliver the completed work until you get paid.

3. You want to get written evidence of the fact that you've been hired to do the project, so you should include a paragraph which states that you won't start any work until either written or oral approval is received.

(The reason to mention oral authorization is this: You don't want the approval sitting there waiting to be signed and possibly delaying the job so long that it never gets started at all. If you do receive oral approval, send out a letter to that effect, thanking the client for calling on *x* day and for giving you the go-ahead, and announcing that you have already begun the work. Also mention that you will be looking forward to receiving written confirmation from the client).

4. You want to get the payment terms in contract form. But since the payment terms vary from job to job, you merely include a sentence which states that payment will be made according to terms described in proposals and letters submitted for each project.

5. You will be billing out-of-pocket expenses in addition to the estimate, so include a section that describes what you consider these out-of-pocket expenses to be and what your mark-up will be. In states with sales taxes, some clients incorrectly feel that they aren't subject to these taxes. Check the tax laws of your state and describe for the client the conditions under which you are required by law to collect taxes from a client.

6. Most of your payment problems will arise from attempts to get paid for corrections, additions, and alterations that you consider outside, or in addition to, the original estimated job. You should deal very directly and in advance with these situations by describing precisely what you consider this additional work to be. You also want to protect yourself from those times when the specifications on a job change so radically that the original estimated price no longer applies. To cover that, include a sentence stating that in such cases, a new estimate will be submitted and must be agreed to by both parties before work can continue.

7. Most estimates are submitted with the assumption that the work will be done on normal schedules, but all too often the actual schedule is much tighter. You should include a paragraph which states that you have the right to revise your estimate to compensate for unanticipated "rush" requests. (Incidentally, since the profitability of your firm is based on both quality and volume, volume can be increased by tighter schedules.)

8. Sometimes you will be asked to deliver a finished, printed product. At other times you will merely be requested to supervise the production of the final pieces. You will need a paragraph that tells what you will do in each circumstance and how you will charge for these services.

9. You do not want yourself included in a lawsuit with your client, so you will need a paragraph which gives you the right to refuse to publish any material which could get you in trouble (This includes anything that is possibly illegal, obscene, copyrighted by others, or politically controversial).

10. You also want to transfer as much of the legal responsibilities as possible to your client, so you should have a paragraph that states that the client is responsible for all claims made, all trademarks, copyrighted materials, and clearances.

11. You want to protect yourself from those situations in which the client runs into a copyright problem and claims that they automatically expected you to get your material copyrighted for them. Include a sentence that offers the client the option of engaging you to do this. You should also mention that you would be willing, if requested, to help secure copyright protection for the client (for a fee).

12. On occasion you will be asked to place ads for a client. Detail how you will charge for this service.

13. You don't want your clients dropping in any time they please demanding to see your books. On the other hand, you want them to know that you run an honest business and have nothing to hide. Include a statement to the effect that any information, correspondence, or accounts relating to their business is available for inspection, if it is done in your office (you don't want these things taken out), during usual business hours, and with reasonable notice.

14. You don't want to have to pay because a printer lost a slide or a piece of artwork, so you should include a paragraph that disclaims all responsibility for loss or damage to the client's property by others.

15. You will need to put a date on the contract identifying the effective contract date. You will also want to leave yourself the opportunity to change it or get out of it completely, so include a sentence that states that the contract can be terminated by either party upon 30 days' written notice.

16. Along with this, you want to protect yourself from being forced to pay for costs already incurred in jobs that are terminated if and when the contract is terminated. So you will need a paragraph to the effect that, in such an event, you won't be held responsible for any such costs.

17. Also in the event that the contract is terminated, you will want to retain ownership of all materials and/or design ideas that haven't been specifically bought and paid for. Say so.

18. You want to be able to use your work as a marketing tool. Reserve the right to reproduce it for this purpose.

19. State that you want to be repaid for any losses that may come as a result of claims or suits made against you for work done on behalf of the client.

20. Mention the legal basis for this contract—the state laws you are operating under.

21. You will need to establish a reasonable range in your estimates and quantities delivered—a 15 percent add-on is an acceptable standard.

22. You will need to set some time limit on how long your estimates will hold for.

23. If you do have to take a client to court to collect a bill, you will want the client to pay the legal fees and interest costs. Say so.

24. Mention that this agreement can't be changed except by signed agreement.

25. Finally, leave a line or two where the agreement can be signed.

GETTING A CONTRACT FROM A CLIENT

Try to remember that the client will have done the same thing you've done—protected themselves against any possible problem that may come from working with you. If there's anything in a contract they send you that bothers you, simply cross it out. Let them come back to you with a better offer.

Other items to consider are royalties or additional fees for identity programs used for a long time or extended beyond a certain geographical border.

Be careful not to give away rights you don't own. The law says that all original photos and illustrations are owned by the photographers or artists who created the work unless *specifically* signed away by them. Don't let your clients think that they are buying more than they actually are. Specify exactly what they own. If it's only the reproduction rights to a particular use, spell it out. Mention that all original art and photos are to be returned to the photographer and illustrator by a certain time. But reassure the client that the work will not be sold to a competitor or used in any way that would be embarrassing to them. To do this, you will need to secure these assurances in writing from your suppliers.

HOW "DESIGNED" SHOULD A CONTRACT LOOK?

There is a difference of opinion here among designers. Those who prefer a more traditional, typewritten look claim it is less threatening in appearance and doesn't invite close scrutiny.

Those who prefer more "designed" contracts claim the appearance of finality lends more weight to it. Therefore it inhibits changes. Furthermore, they look more professional and give the firm credibility. My feeling is that a design firm should seize every opportunity to communicate to clients the message that the business of design firms is to solve communications problems. A contract is just such a communications problem. If the design firm can demonstrate how clearly and well they can design even such an arcane object like a contract, perhaps they can get past the feeling that designers merely decorate other people's solutions.

TYPICAL CHARGES

PAGE RATES:	LOW RANGE	AVERAGE RANGE	HIGH RANGE
Up to 12 pages	$400–$500	$600–$800	$1,200–$1,500
Over 12 pages	$250–$400	$500–$750	$1,000–$1,200

Note: In addition to their page-rate-based total fee, most design firms quote such items as charts, graphs, and maps on a per-piece basis. Usually they range from $200 for a simple chart to $500 for more complicated ones. Production is also usually quoted as a separate charge on an hourly basis. In the lower page-rate ranges, most major design firms will usually provide roughs only, not comps.

IDENTITY PROGRAMS:	LOW RANGE	AVERAGE RANGE	HIGH RANGE
Simple program	$ 2,500–$ 5,000	$10,000–$15,000	$25,000 up
Large program	$10,000–$20,000	$25,000–$35,000	$50,000 up
Manual	$15,000	$25,000	$40,000 up

Note: Simple identity programs may involve only one or two symbols or logotypes, usually presented as roughs only. Larger programs usually require elaborate presentations and/or research.

PACKAGING:	LOW RANGE	AVERAGE RANGE	HIGH RANGE
One package	$5,000–$10,000	$15,000–$25,000	$30,000 up

HOURLY RATES:	LOW RANGE	AVERAGE RANGE	HIGH RANGE
Principals	$55–$75	$100–$150	$200–$300
Senior designers	$50–$70	$ 75–$ 90	$100–$135
Junior designers	$35–$50	$ 55–$ 70	$ 75–$ 85
Production personnel	$35–$45	$ 50–$ 65	$ 70–$ 80

Note: Printing and photographic supervision, research, and writing are usually charged as additional costs either in flat rates or on a per diem basis.

MARK-UP ON OUT-OF-POCKET COSTS:	LOW RANGE	AVERAGE RANGE	HIGH RANGE
	15%	17.65%–20%	25%

Note: Although most design firms will mark up some out-of-pocket costs, there appears to be a wide difference among design firms as to which costs will be marked up and which will not. Half the design firms include printing as a marked-up item, while half only charge a flat supervisory fee. Many mark up all out-of-pocket costs, while many exclude all costs outside of service bureau charges. Those who do not mark up their costs believe it makes them appear more professional, since they benefit in no way from money spent on anything other than their own labor efforts. Those who do mark up all out-of-pocket costs argue that, since they have in effect advanced the money for their client, they are entitled to recover at least the interest they have lost on their money during the period the money was being used by their client.

Sales
and
Marketing

Of all the words in the English language, none strikes more fear in the hearts of young graphic designers than *sales*. Designers are not alone. Most people seem to believe that selling is an unsavory activity to be avoided at all costs. This is an attitude deeply ingrained in the artistic tradition, which defines fine art and commercial success as mutually exclusive. It is reinforced in school and permanently sealed for most designers by jobs that are totally divorced from sales and marketing concerns. This aversion to selling is a normal feeling, and it is harmless for any type of designer except one—the designer who wants to succeed in business.

Like it or not, the simple fact is that once you hang out your shingle, you're in a real business. You're not hidden away in a garret churning out masterpieces of pure artistry; you are in the thick of a difficult, highly competitive, sometimes even cutthroat, business environment.

Your capability of doing excellent work is not enough to survive in business. You also must find ways to let potential clients know about your ability. This requires *marketing*. And you must learn to transform potential clients into actual paying clients. That requires *selling*.

Practically all the designers I have interviewed told me that they rely almost entirely on referrals for their work. Does that mean they don't have to knock on doors making sales calls? Perhaps. (Most of them admitted to trying cold calls at one time, but without success.) Does it mean they don't have to sell? No! If you think your business can succeed by relying completely on luck, or if you believe clients will come running into your office waving their checkbooks and begging you to take their projects and their money, it's time to pinch yourself and wake up.

Clients do not buy design on impulse. They seldom make up their minds to do business with a designer without prompting. Clients buy design because a designer convinces them they will benefit from doing so. Clients buy design because a designer persuades them that his or her firm can solve their problems better than any competing firms. He or she does this by describing how the firm has successfully solved problems for other clients.

That doesn't sound so terrible, does it? In fact, it serves three rather noble purposes. First, it enables the client to obtain a service of genuine value to their business. Second, if done well, the designer's work helps to reinforce the message that well conceived, well executed design has a value and function that goes far beyond mere decoration. And, perhaps more important than those two reasons, it enables the designer to eat. Looked at in those terms, selling isn't quite so reprehensible. In fact, much of people's discomfort with sales has to do with unfair stereotyping. "Sales" and "selling" automatically call up visions of used-car lots and late-night TV pitches for Veg-O-Matics. These are the worst cases, the grotesque extremes. They are not models that must be followed. "Selling" is not a synonym for exaggeration, exploitation, or deceit. The fact that you must persuade a client to buy your services is not degrading; it is a fact of life. Selling is not lying; it is expressing convincingly what you surely believe: that you can help clients achieve their goals. Every successful design firm, without exception, sells its services.

Most successful designers also market themselves. Marketing is not the same as selling. Sales is focused on *today;* it is persuading *today's clients,* usually in face-to-face contact, to use the design firm's services. Marketing is focused on the *future;* it creates awareness of the firm's presence and abilities by targeted prospects who are the design firm's most promising potential customers. Effective marketing creates a desire for your firm's services. It softens up the marketplace, making later sales efforts that much easier. Most design firms that rely almost wholly on referrals are reaping the fruits of seeds sown by their own continuous marketing efforts.

Both sales and marketing are vital to the growth and health of the design firm.

THE MARKETING PLAN

Word of mouth is a wonderfully efficient and inexpensive way to bring in business. But it is risky to rely on referrals exclusively, and when you're beginning a business, it's a sure formula for failure. Building a solid reputation takes months—sometimes years. In the meantime, bills, rents, and salaries still have to be paid. Depending on referrals for new business also takes the control out of your own hands and entrusts it to luck.

A design firm has to find a way to keep work coming in at a steady and controllable pace. When the economy is booming, a well-established design firm can usually get along by relying completely on referrals for all its work. It's in slower times, as we've seen recently, that problems begin to surface.

When a studio develops a well-conceived, practical marketing plan—a plan unique to its own particular goals, needs, strengths, weaknesses, and interests—it begins to commit itself to staying in business.

You begin a marketing plan by taking a hard look at your business. No two design firms will have exactly the same strengths, weaknesses, interests, or goals, simply because no two people are alike. It is important to identify the range of differences before planning the future of the firm. A goal of growing into a very large firm will require a totally different marketing plan than one that merely seeks to maintain present size or seeks moderate growth.

There are three questions you want to ask yourself:

1. What is your business like today?

2. What would you want your business to be like tomorrow, if you could choose?

3. What would be the best way to get there?

The answer to the first question requires information-gathering and analysis. The answer to the second requires soul-searching and the weighing of pros and cons. The answer to the third question requires strategic thinking.

What is your business like today?

You need to know a number of things: Who are your major clients? What industries do they represent? Where are they located? How difficult are they to work with? How profitable are they? What services and products do they ask you to provide? How much money do you make from your business? How do your products and prices compare with those of your competitors? Get as complete a picture of your present situation as possible. With this information you can then begin to evaluate the information in personal terms.

What do you want it to be?

Are you working in the place you want to work? If not, where would you rather be working? Are you spending your days doing what you want to be doing? Are you, for instance, doing paperwork when you'd rather be designing? Do you want more of the same kind of clients you now have, or do you want to go after a different market? Are you getting paid to provide the services you think you should be providing? Are you getting paid enough? From the answers to these questions, you arrive at a set of business goals.

How can you get from Point A to Point B?

To change what you are doing, do you need to get larger or smaller? Do you need to hire more people, let people go, or keep the staff the same size? If you choose to expand your staff, how will you be able to increase your volume and profit to afford the increased overhead this will bring? What are effective ways to win business in a new segment of the market? The answers should take the form of a plan for achieving your business goals.

In most cases, achieving these goals will require a deliberate effort to increase your sales. Most designers have no trouble recognizing the point at which they have enough work to enable them to hire assistants. Few designers know how to accelerate the process or work actively to maintain volume levels high enough to keep additional employees full-time.

Waiting for referrals is a passive approach. At best, it leaves you at the mercy of fate and circumstance; at worst, it leaves you coughing in the dust while more aggressive competitors go after the most attractive clients.

Marketing and selling are the active approaches to being in business. They are techniques for taking control of your own destiny.

Suppose, for example, you look at the work you are doing and conclude that some of your clients only allow you to do mediocre work, and are low payers, slow payers, or nonpayers, to boot. If you thrive on masochism, fine, let it be. If you don't, you have to take action to change the situation.

Many options are totally within your control, if you choose to exercise them: Where you live and work; how you spend your time; whom you work for. Once you accept this fact, and the responsibility that goes with it, you can gain control of your life and control of your business.

When Jack Summerford, of Summerford Design, Dallas, first started in business he quickly realized that he couldn't sit back and wait for business to come to him. So he deliberately set about finding a way to bring clients in, especially those who might need annual reports, Jack's specialty. First he identified all the public companies and people in a five-state area who might be interested in what he could offer them. Then he got on the phone and started calling them, beginning with those in Dallas. Cold calling didn't come easily to Jack, and most of the calls ended up as dead-ends. But the calls did give him some leads, and many of the leads did turn into jobs eventually. Most of these clients have continued to form the basis for his present business.

LAYING THE GROUNDWORK

Most designers make some effort to create sales indirectly. They enter shows and exhibitions, make speeches, write some articles, join some local clubs. They work up a capabilities brochure for their firm. All of these are tools for marketing.

In fact, every action you take that places your name and your firm's name in the public eye is an act of marketing: The name you select, the logo you use for stationery and cards, the location you select, the office decor you select, the promotional materials you produce, the clubs you join, the competitions you enter, the awards you win, the classes you teach. All of these create awareness of your firm. Even more important, they affect how your firm is perceived by fellow designers, suppliers, and by potential clients.

These actions are most effective when they fit within the framework of your overall marketing plan. Ideally, they should supplement and support—not replace—direct selling efforts.

When it is handled correctly, marketing lays the groundwork for sales. It softens up the marketplace; it makes prospective clients more receptive, so that a direct selling effort is not a cold call, but a warm call. And if you are very, very fortunate, the marketing alone will bring clients right to your doorstep. (Warning: Don't count on it.)

In naming your firm, designing your stationery, or decorating your office, you should be asking yourself, "What effect will this have on a client? What will this say to a client about my firm?" Too often, design firms give themselves esoteric, artsy names that turn off business clients or fail to convey what sort of work the firm really does.

A very talented designer once produced a business card for himself that featured a beautifully rendered illustration of a face on a light bulb. He was trying to say that he was imaginative; instead, the card gave the impression that he was merely an illustrator. He was surprised to find himself getting few design projects but lots of illustration assignments. Only after he changed his business card to a far more typographic design did he begin to attract the kind of clients he wanted.

Marketing is also talking to business people in informal settings. It is making contacts. Too many designers limit their social and professional activities to a small circle of fellow artists and designers. This is a serious mistake. This may be good for personal morale, but it does nothing for the bottom line.

There is probably no better marketing tool than a reputation as an expert. You build such a reputation by making appearances and speaking at various trade meetings and conventions, joining industry associations and trade groups as well as local Chambers of Commerce and other such business-oriented groups and clubs where you will have opportunities to meet prospective clients.

There are other advantages to increasing your exposure to the world beyond the artistic set. The more business people you meet informally, the more exposure you have to the concerns and views of the people you hope to do projects for. The better your understanding of clients' problems and mind-sets, the more successful you will be at persuading those clients that you can solve their problems.

Along the same lines is the question of winning awards. Does a string of prizes help attract business or merely impress your peers? My own sense of things is that young designers are wise to enter as many shows as they can before they go into business. It helps a designer just starting out to establish credibility. It is the cheapest advertising available. Once you are in business, though, it seems to have very little impact on clients; results mean more than design awards.

Contacts are everywhere. Don't be hesitant to let your friends, relatives, and business acquaintances know that you're in business and would appreciate any leads they can give you. Practically every designer I have interviewed got his or her first free-lance jobs this way. Make friends with your colleagues in advertising agencies and public relations firms, even if you don't do any work for them. They often have the ear of a client and may play a large role in determining which design firm gets what.

Make an effort to cultivate your suppliers. Suppliers can be one of your strongest allies in getting work. Suppliers work with a tremendous number of potential clients and have many opportunities to recommend design firms. You want them to recommend you. Be good to them. Send them notes when they do a good job for you. Send them presents at Christmas. And, especially, pay your bills quickly. Try to work with the biggest and the best. They'll have the biggest and best clients.

YOU CAN'T ESCAPE SALES!

Even if your marketing efforts have brought the client to you, in most cases, you still haven't gotten their assignment. You still have to persuade them that, indeed, they have made no mistake and that you are the one who can give them value for their money. You can call that "charm," you can call that "luck," you can call that "gentle persuasion." I call that "selling." Whatever label it wears, it cannot be ignored, willed out of existence, or escaped, not if you are serious about *being* in business and *staying* in business. And most clients do not come self-propelled to your door. You must find them, court them, and win them over. But it pays off. Hour for hour, the effort spent in creating sales through indirect channels will never produce as much as the same efforts in direct, face-to-face sales.

When a studio sends out a mailing, it is *marketing*. When it makes a presentation to a client, it is *selling*. When the principals of a design firm make speeches, they are *marketing*. When they get on the phone and persuade a potential client to let them make a presentation of their firm's capabilities, they are *selling*. I am not suggesting that deep in the psyche of every designer lies a natural salesperson. Far from it. Designers tend to be people who enjoy sitting alone and thinking deeply. They tend to prefer communicating more by what they do than by what they say. Successful salespeople, by and large, are the opposite personality type. But it is no accident that the majority of the world's most successful designers tend to be charismatic and incredibly persuasive, energetic, and competitive, as well as highly creative.

I know from personal experience that sales are essential to staying in business. My first job after graduating art school was in a small studio, where most of the business came from one account. This one account kept three people busy full-time. So busy, in fact, that the owner of the firm hardly had time to *do* any other work, much less seek it. One day the firm's major client called to say they were getting out of the business. The bottom had suddenly dropped out. To his credit, my boss didn't fall apart or fire his two assistants immediately, although he must have been feeling somewhat panicky. Who wouldn't? He simply hunched up his shoulders and started making sales calls. Before too long, he was bringing in enough work to keep the place going.

WHO DOES THE SELLING?

There are various approaches to building sales directly. One way a designer can approach direct selling is to hire a salesperson. Every designer I've talked to who has tried this approach has said that it doesn't work. Although I'm sure there are exceptions, most of the time the person who is selling doesn't understand the needs and desires of the designers. Sooner or later the relationship sours.

A second alternative—better, but potentially costly in a lot of ways—is a partnership between a designer and a salesperson, especially one with a strong background in printing. The keys here, obviously, are that the two partners must be highly compatible, that they share common goals, and that the partner responsible for sales must have a real understanding of design principles. Considering what it takes to be successful in each discipline, this is a tall order. A good example of a combination that works well is the Baltimore firm, Graffito (pages 170 to 173).

But Graffito is more the exception than the rule. The best way to handle sales, by and large, is to learn to do it yourself. It's the least costly; you don't have to increase your overhead or share your profits. It's the most efficient; you don't have to speak through someone else's mouth or hear through someone else's ears. It's also the most effective. It has been proven time and time again that clients prefer to deal directly with the person who will actually be doing the work. They feel uncomfortable buying design services from people who are clearly only selling, not designing. At the very least, they need assurance that the person who is selling the firm's services will be heavily involved in the production of the client's job.

IDENTIFIED FLYING OBSTACLES

To create an effective direct sales approach, you should first recognize the obstacles that must be overcome.

The Insecure Client

First of all, you have to remember that design isn't something that can be picked up and examined, like a banana. A shopper can tell at a glance if a banana is ripe, too ripe, or not ripe enough; he or she can compare prices easily from one supermarket to another; and one bite will tell whether the banana was good or bad. Clients have no comparable way to evaluate design before buying it or even after it has been produced. Furthermore, few clients understand design principles or how to use them to serve their own marketing purposes.

Even when clients are aware that they need professional design services, they seldom have a clear idea of how much it will cost. If they get competitive bids from three or four design firms, they have no way to measure value against price. They really don't know how to make any choice at all, much less an educated one. Finally, they have virtually no way to measure accurately whether the design firm's work, when completed, was successful.

In short, the client is full of tremendous uncertainty. The single most important thing a design firm has to do in its dealings with its clients, potential as well as current, is to reduce this uncertainty—to make a client feel safe, secure, and comfortable. Every single contact that the design firm has with its clients—known and unknown—should be carefully measured as to whether the contact increases or decreases the clients' uncertainty.

How do your firm's promotion materials look and read? Are they directed toward the client, toward other designers, or, even worse, only toward your own design firm? Do the brochures concentrate on procedures or on results? Do they talk more about *how* your firm works or the benefits to a client of their working with you? Clients need to be educated on the *value* of design for *their* purposes. They need to be *taught* what they can expect design to do for them.

What do your offices look like? Are they decorated in such a way to make clients more comfortable, or are they likely to make clients feel out of place? Do you have all your awards on display? Will the client be impressed by your reputation, or see the display as evidence that you're more interested in what they can do for you than in what you can do for them?

How do you dress when you call on a client? Does your dress say you're different or does it say you understand the client?

What kind of car do you drive when you call on a client? Dave Goodman, a highly respected business consultant for design firms, tells of one designer who owns a Porsche but rents an American compact to call on clients that he believes aren't making enough money to afford a foreign sports car.

The Need to Feel Wanted

Clients who are insecure about dealing with design firms want constant reassurance that their interests are the most important thing in the world to the design firm. They get very irritated when they can't get through on the phone or when their calls are not returned promptly, or at all. They want to stay posted on every twist and turn in their jobs. It is impossible to give them *too* much information on the progress of their jobs.

If they've hired you, instead of doing it themselves, which is a choice more and more companies have today, they are usually in some kind of trouble. The last thing they need is to feel that you're too busy for them or that they're one of a crowd. Make them feel they're the most important people in the world to you, and prove it by doing the job for them better than anyone else has ever done it before.

Experience, Experience

Because of the scarcity of guidelines for evaluating design firms, most clients tend to lean heavily on how much experience the firm has had and how closely this experience matches their needs. The closer, the better. A bank wants to work with a designer who has worked with banks. A cookie company isn't satisfied that your firm has designed packages; it wants a firm that has designed food packages at the very least—cookie packages preferred.

The bigger the client, the stiffer the experience requirement. Buyers of design services in a large corporation have supervisors looking over their shoulders. Those buyers want to protect themselves as much as possible. The greater the design firm's experience, the less risk for the buyer.

But suppose you have no experience. The client's insistence on experience leaves your design firm with several marketing choices:

1. Specialize, so that you can narrowly focus your marketing efforts on those clients who are more likely to use your firm.

2. Bring in a designer or a partner with considerable experience in the industry you want to target.

3. Charge fees significantly lower than your competitors' in an attempt to buy entry into the industry you are targeting.

Be aware, however, that the third option could cause problems later. It will be difficult to raise fees later without losing existing clients. And the firm might acquire a reputation for producing low-quality work for its low fees.

The Positioning Problem

As difficult as it is for clients to evaluate the quality of design solutions, it is doubly difficult for them to distinguish differences between design firms. Unless a firm manages to position itself in a way that clearly distinguishes its work from that of its competitors, it faces the difficult task of persuading a client to give it work on the basis of faith and trust alone (translation: without experience and reputation), which are unavailable to the young firm just getting into the field.

Arriving at a distinctive design look may be an answer—if, of course, that look is flexible enough to be useful for a broad range of design problems. While having such a style poses the risk of narrowing the market for a design firm's services, on balance it seems to be more helpful than harmful.

The graphic design work of David Carson, Neville Brody, Charles Spencer Anderson, Kit Hinrichs, April Greiman, Rick Valicenti, and dozens of others are not only brilliant in conception and execution but also have distinct and recognizable looks. It is unlikely that any of these designers consciously tried to create a look or style for themselves; more likely, their styles evolved from a complex combination of influences, philosophies, and training. Nevertheless, the recognizable look of each designer's work multiplied its impact on the design world and solidified its commercial success. Do not misunderstand: I am not suggesting that all young designers should run out and manufacture a look when one doesn't exist. Quite the reverse. What I'm saying is that designers should work hard to find within themselves their own unique way of dealing with design problems, not just because by doing this they become better designers (I happen to think they will) but because it makes more sense for their business.

THE DIRECT APPROACH

The direct approach to sales can be broken down into five steps:

1. Identifying prospects

2. Contacting prospects

3. Making sales presentations to prospects

4. Closing

5. Follow-up

Identifying Prospects

Whom do you approach for new business? Your first logical step is identifying likely prospects and qualifying them. If you have been in business for a time, you have two immediate sources to look to: present clients and past clients.

Present clients are by far the easiest to sell more work to. They already know you. There is already an existing element of trust (however slim it may appear to be at times). The challenge is to make them aware that you can provide more services than you are now providing. At large companies, this may mean making a pitch to a different division or department. Asking your present contact to set up a meeting for you with one of his or her associates is a commonly accepted practice; if your contact is willing, these associates will rarely refuse such a meeting. If your contacts can't or won't help you directly, you might ask to use their name as a reference instead; this is usually enough to get you an appointment to make a presentation.

Every time you finish a project for a client, you are theoretically fired. You don't want to change theory into practice. It is very important to treat all present clients as if they were future clients. Pay attention to them. Keep calling them, even when you're not actively working on one of their jobs.

Past clients are worth considering also. Whether they can become active clients again may depend on why they stopped sending you work in the first place. If it was because they thought you were too expensive at the time, perhaps their perception has changed, perhaps their budgets have increased, or perhaps the people who objected to your prices before have been replaced by people more willing to pay higher design fees.

In any case, the real barometer is not price, but value. Go back to your clients and try to find out the results of your work for them. Were sales increased? Was money raised? Were goals met? Don't be afraid to ask. The worst they can say is "No." Or they could tell you what you want to know. If the answers to your questions are mixed or don't help you, you're under no obligation to use them. But if they are supportive, get the clients to allow you to quote them in your sales material.

Be cautious about taking a client's word alone. Sometimes they won't tell you the truth, and sometimes they're wrong. Check other sources. In the case of an annual report you have designed, for instance, check the stockbrokers. Has their perception of the client's image changed for the better?

There's no good way to deal with a bad experience with a client, unless the people you worked with have changed. The best way to deal with a previous bad experience is to admit that it was bad, assert that whatever conditions caused the problem originally have been taken care of, and ask for a chance to prove it. This approach doesn't always work, but it does work occasionally.

New prospects represent the smallest percentage of return for the greatest effort.

In total dollars, of course, new prospects represent a much larger universe than the clients you've already worked for. But be aware, going in, that you will be facing lots of rejection. A typical ratio for direct selling in today's more competitive design world is 75 to 5 to 1. That is, every 75 cold calls result in invitations to make five presentations, which result in one sale.

If, after a year, you're doing better than average, adjust your ratios for what is normal to you. If you're doing worse than the average, look hard at your telephone techniques and your presentation methods and materials. You may need to sharpen any or all of these. If an honest effort to improve these still doesn't improve your percentages, perhaps your market environment is just too difficult for the moment and your ratios must be more realistically adjusted.

The actual ratio is not terribly important. What *is* important is that you know with some accuracy what a certain level of sales effort will net you in increased business volume.

Let's assume, for example, that your average profit per client is $5,000, and your goal for the next year is to add $25,000 in profit, or roughly five new sales (with adjustments to compensate for increased overhead to handle the additional work). At a ratio of 75 to 5 to 1, you could expect 375 cold calls to generate five presentations, which would result in the five sales you seek. This means that, to reach the goal of adding the five new jobs needed to reach your goal of adding $25,000 to the bottom line, you would have to find the time and the energy to make about two cold calls a day for about nine months. Doesn't sound too tough, does it? Especially when one considers that over time, the need for cold calls diminishes as the list of loyal clients increases.

The figures may not work out, but by forcing yourself to create definable sales goals, and by constantly measuring and evaluating the results, you virtually guarantee that you will make more sales. Your track record should constantly improve as your confidence in yourself and your material builds.

Remember, every sale you make is a sale you never would have had if you had done nothing.

Where do you begin to find the 375 prospective clients to call? You start by looking for companies or institutions in fields related to those in which you have had the most experience. These clients are likely to have problems similar to those you have already dealt with. Your work will have the most credibility with these kinds of firms.

Say, for example, that most of your projects have been done for furniture manufacturers. How do you find the names of other furniture manufacturers? Well, for one thing, you can go to furniture stores. You can make a note of every manufacturer of furniture you see in the stores. Look in magazines and newspapers for ads from furniture manufacturers.

Go to trade shows. Every industry has them, and there's probably no better way to get a handle on who your prospects are. You get a chance to talk to some of the reps, which gives you a feel for how the people in the field feel about their support material. You also get a good background on the individual manufacturers and their problems. This is invaluable when you make presentations, for you want to talk about your client's problems first, not your own firm's capabilities.

Most industries also have their own trade publications. These will not only give you the names of your prospects, but most of them also have a column or section that helps you track the movement of people within the industry. A trip to your local library will give you the names and addresses of these publications.

That same library trip will also allow you to look at the various directories where you can find the names and addresses of most of your prospects. There's a directory for practically everything now. To name a few: *Thomas's Register of Manufacturers; Standard and Poor's Register of Corporations, Directors and Executives; The Directory of Corporations; the Encyclopedia of Publications; the Encyclopedia of Associations.* There's even a *Directory of Directories,* which is probably where you'll want to start.

Once you've identified a list of possible prospects, you'll next want to zoom in on the most promising targets. Write for the annual reports of the public companies; most companies will send a report to anyone who requests one. Also send for catalogs, capabilities brochures, even recruitment materials. What you're trying to find out is whether or not you can help them. Can you make a strong case for how much they need you? Concentrate on companies whose materials appear to need help, yet are not without redeeming graces. These could be companies that are willing to spend for good work but aren't getting it yet. Your toughest sells will be the firms producing the best and the worst materials—the firms who already use good professional designers, and those who look like they have no interest at all in quality design work. Put these in a lower category of prospects—ones to be contacted later. Conditions do change in every industry and for every company.

Read an annual report for clues about whether the company is growing and how quickly. The best kind of client to contact is the company that is on its way up but hasn't yet arrived. These firms go through many transitions along the way, and each transition usually requires a great deal of communication with their public and employees. Often they require identity programs with numerous applications.

Narrow your basic list of prospects to those that are most easily accessible to you. Start with your own city, then expand to your state or nearby states. Staying closer to home keeps travel expenses down as well as time spent away from the board or computer.

But, on the other hand, whenever an out-of-town client calls to invite you to see them about a possible job, treat it as a golden opportunity for prospecting. Try to postpone setting up a date as long as possible without getting your client upset. Then get on the phone and attempt to line up at least one or two other prospect presentations with clients near the one who called you. Don't waste an opportunity to cluster calls when it's given to you.

Once you've narrowed your list of prospects, you're almost ready to start contacting them. But not quite. First, make certain the information you have about the client is accurate and current. Nothing makes for a worse start than talking to the wrong person, misspelling the name of the person you're writing to, or sending a letter to the wrong address. Double-check first to save embarrassment.

Contacting Prospects

Be careful that you contact the right person at the prospect company. In some cases, depending on the size and structure of the company, it will be the president. In some it will be a vice president, while in other cases, it might be a manager.

The larger the program you're trying to sell, the higher you'll eventually have to go. But you might not be able to start at the top. In fact, it is usually counterproductive to try, unless the person you seek happens to be a personal friend. Although the president of the company may get involved in selecting a design firm, a lower level of management is usually responsible for taking these concerns off his or her shoulders. You don't want to make these people look bad in front of the president, nor do you want them to feel that you

went over their heads to try to get work. They won't appreciate it, and neither will the president. Try to identify the proper channels to go through, and let your client call the shots as to where it goes from there.

The names and titles that you get out of directories will indicate generally who is the right person to contact in a company, but if the directories are no help, call the company and tell them your problem. Sooner or later you'll be given someone's secretary who will help you identify the right person to talk to.

It doesn't make any difference whether you call immediately or write first and follow up by telephone. Both work equally well. Do it whichever way you feel most comfortable.

If you write first, keep the letter short, clear, and direct. Tell who you are and what kind of business your firm is in. As soon as possible, mention a name or a company they will recognize: A name, if someone has suggested you write to this person; a project, if it's going to be an absolutely cold call. Don't try to sell them on using you at this point. Merely mention that you'll be calling them next week to set up a date when you could show your work.

If you call first and actually get to talk to the person you asked for—which, more often than not, won't be the case—make certain that, regardless of the outcome of the call, a letter gets sent thanking them for taking the time to talk to you and restating your qualifications.

Making phone calls cold isn't easy for anyone, but it seems to be especially hard for designers. They're not prepared to deal with the barrage of rejections that cold calls produce. More often than not, they're just waiting for the first negative response to provide the excuse to hang up the phone and dispense with this unpleasant chore.

The key to successful telephone cold calls is absolute confidence in what you want, how you intend to get it, and what your expectations are. You get this confidence by planning your calls carefully, even to the point of rehearsing with spouses or friends until you think you've got it down.

Remember: Your goal is very limited. It is merely to get through to your prospect and get him or her to agree to take a look at a presentation of your firm's capabilities—nothing more, nothing less. You're *not* trying to do any selling at this point.

If you even begin to sell your firm over the phone, you're going to lose before you've even started. You don't want to be thought of by your prospect as a salesperson. Instead, your objective is a short, friendly conversation that helps your prospective client understand who you are, what your firm does, and why it might not be bad to let you provide more details in person. That's it.

Next, remember to keep your expectations low. A ratio of 75 to 5 to 1 is all you should be aiming for, for the moment. Keep reminding yourself of this when you are turned down, as you will be most of the time. Don't get discouraged. Just meditate briefly on the law of averages, and pick up the phone again. Remember as you go through your list of prospects that as each one turns you down, your odds improve on the next call's being a success.

Because you're going to be less experienced and more nervous in the beginning, make your first calls to clients when success or failure won't be very critical to your self-esteem. Try to make your calls when you feel ready to deal with them. It's tough work, so you must be in your most positive mental state. Don't call when you're likely to communicate the wrong impression to your prospect. Since the phone can only allow you to communicate with your voice, you have to rely on it to do all the work.

Be prepared. Have in front of you everything you might need in the course of the conversation, such as your appointment calendar. If a prospect should, by some slight chance, actually take you up on your request for an appointment, you should be ready immediately to offer dates and times. Give the prospect two choices to pick from. If you already know which one you want him or her to take, make sure that one of the choices is clearly less likely to be accepted than the other. If, for instance, you have an open calendar next Tuesday at 10:30, say, "Would you prefer Tuesday at 10:30 or Friday at 4:00?" Since it would be unlikely that busy executives would prefer Friday afternoon, when they're probably trying to get away early, they are more likely to choose Tuesday at 10:30. If not, take Friday and rearrange your schedule, if you must.

If your prospect can't see you at either time, don't say you'll call back later to set up a time. Wait. Ask for a date and time more convenient to her or him and then take it, whenever it is.

Also, have before you a list of your major projects and clients and perhaps some references. You don't want to hem and haw if a prospect asks about other clients and projects or wants to check out whether you are really a designer or Jack the Ripper. It may even be a good idea to have a map of the city to which you have to travel in front of you, so that you can pin down directions then and there.

You don't want to call again to either confirm your appointment or get directions.

Don't give prospects a second chance to cancel your appointment! If it turns out that you show up and they can't see you then, see if they'll see you later that day. If they can't or they're not even there, they'll probably be feeling so guilty about you're having schlepped yourself out to them fruitlessly that they'll be more than willing to reschedule the meeting for another date.

Start out by identifying yourself. If you sent a letter in advance, mention it. Don't go too far yet in trying to tell a lot about yourself. Next, let them know that you're aware that they are probably very busy and that you won't take too much of their time. Don't get off the track with personal or friendly remarks that are obviously designed to set them at ease. Get to the point first, and then try to get the conversation on a friendly basis. People resist having to deal with orchestrated chit-chat. Ask them if they've had time to read your letter. If they say "yes," tell them that you would really like to be able to set up a date to show the work of your firm. If they say that they haven't had time to read it yet, don't tell them you'll get back to them after they've had time to read it. It's quite possible they've already filed it in the "circular file." Just summarize the letter for them, emphasizing the clients and projects you've worked on that you think they will recognize.

Chances are that this is when you'll begin to get some resistance. Be prepared for it. Take notes so that each negative response you hear and each counterargument you make is documented, so that you can keep track of what works for you and what doesn't. What works for one person won't always work for another. You have to find what you, personally, feel comfortable with. Go over this "response book" before you make your call, and keep it in front of you when you call so that you're prepared to handle anything that might come up, easily and gracefully. If you keep your goal firmly in mind (just getting an appointment), if you're not put off by rejection and evasion, and if you're determined to keep at it until there is a definite, absolute "yes" or "no," eventually your ratio of success will improve to the point where it is working for you. This is not speculation. It is a proven fact, borne out by the experiences of hundreds of salespeople and dozens of design studios who have tried it.

"No" Is Not the Last Word

Although each prospect will be unique and each designer will have to find his or her own way of handling negative responses, here are some possible rebuttals to a few typical prospect responses.

1. Mr. X's secretary: "Mr. X got your letter and told me to give you the message that he's not interested (or "our needs are already being taken care of" or words to that effect).

Possible response:
This is a tricky one. At this point you have no idea what Mr. X has really said or even if he saw your letter. You also have no idea whether Mr. X's secretary has his ear or not. The best way to handle this situation is to shift the selling from Mr. X to the secretary. Show respect for her or his position and be friendly, saying: "Well, I can understand that, but we really feel that we have something to offer that's not typical of other design studios. Let me explain...."

2. "We do everything in-house now."

The efficiencies of the computer and the aggressive marketing of the manufacturers of computer hardware and software have encouraged more and more clients to bring their work in-house. Even if a client recognizes that the quality of the work generated inside might be less than that available by going outside, most clients who have done this are absolutely convinced that they are saving tons of money. Trying to convince them that your work is worth more because it's better usually is met with a response something along the lines of "I realize this, but the work we're getting is good enough, considering."

Sooner or later the argument of providing a better product, more variety, an objective and fresh point of view, and more experience will have to be made, but you first have to recognize that, more than likely, the most likely reason the client brought the work in-house in the first place was because they thought it would save them lots of money. Until they become convinced that this ain't necessarily so, they're going to be a tough nut to crack.

Possible response:

"Lots of studies have shown that in-house costs can be very deceiving. When you factor in all the costs, including not only salaries, but also taxes, benefits, expenses, equipment maintenance, training, upgrades, support staff needed, and so on, it turns out that most in-house operations are not only producing work that doesn't do the job, but also that in-house departments are losing a lot of money, are far less productive, and are difficult and time-consuming to administer."

Studies (see *Creative Business,* Nov./Dec. 1994) have shown that the actual dollar difference is closer to parity. That is, a free-lance designer's hourly charges are based on the same criteria as an in-house designer's. The only difference is that the free-lance designer's hourly rate already has all these other costs built into it, including a small profit for the designer's firm, while the in-house designer's hourly fee or charge-back fee seldom does.

There may or may not be many other very valid reasons to keep some work in-house, but, except for very small jobs, the difference in actual costs is seldom worth the risks, costs, and aggravation of trying to do all of a company's work in-house.

3. "We already use a design studio, and we're happy with them."

Possible response:

"We're happy to hear that. It shows that you recognize the value of using professional designers. Many companies haven't even gotten to this point. But every design firm is different, and you really owe it to yourself to look at the capabilities of other studios. After all, your situation may change."

4. "Our advertising agency handles all our work."

Possible response:

"I'm happy to hear that. Agencies know how to work with designers, which makes our job a lot easier. We work with lots of agencies (name some here) through our clients, and it's never been a problem. As a matter of fact, most agencies farm work out their design projects to free-lance designers (plant seed of doubt). We would like to show you what we do so that you can see for yourself how we work together with other agencies for the benefit of a client."

5. "I want to know more about you before making a decision. Can you send me some literature?"

Possible response:

"Sure. I'll get it off today. (Do it!) Suppose I call you next Thursday after you've had a chance to go through it?" (Do it!)

6. "We have no work to give out at present."

Possible response:

"Fine, but it's a good idea to have a number of different design firms you feel confident you can call on when there is a project that needs to be done quickly."

7. "We've heard you're too expensive."

Possible response:
"Really? There have been an awful lot of times when I was sure we weren't expensive enough. But, seriously, design is such a custom business that it's practically impossible to compare prices easily. We realize this, and we make it our policy to deal with our clients in such a way that they will never be surprised. Every job is estimated precisely before we start it, and we never do any work without a direct approval of costs by the client. If you haven't expressly approved the price before we do the work, you don't pay for it. So, if our price isn't in line with your budget, we can talk about what can be done to reduce the costs."

8. "What's different about you?"

Possible response:
Be alert. Prospects who ask this are really asking you to sell them over the phone so that they can turn you down without having to see you. Don't fall into the trap. Keep in mind that all you're trying to do is get a chance to make a presentation. One possible tack: "We approach design strictly from a marketing standpoint. So really, until you've had a chance to look at the specific client problems we have worked on and seen our visual solutions, it's almost impossible to fairly evaluate our work. We'd be happy to arrange for you to see some of the projects we've produced for other clients and talk about the results. We plan to be in your area this coming Tuesday and again on Friday. Would either of these dates fit in your schedule?"

9. "I got your literature, but I haven't had a chance to read it yet."

Possible response:
"Do you think you'll be able to look it over this week? (Don't say "today." Expect to have to call a couple of times before they finally agree to read it.) "I'll call you next week after you've looked it over." If they have actually thrown your mailing piece away, don't expect them to admit it. Send them another copy, along with a short note explaining that it was sent on the chance that the original mailing piece might have been misplaced. Do this before you call them again.

10. "Ms. Y is the person here who has to make these kinds of decisions, not me."

Possible response:
Either Ms. Y is there, in which case, ask to speak to her, or she's not there, in which case you should find out when you should call back.

11. "I'm too busy to think about it now. You'll have to call me back another time."

Possible response:
"Fine. How about if I call next Tuesday. Suppose I call at the same time, or would another time be better?"

12. "You should have called last week. We just hired a design firm to do a whole identity program."

Possible response:
"Gee, I wish I had called last week. That sounds like something we could have helped you with. Suppose I call you back in about three months, just in case things aren't working out as you planned, and you want to look at some options."

13. "We've used our entire budget for the year. We won't be able to spend any more the rest of the year."

Possible response:
"When will next year's budget be set? January? Fine. I'll call you then. How about January 10th?"

Tips on Telephone Technique
1. Listen more than you talk.
Be alert to where the conversation is going. Let prospective clients lead you to where you want to go. They may not know who you are or what you can do, but they certainly know what they want.

2. Give your prospect time to speak.
Some people speak quickly. Some speak slowly, pausing to consider their words carefully. Don't assume just because there's a long pause that your prospect is finished speaking. Give him or her a chance to choose words and complete thoughts.

3. Don't anticipate.
Don't finish your prospect's sentences, just to show how quick-witted you are. People don't appreciate the implication that they're wasting your time.

4. Don't be afraid to try to clarify points.
If you don't understand something or you're not certain what you heard, ask your prospect for clarification. This won't make you appear stupid, but it will convince them you're interested and serious. It will also avoid problems later, in case you really did misunderstand something.

5. Don't argue.
Regardless of how rude other people can be, don't show by your tone or your words that you're irritated. Remember, you called them, and you want something from them. It won't do you any good to argue with them. They have the power. Just say something like, "I guess I caught you at a bad time, didn't I?" Who knows? They might have just had a real trying morning and would love to unburden themselves on someone. The worst that can happen is that you set up a time to call them back when they aren't as harried.

6. Put yourself in your prospects' shoes.
Evaluate what you're saying from their point of view. You want to serve their needs, not yours.

7. Learn to hear between the lines.
People communicate almost as much by the way they say things as by what they say. Be alert to the nuances in a conversation. When someone is saying "no," but what you hear is a "no, but…," you've got a chance to turn it into a "yes" if you're alert.

8. Take notes while prospective clients are speaking.
Don't interrupt, but wait until they're finished to clarify any points they may have raised or answer any questions or reservations they have expressed. But be careful not to try to write down everything they're saying. You won't be able to keep up with the conversation. Just write the key points.

Follow-Up

If your call succeeds in landing a firm appointment, *don't* send a confirming letter. The date is set. You should already have directions. Don't offer the prospect a chance to cancel out. Just show up on the appointed day and time.

If, however, a prospect has agreed to give you an appointment at an unspecified later time, send a polite letter of appreciation. Thank the prospect for his or her time, and say that you'll be calling again at such-and-such a time. Say this even if it hasn't been agreed that you will. What have you got to lose? Include something in your letter that you think would help make your next call more productive, such as a list of clients that you know would look impressive or a printed piece which, based on your telephone conversation, you feel certain would be of interest. *Don't* send your capabilities brochure, unless you are specifically asked for it. You don't know yet whether this would appear to be more than the prospect needs to know.

In summary, the cold-call process consists of four steps:

1. Developing a list of possible prospects to whom you feel you can offer something of real value.

2. Confirming your information on the prospects. Making certain that names and addresses are correct.

3. Contacting the prospects with a phone call, either preceded by a letter or not.

4. Following up on the calls.

Remember, the cold-call telephone contact has one purpose and one purpose only: To set up a meeting at which you can make a presentation and only *there* to convince the prospect to give you a project. That's it. Don't try for too much, too soon. It will backfire.

The Presentation

Your first objective was getting an appointment to make a presentation of your firm's capabilities. Now your task will be to make a presentation that will land you a specific project or earn your firm consideration for handling the prospect's next project.

The initial presentation may be your one and only chance to win the prospect's trust and convince him or her that your firm can do better work than anyone else. If there ever was a time to pull out all the stops, this is it.

On the other hand, remember that it normally takes five presentations to make one sale. So don't be too surprised or depressed if four out of five presentations yield no sales. As your confidence and techniques improve, so, too, will your percentage of sales.

CONVICTION AND TRUST

The heart of any successful presentation is your absolute conviction that what you have to offer will truly help the prospect. You must believe implicitly in your firm's ability to deliver real value. Most problems in presentations grow out of a lack of belief—in your firm, in its services, in the benefits of working with you, or in yourself.

A good presentation deals directly with the prospective client's expectations. They want to know what's in it for them. What *can* you do for them? They have a problem somewhere or they wouldn't even be talking to you. But, before you can solve their problem, you will first have to win their trust and confidence in you, personally. After you've done this, you will then start to transfer those feelings of trust to your firm.

The best way to do this is to understand clearly the prospect's concerns before you go in, and to construct a dramatic presentation which you *know* deals with these concerns in every way.

As a designer, you also need not be reminded that form is at least as important as function. Don't weaken your dynamic message by sending contradictory signals in your speech, dress, and behavior.

The prospect will assume that how you behave in the presentation will indicate the way your firm will behave in its client dealings. If you arrive late, how credible is your claim that your firm will make its deadlines? If you dress sloppily, make a disorganized presentation and show inattention to details, why should the prospect believe that you are a precise, careful project manager? If you are vague and confused in communicating the strengths of your own company, are you likely to be extraordinary at communicating the client's message? If your samples are amateurishly pho-

tographed or old, dirty, and torn—indicating that not even you regard them with respect and esteem—why should your prospects be impressed?

In short, a carefully prepared presentation, with attention both to appearances and content, delivered with the self-confidence and conviction of a true believer, will be a presentation that will be difficult for your prospects to forget.

THE PROSPECT'S CONCERNS

Several questions will be on the prospect's mind as he or she evaluates your firm.

The primary question will be the depth of your experience, and whether it is in a closely related field. A financial institution will probably feel less secure about your experience if you've only designed annual reports for heavy equipment manufacturers. A competitor with a portfolio of annual reports for banks will have an edge on you. This is why your primary prospects should be in industries quite closely related to those you have already worked with.

Nevertheless, there are ways to turn a lack of experience in a specific field to your advantage. If you are making a presentation to a prospect in a field that is new to you, try to convince the prospect that you can bring a fresh, objective new approach to a problem. Don't directly criticize the work that has been done; instead try subtly to find an ally on the prospect's side. You can be certain that *someone* to whom you're making the presentation will be dissatisfied with some aspect of the current work or you wouldn't be there in the first place. Furthermore, you can take it as almost an article of faith that no client is ever totally satisfied. If you can make a compelling case for a fresh approach, you might be able to remove the stigma of your lack of related experience.

Another issue for prospects is how creative you are. This is the area that is hardest to define and sell. While a lot of the judgments of this creativity will be reactions to your decoration skills, it is better to emphasize the nondecorative, problem-solving aspects of your projects and let the look of the work speak for itself.

Because computers have reduced the need for people hired to produce paste-ups, the size of a design firm's staff is less of an issue today than it used to be. Nevertheless, many prospects, especially large corporations and companies unfamiliar with the way design offices operate today, will have questions about the size of your staff. Read between the lines of the questions and use them as an opportunity to sell your firm's capabilities. Some large companies just feel uncomfortable dealing with small design firms.

In most cases, prospects don't really care how many people you employ. What they really want is reassurance that you can be depended upon to stick to schedules, stay within budgets, and deliver the goods. (Don't talk specific prices at large presentations; hold these discussions for your individual proposal.)

If your design firm is relatively large, talk about how the size and diversity of your staff ensure that your clients are protected against both "cookie-cutter" creative solutions and any possible delays in production due to staffing problems. If you have a small design firm, talk about your computer capabilities and how this technology will help them both in saving time and on the bottom line.

Demonstrate a typical job as it moves through your project management system. The fact that you have a system at all may impress the prospect, since design firms are often stereotyped as creative but disorganized and a bit flaky. While most clients now accept that design firms have a number of designers, and that the principal of the firm in all likelihood won't be doing a lot of hands-on work on their job, they will want some reassurance that they will still be getting a lot of personal attention from the firm's principal.

They will be very interested in your geographical proximity. If you're far away, you'll be expected to tell them why they should choose you over a firm that's closer. This is a wonderful opportunity to demonstrate how fax machines, modems, and computers have changed the way design firms operate and have reduced the need for face-to-face meetings, with the added benefit to your clients of faster turnarounds and less cost to them.

If you're nearby, you'll have to emphasize how, in spite of all that's been said about the benefits to a client that the new technology has brought, when all is said and done, the creation of a design solution for a specific situation is still a very personal process and can't be done well by working at arm's length by machines.

Finally, they will expect you to demonstrate that you have many satisfied past and present clients, at least some of whose names they recognize. Show a partial list of clients—labeled as such. Even if you've only done one small job for a client some years ago, use their name. There's nothing unethical or wrong about doing this. You did the work for the client; you can say you did. You have no obligation, unless asked, to explain what it was you did. Of course, don't list a client if you had a bad experience with them.

SHOWING WORK: PROBLEM-SOLUTION-RESULT

There is a right way and a wrong way to show a prospect the work you have done for other clients. The most common way is to hold out the cover of a printed piece and announce, "This is a piece I did for XYZ Company. It won a silver medal in our local art directors' exhibition." That also happens to be the wrong way.

What does it tell the prospect? That you're an award-winning designer? No. It announces to a client that you're a designer who cares about winning awards. Which may be good for you, but what does it do for them?

In other words, show not what the client can do for you. Show what you can do for the client.

How? There's a simple formula: problem-solution-result. Tell the story behind your previous assignments in that order. What was the client's problem? How did you work with the client to solve it? How well did it work for the client?

For example: "Here's a leasing brochure we produced for XYZ Company. This shopping center had heavy competition from several established centers. We sat down with the developer and agreed on several points to emphasize in the design—factors that made this project distinctive. We were pleased with this solution, which deals with each of these points in this way. The center was fully leased four months before the target date."

Sometimes the results are not going to be easily quantifiable. In that case, use a "satisfied customer" quotation: "John Jones at XYZ says the sales reps call this the most useful sales piece they have ever had."

Make it a point to use market research to prove the benefits of working with your firm. Graphic design has long been thought of as something that can't easily be translated into quantifiable benefits to a client. Advertising agencies and public relations firms, to name just a few, use specific numbers of all kinds to prove that their campaigns and strategies work. They wouldn't think of relying on pure argument alone to solidify their case. But, except for a few firms that specialize in package design, most graphic designers have scarcely used market research as a tool to sell their services.

Market research, however, can be used to prove just about anything, including the benefits of using a professional design firm. And market research doesn't have to be very expensive. A survey, to be statistically valid, doesn't necessarily have to test large numbers of people. It merely has to be a reasonable reflection of the makeup of the audience to whom the message is directed.

Everyone is familiar with the fact that television ratings are based on a relatively small segment of the viewing audience. And yet these numbers have, time after time, been proven to be fairly accurate indicators of who is watching what.

Begin by recognizing that solving a specific design problem is only half the job faced by your design firm. The other half is using that job to get more jobs. Any individual job only brings in income for the duration of the job itself. Its real value lies in its potential to continue to bring in more work and more income.

If the solution to the problem faced is statistical in nature, such as increasing the number of products sold, or the number of students applying to a college, you can be certain that the client will have plenty of before-and-after figures for you. The problem is that these figures alone do not necessarily reflect the impact that design has had on achieving or not achieving the desired goals.

To overcome this problem, before tackling any design problem, regardless of size, a design firm should begin by doing some inexpensive market research. Along with your client, determine the exact nature of the audience to be addressed and the hoped-for results of the work to be done. Then, using lists furnished by either your client or ones you've created yourself, put together a small telephone or mail survey and call or send it out both before the job is started and after the job is completed. Focus only on design issues as they relate to audience perceptions. Depending on how the numbers turn out, you may or may not be able to use numerical results, but you will always be able to use changes in perception based on design. If they are good, use them in your presentations; if not, chalk it up to experience and use them to change the way you solve another client's problem.

The point is obvious, but it cannot be emphasized enough. Clients don't give a flip how many design awards you win with their pieces. They do care about getting results for their dollar. Show them that you understand this. Show them how good design can solve business problems and get results, and prove to them that you know how to do it.

SUPPORT MATERIALS

The ideal presentation is custom-fitted to the unique needs of a specific prospect. But a good presentation might take two to three months to create, and rarely does a design firm have the luxury of spending that much time. Instead, smart firms create several flexible marketing pieces that can be adapted quickly and easily to different prospect types.

There are basic tools that will have to be created in advance:

1. A slide show and/or a presentation to be shown on a computer

2. A capabilities brochure and/or folder.

In addition, one more tool should be created during the actual presentation: a flip chart.

THE SLIDE SHOW AND/OR
THE COMPUTER PRESENTATION

Slide shows, admittedly, present many problems as a selling tool. They are cumbersome to carry around, especially on airplanes. They can be presented only in a darkened room. Electrical problems and equipment failures present hazards. Many clients don't like them. Other clients give the clear impression that they find them intimidating.

Computer presentations have their own limitations. Laptop computers are really the only practical way of presenting them, for the time being, and these all have small screens with varying degrees of resolution.

These and a host of other frustrating problems can turn even the most brilliant visual presentation into the "Presentation from Hell."

All these are valid concerns that must be considered by a firm that chooses to create these kinds of shows, but all pale beside the obvious fact that there is no more powerful, more flexible, and more useful tool for presentations to new prospects than a well-constructed, dramatically presented visual show, whether it be in the form of slides or shown on a computer monitor. For firms doing aggressive cold-call marketing, these kinds of shows are indispensable.

A slide or computer show is a tool, no more and no less. In some situations, it may be the wrong tool—and it is foolish to use a hammer when a socket wrench would be more appropriate. If it is clear that the prospective client is going to be very uneasy with a slide or computer show, or if the physical environment is absolutely wrong for showing it, *don't*. Put it aside and proceed as if it never existed. And work out a contingency plan to cover yourself in such circumstances.

Generally, a show of this kind should be about 15 to 20 minutes long if shown as slides and a bit less if shown on a computer. It should include, in no particular order:

1. Identification of the design firm and some broad descriptive line telling what you do.
Keep this description as broad and general as possible (let the prospect fill in the blanks): "Marketing Through Design," "Visual Communications," and so on.

2. A section that broadly describes your firm's design philosophy.
Emphasize the problem-solving approach to design—which sets the stage for case studies.

3. Case studies, using the problem-solution-result approach to tell about the firm's work.
For best results, arrange products in coherent, understandable categories. For example, in dealing with college admissions materials, group together graphics that show how the design firm used the excellent location of one college as its basic message, while handling another college with a less attractive location in a different way.

Where it strongly emphasizes the design improvements made by your firm, show what a client's products looked like before you were hired and what they looked like after you did your work.

To emphasize client satisfaction, show a whole program or what is clearly work done over a number of years. If the client kept coming back to you, you must have been doing something right!

4. A practical and selective client list.
The clients you decide to list could be grouped one category to a visual to make it easy to custom-tailor the show.

Clients whose names are self-explanatory, such as IBM or Xerox (should you be fortunate enough to have a few like this on your list), need no other words to describe who they are, but any clients whose name means nothing to your audience should be identified by who they are: "XYZ Company, a manufacturer of aircraft widgets."

5. Optional graphics: photos of your offices, equipment, and people.

These should be used only if they would help to strengthen feelings of security in your client. If you have beautiful offices, show them, especially to corporate clients. If you have a large staff and this will be seen as an advantage by your prospect, fine. But don't let your prospects get to the point where they expect to see these terrific professional offices peopled by lots of busy designers and then show them three people in a space the size of a cupboard. Similarly, don't allow photographs of designers amidst their cute, artsy office decorations widen the gulf that already is seen to exist between corporate America and artists. The client expects, even wants, to see some evidence that the design firm is creative, but within tasteful and acceptable limits.

6. A graphic which signals that the show has ended.

It doesn't have to be the name of your firm but it usually is. This doesn't mean the name has to be just type or a logo. If the name or logo appears on a door or a window or a wall, this can be an effective ending slide too.

The ingredients and structure of the show, while important, are no more important than the style and quality of the show itself. Among other things, a design firm is selling its creativity, imagination, and knowledge of what is or is not an exciting and persuasive presentation of concepts and ideas. If it can't even demonstrate this ability in its own visual sales presentation, clients are not likely to be impressed.

The visual show should be reviewed at least every couple of years and updated, if necessary.

THE CAPABILITIES BROCHURE AND/OR FOLDER

Just like the shoemaker's children who never have shoes, an amazing number of design firms never get around to producing a capabilities brochure for themselves. Most manage somehow to get out a small folder, which tides them over for a while.

But, sooner or later, if a design firm ever wants to be considered truly professional, it will have to publish a good capabilities brochure.

Capabilities brochures take many forms and sizes and have a range of prices. How large, elaborate, or expensive they should be depends largely on the size and wealth of the clients the firm works with and wants to attract. If the present and prospective clients are huge corporations, the brochure has to reflect this. It has to be large and lavish and have a look of permanence. If the clients desired are not large corporations, a less expensive brochure might be all that is needed.

One of the most important characteristics of a capabilities brochure is its flexibility and easy adaptability to different prospect needs. Brochures that are constructed more like packets or kits are usually less impressive than those that are permanent, yet they may be more suitable to a design firm's general needs. The material covered in the brochure is similar to the content of the visual show, but generally it is more detailed. A list of possible ingredients:

1. The firm's design philosophy.

Don't dwell too long on procedure, but do spend time establishing the proper professional tone. Strive to create a common ground between your firm and the client—to reduce the feeling that the design firm is only concerned with decoration.

2. The principals and staff.

Who are they? What are their credentials? The principals probably won't change, but the staff list might, so design it in such a way that it could easily be updated.

3. The work of the firm.

Again, the focus should be on benefits, not procedures. The prospective client has little interest in how the design firm does its job, but is very interested in the results of those procedures. Spell out clearly the *problems* posed by a job, the design firm's *solution* to those problems, and the positive *results* for the client. The benefits to the client can be quantifiable, qualitative, or both. Use figures, charts, quotations, or whatever it takes to make the point.

4. A list of clients.

Again, clients should be grouped by categories and identified by type of business, if not immediately recognizable. As with the staff list, this should be designed for easy updating.

5. A list of references.

Be sure to ask for clients' permission before printing their names on a list, for several might be called.

6. Special inserts.

These might be reprints of articles about the firm, press releases, speeches made by principals, or other such material that might help the client understand the firm.

Because of its expense and the fact that no design firm (as far as I know) was ever hired strictly on the basis of the quality of its brochure, a capabilities brochure should be used only as a "leave-behind," distributed as part of the closing remarks of the presentation. If something printed is needed to respond to specific inquiries for information about the firm, send a handsome, but purely informational and inexpensive "Fact Sheet." If you choose, this can accompany some printed samples in a well designed folder.

THE FLIP CHART

After the slide show, the spokesperson for the design firm should ask for questions from the prospect group. Whether there are questions or not, he or she should try to steer the discussion in the direction of the design firm's project management system. If there are questions, this shouldn't be too difficult, since eventually someone will ask a question that will naturally lead to this subject. For example: "The last designer we worked with gave us what we thought was a firm price, but when we got the bill he had added on enough to double his bill. How do we know you won't do the same?"

If there are no questions, just raise one yourself. "A lot of clients are concerned that a designer will quote them one price, but try to bill them something more. We don't work that way. Let me show you exactly how we would work together." At this point, move to the flip chart, which consists of a collapsible easel with a large blank newsprint pad on it. Then diagram exactly how you intend to work with these prospective clients, right before their eyes. By doing this you set up a counter to the visual show, which often has a slightly canned effect.

This two-pronged presentation technique gives you the advantage of showing the work of your firm at its most beautiful and powerful, orchestrating the message so that the emphasis is on creativity and results, while at the same time allowing you to get into a direct and personal discussion of budget and schedule management, which is difficult to do in a slide show without boring the audience.

It also allows you to end the presentation on an upbeat note. Putting on the lights after a slide show is no way to end a presentation. Nor is a question and answer discussion a better way. You want to end the presentation by passing out your leave-behind material and telling your audience directly that they are very important to you and that you want to work with them—now!

Tips for "On-the-Spot" Flip Charts

1. Use a large newsprint pad, but be sure the size of the pad is appropriate to the size and distance of the audience. It should be large enough to be seen in the back of a big room, but go to a smaller size if you're talking to a handful of people seated only a few feet from the easel.

2. Test all your equipment and materials. Make sure your markers are fresh and will write. Test to see that your easel won't fall apart or tip over. Make sure there are enough sheets in the pad to tell your story. Make sure the area you'll be standing in is well lit.

3. Don't turn over the cover sheet until you are ready to write on it. When you do, get to it; don't waste time talking. Get the information down, discuss it, tear it off, or flip it over. Don't leave it out while you talk about the next point. You don't want your audience staring at one thing while you talk about another.

4. Don't be sloppy. Don't make errors in spelling or grammar.

5. Don't turn your back completely to the audience. Stand to the side of the easel to write.

6. Try to make the information you present on the flip chart as graphic, spontaneous, and personal as possible. Don't use the generic terms "client" and "design firm" when discussing how information will flow back and forth; use the prospect's real name and your firm's name. Use lots of boxes, circles, arrows, and dingbats. Check things off, cross things out. Put action into your presentation.

7. Be enthusiastic. A prospect will want to give work to a firm that appears to be eager and excited to do the work, not blasé and bored.

CLOSING AND FOLLOWING UP

Don't be afraid to close. When you sense the prospective client is really trying to find a way to give you a project, ask for it. Don't forget to follow up the presentation with a brief thank-you note. Use your note as another opportunity to ask for a specific job, if one is ready to be awarded. If there is no job to be given for the time being, tell your prospects you look forward to working with them on a future job, and *stay in contact*. If you were allowed to tape-record the presentation, review it to see what worked and what didn't.

If you find out from the prospect that you didn't get the job you were trying for, don't be bashful about asking why. They may not always tell you the truth, but they won't be offended if approached tactfully.

Managing Projects

It's an all-too-typical day for our hero, the owner of his own design studio. He has just returned from an important presentation, which took longer than expected and went badly. He needs to finish a design for an annual report that is due tomorrow (the rough sketches for which are hidden somewhere in his office under a pile of other papers). However, one of his junior designers is impatiently waiting to show him some sketches for a major corporation's logotype. There are five phone calls waiting to be returned; two seem to be from prospects he has been wooing for a year. Either or both may require him to fly to cities hundreds of miles away to make presentations, where it would be nice to show his leave-behind brochure that has been in the works for two years but is, unfortunately, still in the early rough design stage. There is also a message on his desk from his bookkeeper: Estimated taxes will have to be paid next month, and there isn't enough cash on hand to pay them. This means either he must call up several clients and get them to pay their overdue bills quickly, or talk to his banker about a loan to tide him over. He's not getting enough sleep, exercise, or relaxation. His children are starting to call him by a name he's never heard before. His best designer has just given him two weeks notice (and he suspects that she will probably take one of his best accounts with her). Worst of all, some of the work leaving his office is embarrassingly slipshod; two years ago he would never have let work like that see the light of day. He feels his business is out of control.

It is easy to understand how our hero found himself in this uncomfortable position. For most of his adult life, he focused on learning to be the best possible designer he could be. Now, suddenly, he is having to learn something entirely different—to take control of himself and other people.

He doesn't want to be disorganized. But, of course, his whole life has been devoted to being creative, not to arriving at organized systems. He is intuitive, not an unimaginative, rigid, bureaucratic superorganizer.

CONTROL VS. CREATIVITY

Being successful in a graphic design business does not require one to make a choice between control and creativity. There is no choice to be made; you need both. Creativity's dirty little secret is that control is not the enemy; control is a necessary ingredient that makes creativity possible. The greatest creative thinkers are, in some sense, the most disciplined, focused thinkers. And the most consistently high-quality design work tends to come from well-organized, well-managed shops.

Control doesn't mean having clean desks or a quiet, unhurried office. Clean desks don't necessarily prove that work is getting done—only that it is being put out of sight. On the other hand, a busy, noisy office isn't necessarily a symptom of chaos and lack of productivity.

Being in control means creating management systems that match your style of working with the specific needs of your business—systems that succeed because they get the work done well, on time, and at a profit. The critical first step toward gaining control is accepting the fact that it should be done at all. It takes a recognition on your part, as the design principal, that you must make the effort. Lifelong habits may have to be changed or relearned. You must invest time in analyzing, planning, and testing different approaches, not all of which will work.

Gaining control means accepting the necessity of being decisive and delegating responsibility well. It means having an information system that keeps you aware of what must be done, when it must be done, how it will be done, and for how much. It means creating a follow-up system to help you stay on top of schedules and budgets, phone calls that must be made, opportunities worth pursuing, and details that otherwise might fall through the cracks. It means the kind of planning that anticipates emergencies and minimizes crises.

Gaining control is mastering day-to-day management of six things: projects, technology, people, time, paper, and money. It is an interactive process. The better one gets at managing one, the better one is able to manage the others.

A graphic design business is project-based. It lives and dies in direct proportion to how successfully projects are brought in and how they get out. Firms can only remain in business by managing projects in a way that satisfies the clients, yet permits the firm a fair profit. Let's turn first to satisfying the client.

WHAT CLIENTS WANT

It isn't too difficult to figure out what it will take to make clients happy:

1. They want their work produced within an agreed-upon budget.

2. They want their jobs delivered on schedule.

3. They want each job to satisfy all its goals.

4. They want these things accomplished with the least amount of hassle.

5. They want their jobs produced on what they recognize as a level of design excellence.

But these requirements are rather broad. What is more difficult is understanding, in specifics, what each individual client really wants. How do they define design excellence? When do they expect to be consulted, and at what point will they consider more consultation a nuisance? What is the reason for the schedule? How much flexibility does the budget have? What are the goals for the project?

It's amazing how many design firms make virtually no real effort to pin down clients for specific answers about what they really expect for their money. Of course, they arrive at a price and a deadline, but all too often, the other more hidden objectives remain vague and undefined. Most often these same ill-defined, but equally important, goals cause problems in designer–client relationships.

For example, a design firm is hired to design an annual report for a corporation that produces widgets. Because of poor interviewing techniques, the firm begins work on concepts that are product-oriented, only to learn later that this year the client really wants to emphasize its management skills. Not only has a lot of time been wasted—time that may not be billable—but the client has lost just a little bit of trust in the design firm. A tiny seed of doubt has been planted. Plant enough seeds during a project, and you may find yourself with a garden of weeds choking the entire business relationship.

The best way to prevent this type of fatal faux pas is a project management system that works by setting up the standards, performing the work according to those standards, monitoring the work so that adjustments can be made as needed, and following up and evaluating the results when the project is complete.

There are four phases or steps to managing a project: defining the criteria, breaking the project down into tasks, doing and monitoring the work, and following up.

1. DEFINING THE CRITERIA

Depending on the kind of design project, there may be different objectives and parameters to deal with. It is important that the design firm identify them all. Most of this information can come only from the client. Typical of the kind of information that the design firm has to dig out of the client are such things as:

What is the total budget?
How would the client prefer to be billed?

When is the final job to be delivered?
Is the client expecting an advance delivery? When is the client expecting to see the first roughs? Does the client expect to see comps? If so, when? Who will be the writer? When is final copy going to be ready?

Who is the ultimate audience for the job?
Is the job going to be directed more toward one sex than the other? More to one specific age group than another? More to one income level than another? Is the appeal more regional than national?

What is the feeling or mood to be?
One of elegance and luxury? Of utility and practicality?

How many pieces are included in the total design contract?
If it is an identity program, does the client expect the design firm to design applications as well as logos or logotypes?

How much text has to be accommodated?
What is the character and texture of the text? Are the paragraphs short or long? Are there many heads and subheads?

Are there any graphics that must be accommodated?
Tables? Charts? Photographs or illustrations? How many?

Does the client have any market research that is relevant?
Is market research needed?

How is the job to be delivered into the hands of its ultimate audience?
Will this require unusual packaging?

Are there color preferences?

Does the job have to be consistent with other materials or with the client's advertising?

Is there an existing trademark or logo that has to be accommodated?

What are the major points to be made?

Who will make the final approvals of the designs?

Are there size, color, or production limitations?

Does the client want the design firm to select and supervise the printing?
What is the quantity desired? Will the client be at the printer to approve the press sheets?

These are just a few of the dozens of questions that might be asked. Often you must ask the questions of several different people in the client's office before you can grasp firmly what's needed or desired.

When the criteria appear to be clear, the design firm should send a letter to the client, spelling out how it understands the ground rules and assumptions. On a small, low-budget job, a short note might do it. If the project is complex and multifaceted, a detailed letter is a good idea. In either case, the objective is to be certain that client and design firm begin from a clear, shared understanding.

2. BREAKING THE PROJECT DOWN INTO TASKS

To get the job done, each step of the process is identified, assigned, and scheduled. Doing this puts controls into place—controls to assure that no task is forgotten, left unassigned, or given an infinite amount of time for its completion. It also creates a series of checkpoints; these afford the project manager chances to catch a job that is beginning to veer off on a wrong track, wasting valuable time and energy. Some tasks will be sequential—that is, one task cannot proceed until another is completed. Some tasks can be accomplished concurrently with other tasks.

Many design firms today create an electronic "job jacket" or file that follows the job through its various stages. Into this file are entered all the specifications regarding size, paper stocks, type styles, grid sizes, and so forth, as well as a schedule including dates by which time various components are to be completed or approved.

There are several software programs available to do this, most of which integrate both project tracking and money management. New programs are being introduced constantly. All of them are perfect for certain specific situations and dead wrong for others. I recommend that a design firm do a lot of questioning and a lot of research before settling on any one software program to manage projects. Don't use one that doesn't do all the things that need to be done, but, on the other hand, don't adopt a system that is too complicated to easily fit into your style of management.

Regardless of whether the project-tracking system is electronic or just exists in the form of a job jacket, someone in the design firm has to be given the task of monitoring the project to see that the components are in place by the due dates.

In making assignments, whether to employees or to outside suppliers, consultants or free-lancers, be certain to establish definite areas of responsibility and clear lines of authority. This is the one area that seems to cause the most problems in project management. A project almost always gets into trouble when the people working on it do not understand clearly what their objectives are, what their responsibility is, how much authority and control they have, or to whom they report for approvals.

There are many approaches to defining and scheduling tasks, depending on the complexity of the project. They include milestone charts, bar charts, and flow charts (see illustration, pages 66 and 67). It doesn't make a lot of difference which system is used, as long as it is compatible with the firm's style and available resources, and as long as tracking a job doesn't take more time than doing the job. Let's briefly survey these three chart types and their advantages and disadvantages.

Milestone Charts

This type of chart merely lists each task in order of expected completion. It may or may not also include budgets for each task, individuals responsible, actual completion dates, and actual costs.

Advantages

This type of chart is easy to prepare and monitor.

Disadvantages

Tracking simultaneous activities is difficult.

Bar Charts

A bar chart lists each task, with attendant budgets, responsibility, projected budgets, and actual budgets. It also uses a series of horizontal bars to identify the schedule for each of the tasks individually.

Advantages

Bar charts more precisely identify when each task will begin and end, which is very useful in a project where there are many simultaneous tasks being performed.

Disadvantages

A bar chart is a little more difficult to prepare than a milestone chart, and it doesn't clearly show links between various activities.

Flow Charts

These charts are sometimes called PERT (for Program Evaluation and Review Technique) or CPM (for Critical Path Method) charts. A flow chart is a series of interconnected circles or rectangles that track the path of each task and how it flows into other tasks.

Advantages

Flow charts identify the relationship between tasks on a very sophisticated level. Not only do they show when a task is to begin and end, but they also show which tasks are dependent on each other and how tasks develop along simultaneous tracks.

Disadvantages

Flow charts are most difficult to prepare and are often confusing to an uneducated eye.

MILESTONE CHART

Schedule

WGDF, Inc.
1 Main Street
Everytown, USA 10000
(100)123-4567

PROJECT: FOLDER DATE: MAY 1, 1995

CLIENT: ABC CORP.

CONTACT: JD

PROJECT MANAGER: EG

Activity:		Date:	Comments:
Design:	Planning meeting	May 1	
	Submit preliminary cost estimate	May 3	
	Receive copy	May 10	
	Present preliminary designs and schedule	May 15	
	Select photographer/illustrator		
	Revisions	May 20	
Photography:	Complete photography (illustration) schedule		
	Begin photography (illustration)		
	Complete photography (illustration)		
	Edit photography and scan photos (illustrations)		
	Present finished dummy with photos (illustrations) in place		
	Release color (art) to printer		
	Correct color proofs		
Typesetting:	Begin to typeset	May 22	
	First laser proofs	May 24	
	Second laser proofs	May 29	
	Third laser proofs		
Final laser proofs:	Present laser proofs with final copy and photos (illustrations)	May 29	
	Client sign-off on laser proofs	May 30	
	Release final laser proofs and disk to printer	May 31	
Printing:	Blueline for client approval	June 3	
	Final corrections approved	June 5	
	Revised blueline for client approval	June 7	
	Project on press	June 8	
	Sample copies to client	June 11	
	Start delivery	June 12	
	Complete delivery	June 13	

BAR CHART

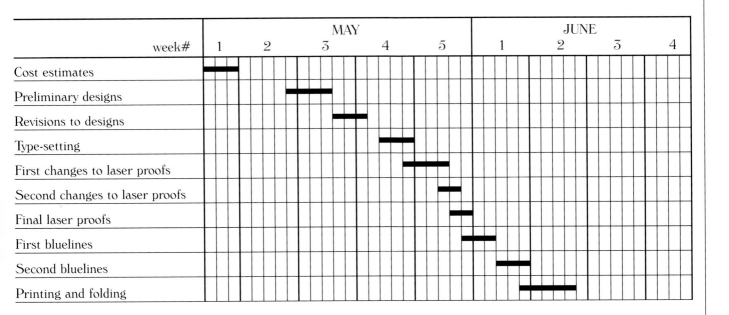

	week#	MAY					JUNE			
		1	2	3	4	5	1	2	3	4
Cost estimates		▬								
Preliminary designs				▬						
Revisions to designs					▬					
Type-setting						▬				
First changes to laser proofs						▬				
Second changes to laser proofs							▬			
Final laser proofs							▬			
First bluelines								▬		
Second bluelines								▬		
Printing and folding									▬	

FLOW CHART

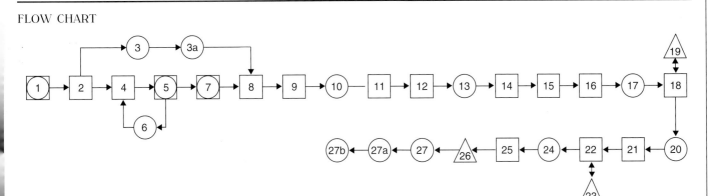

□ Designer-action points ◘ Client-designer check points ○ Client-action points △ Supplier-action points

1. Planning meeting, 5/1
2. Prepare preliminary cost estimate, 5/2
3. Preliminary cost estimate sent to client, 5/3
3a. Client writing copy, 5/3–5/22
4. Designers receive draft of copy, prepare preliminary designs, 5/10–5/15
5. Present preliminary designs, 5/15
6. Make revisions to designs, 5/15–5/20
7. Present revised designs, 5/20
8. Receive released copy on disk, 5/22
9. Set and format copy, 5/22–5/23
10. First laser proofs to client, 5/24
11. Copy changes received from client, 5/27
12. Make copy changes, 5/27–5/29
13. Second laser proofs to client, 5/29
14. Second laser proofs returned with changes, 5/29

15. Make final copy changes, 5/29–5/30
16. Prepare final laser proofs, 5/30
17. Send laser proofs to client for final check, 5/30
18. Final laser proofs returned, released for press, 5/31
19. Laser proofs and disk to printer, 5/31
20. First blueline to client, 6/3
21. First blueline returned with changes, 6/5
22. Changes being made, 6/5–6/6
23. Changes to printer, second blueline being pulled, 6/6
24. Second blueline to client, 6/7
25. Job released for press by client, 6/7
26. Job on press, 6/8
27. Sample copies to client, 6/11
27a. Begin delivery of job, 6/12
27b. Complete delivery, 6/13

3. DOING AND MONITORING THE WORK

Most designers agree that computers have had their greatest impact on the way designers actually design their jobs. They are only partially right. Computers have revolutionized the entire design process. The ability to handle and compare massive amounts of data stored in relatively tiny spaces and files has given designers an incredible tool to help them run their business.

Because computers allow design firms instant access to hundreds of thousands of pieces of information in almost no time at all, job estimating, tracking, scheduling, budget, expense, and time tracking—chores that used to be slow, costly, complex, and often inaccurate—have become quick, inexpensive, simple, absolutely accurate and easily monitored.

The ideal project-management system should have these capabilities:

1. It should have a listing of all tasks called for.

2. It should have an estimate of all time, associated costs, and out-of-pocket expenses built in.

3. It should have a schedule of dates and target dates built in.

4. It should be very flexible, so that it can easily be adapted to various kinds of projects.

5. It should generate information fast, so that the information is available when needed, not when ready.

6. It should be capable of providing the information in many visual forms and in large or small chunks, as needed. If, for example, the design firm would like to plug in the information and then pull out a portion of the information in the form of a bar chart to send the client, it should be capable of doing so.

7. It should be capable of using the same information in a variety of ways. For example, as bills come in from suppliers, they could be typed into the system once and automatically be distributed into accounts payable files, individual job-order files, total supplier files, estimate files, and perhaps a variety of other files. This eliminates considerable duplication.

8. It should be capable of a variety of measurements in response to inquiries. These should be for individual jobs. For example: in Job X, how do the actual costs compare to the estimated costs? How does the estimated time compare to the actual time? What percentage of the work that needs to be done has been done? And for several jobs collectively, what current projects are now 10 percent over budget or 10 percent behind schedule? What bills need to be paid this week to preserve available discounts?

The next chapter, "Managing Technology," pages 69 to 76, deals with specific steps to be taken to select and install a computerized management system, but one of the first steps in constructing such a system is sitting down with the company accountant and making a "wish list." On the list is all the information the accountant needs to pay bills, set up accounts receivable files, create profit and loss statements, pay taxes, meet the payroll, and so on. Also on the list are the things the principal of the firm and any other project managers would like the system to do.

4. FOLLOWING UP

An ideal project management system includes a follow-up after a job is complete. One part of the follow-up is assessing whether each project came in on budget and schedule. Measuring what happened, in comparison to what was expected in time and cost, gives the firm information to use in refining its estimates and expectations on new jobs.

A second part is continued contact with the client. Since former clients are the most easily cultivated source of new sales, it's in the design firm's best interests to maintain contact with the client. Its goal is not merely to produce projects, but also to build strong relationships.

Managing Technology

Hundreds of look-alike, dress-alike, strange-looking men and women sat in long rows, staring blankly at a huge television screen upon which the face of a man appeared, speaking unintelligible words.

Suddenly, an athletic-looking young woman dressed in shorts came running down one of the aisles, swinging a large sledge hammer. She stopped and, with a mighty heave, threw the hammer at the screen, shattering it to smithereens.

It was Super Bowl Sunday, 1984, and, with this commercial, Apple was sending a message to the world that its new Macintosh computer was about to change the computer industry forever.

It certainly did.

While there's no way to identify with precision the impact of the Mac on the computer industry as a whole, a valid case can be made that the Mac was the prime catalyst for most of the technological breakthroughs that poured forth shortly after its release: improvements in laser and color printers, paper products created especially for these printers, type font and page layout software, chip technology, drawing and painting programs, manufacturing and distribution innovations, and hundreds of other technological improvements and changes.

We can almost certainly say that the Mac greatly accelerated the so-called desktop publishing market and that the demands created by this market have driven all the innovations noted above.

And we can say with equal certainty that technology is now, and forever will be, a major factor to be reckoned with in the design business.

"WHAT HATH GOD WROUGHT?"

S.F.B. Morse's historic query during his demonstration of the telegraph, in 1844, could be applied on an almost monthly basis to developments in computer technology today. What effect has all this technology had on the graphics industry and the graphic design profession?

A hell of a lot.

Traditional typesetters have virtually disappeared, along with most of the pure production jobs in design firms. Clients who once sent most of their design jobs to design firms now opt more and more often to design them in-house, often relying on amateur designers. It is far more expensive to open and maintain a design office than ever before. The combination of more in-house design departments, more design-school graduates, and more small DTP operations has created more competition for fewer design jobs and projects. This, of course, has had the inevitable effect of driving down prices, salaries and profits for all designers.

In fact, though inflation has sent prices spiraling upward in almost every other service sector during the past decade, designers are still charging just about the same prices, or even less, than they were ten years ago. Beginning salaries are actually lower.

But perhaps the greatest change of all has been the effect that technology has had on the look of the work itself.

During the Industrial Revolution the introduction of advertising encouraged printers to design and create hundreds of new display typefaces that found expression on the thousands of posters, flyers, and handbills they printed. With all these typefaces to choose from, most printers did what might have been expected— they used as many as possible, often on the same printed piece, creating a hodge-podge of typefaces and a unique look we associate with Victorian advertising ephemera.

Today's graphic designers, faced with even more choices and options, have followed the example of their Victorian counterparts—if they can do it or use it, they surely will.

Type, images and colors are bent, stretched, layered and commingled in an almost incomprehensible mélange.

As we saw with the printed work of Victorian times, eventually water will seek its own level. A William Morris will emerge to lead a twenty-first-century version of the Arts and Crafts Movement, and we will probably see a return to the basic principles of readability and classic design that followed the Industrial Revolution, but with the exciting new twists that technology has given us—at least until the emergence of the twenty-first-century equivalents of Art Nouveau, Art Deco, Dada, Futurism, and Cubism.

Until then, designers will just have to do the best they can to stay both ahead of and on top of the unsteady and quickly shifting landscape that is the graphic design profession today.

TECHNOLOGICAL TRUTHS

Computers are not only here to stay; they will surely get faster, smarter, smaller, cheaper, and more "user-friendly." It has been said that today's technology becomes obsolete almost every six months. In the future, it might happen even more quickly.

Faced with this, designers have a choice: Manage the technology or let the technology manage them.

How can designers take control of the technological tiger? They can begin to do this by first accepting some basic facts:

1. "State-of-the-art" will always become "less-than-state-of-the-art" very quickly.
Not only is the technology improving at an incredibly rapid pace, but the manufacturers of technological products are in the business of selling as many of their products as they can, for as much as they can, as often as they can, to as many people as they can. As long as they can get away with persuading people to buy new upgrades, models, and software as soon as they are released, they will almost certainly continue to do so.

2. Regardless of how much memory, power, or speed you already have available, there will come a time when you find it isn't enough.
As this book is written, if one has the Power Mac version of Photoshop, it takes 11 megabytes of RAM (Random Access Memory) just to open the program. This trend is sure to continue. It is the nature of software to stay ahead of hardware capabilities.

3. Six months after you buy any hardware or software, you will find that it has already been discontinued and that you can buy something newer and better for much less money.

4. The computer is not just another tool.
It is a door that gives designers' access to design solutions, markets, profits, and unprecedented control over their futures.

Once a designer accepts these basic truths, it makes living with technology a lot less stressful. Armed with the knowledge that any decision made regarding the purchase of any kind of technology, whether it be a computer, a fax machine, a printer, or simply a telephone, will soon be irrelevant, each decision becomes less of a painful choice. It doesn't make any difference whether one chooses model "A" or model "B" today. Both will be obsolete anyway, in six months, six weeks or, possibly, six minutes.

Many people use this fact as a reason to delay a purchase of equipment they really could use immediately in hopes of making a better buy later. They forget that, where technology is concerned, there will always be a "later," later. If a "good buy" were the only concern, there would never come a time when it would be the perfect time to make a technology purchase. In 1989 I bought a portable telephone for my car. It cost me about $1,000. In 1994 I replaced that telephone with a new one that is much smaller and much more powerful. It cost me $100. Although there is a bit less static on the new phone, the fact is that the new phone hasn't really allowed me to make a single telephone call that I wasn't able to make on my old one. Why did I buy it? I guess like many other people, I just couldn't resist such a good value.

The perfect time to buy technology is when you can afford it and when you need it to get where you want to go. And then you should buy the best and the most that you can afford. No more, no less.

The fact that the technology quickly becomes obsolete, as it surely will, has not made your purchase any less useful. As long as it works for you and does the job you are asking it to do is all that is important. Use it until you can afford something better or until it no longer works at all. And then replace it with no regrets. Remember that whatever new gizmo you buy will also be obsolete in a few months or weeks.

Two alternatives to buying new equipment are leasing and buying used equipment. The former protects against obsolescence and reduces your need to lay out cash. The latter reduces your total costs.

The problem with leasing is that it almost always ends up costing a lot more in total dollars. This isn't very surprising, considering the short life of this equipment and that the people who are doing the leasing are not in business to lose money. Before leasing any equip-ment designers should first consider using service bureaus if they can't afford to lay out the cash.

As far as used equipment is concerned, the good news is that, since technology changes so quickly and an awful lot of people feel compelled to replace perfectly good equipment with new gadgets as soon as they become available, it is possible to find used computers that will do the job for you. The trick is to figure out what speed, power, and features you really won't forgo and then make certain that you seek these out as a minimum.

The bad news is that buying used computer equipment is a lot like buying a used car, only worse. At least with a car you can kick the tires. Computers really don't like to be kicked. If you don't know a lot about computers, don't even begin to try to buy a used one alone. Find or hire a knowledgeable friend to help you find equipment that is what you need, that will work more than a week or two, and that you'll be able to get parts and service for.

FIRST THINGS FIRST

All designers, of course, want to do great work and win lots of design awards, and some even want to make a lot of money. But, beyond these general pursuits, designers have goals that are uniquely their own. Some are helped by filling an office with the latest and most powerful computer hardware and software, some are hindered.

Computers will never make a designer happier, more talented, taller, or more beautiful. *If properly managed,* however, computers can help a designer to compete more effectively, to make more profits by providing new services and entering new markets, to become more efficient, organized, and productive, and to experiment with new creative approaches. The operative words in the last sentence were "if properly managed." If not properly managed, all the changes in technology can drive you crazy and make you broke as you try to keep up.

There used to be a time when designers had a choice: Bring technology into the office or don't bring it in. As long as clients were satisfied with the work done for them, they couldn't care less how it was produced.

This is no longer true. Today, right or wrong, the majority of clients demand and expect graphic designers to be very computer literate and to have an office full of the latest technology. If designers wish to compete strongly for jobs and be able to enter new markets, they must be prepared to buy into the available technology at some professional level.

But there are all kinds of ways to do this, and each has its own price tag, not only in dollars and cents, but also in the way the design business itself needs to be managed.

Before spending a penny on technology, a designer needs to look very closely at the entire picture and decide not only how much he or she can afford to pay for technology, but how much outlay *should* be made to accomplish business objectives.

These business objectives differ with each designer. Some designers just want to spend their time designing and solving design problems. Some want to build the design business equivalent of IBM and sell it to some fool for a billion dollars. Some want merely to have a warm, fuzzy place to do their work.

Design is a client-driven profession, however. Different kinds of clients have different kinds of needs—real or imaginary. Therefore, the kinds of clients a designer has will, for the most part, determine the kind of offices and services the designer must provide to satisfy the needs of those clients. A designer must decide to satisfy these needs or not, depending on whether the price to be paid, not just financially but on every other level, is worth it.

If a designer is after big bucks and highly visible jobs, then he or she must recognize that the most promising path is to work with large, multinational clients. As large clients generally have complex structures and big budgets, a design firm serving them needs to offer many and varied services, large staffs, and fancy offices with lots of big conference tables to sit around and confer over. The clients are usually knowledgeable about design and experienced at working with designers, although this doesn't necessarily make them any easier to deal with. Working with large corporate clients also translates into a more complex design office to manage, lots of travel, more time devoted to selling and managing design than to actually designing, higher overheads, and a greater need to stay current and technically state-of-the-art.

Yet some of the happiest and most successful designers I have ever met, (by their own standards as well as by any reasonably objective criteria), have no or few employees, little investment in technology, and modest offices in beautiful surroundings.

The designer who would prefer living in Santa Fe to San Francisco must generally work with smaller clients. A client base of nonprofits and small companies with simple management structures allows designers the freedom to keep their staffs smaller, their offices less luxurious, their investment in technology lower, and their life and work styles more flexible. It *doesn't* guarantee that life will be any less stressful or that the work done will be any better. Working with smaller clients often means working with smaller budgets, less design-literate people, and a higher percentage of clients who turn out to be deadbeats. And, while expenses can be kept to a minimum, income can be quite unpredictable. If you don't believe this can be stressful, try looking your cat in the eye while you're stealing her plate of Kibbles.

Once the really tough decisions have been made (or made for you) regarding the kinds of clients you want to work with, how much money you want to make, where you want to live, and the kinds of jobs you want to work on, choices regarding the technology toolbox you will need to do the job becomes relatively easy.

THE TOOLBOX

What kind of hardware and software will you need?

I asked four of the most computer-knowledgeable people I know to put together a list of hardware and software recommendations.

Craig Ziegler is President of Graffito (pages 170 to 173), a Baltimore-based design firm that has been on the forefront of computer technology almost from the day they opened their offices in 1985.

David Patschke manages the graphics lab at the University of Baltimore.

Max Boam is an Englishman who is a partner in the Baltimore design firm Boam and Boam. He has been working with computers for years both here and abroad.

Jerry Greenberg is General Manager of Comp USA, in Towson, Maryland.

Recognizing that by the time this book is published whatever they may recommend will probably be obsolete already, here are their choices:

Macintosh

Entry-Level Equipment (under $6,000)
- Power PC 6100
- 16mb RAM
- 350mb hard drive
- CD ROM drive
- 15″ monitor
- Black-and-white postscript laser printer
- Appropriate software and fonts

Mid-Range Equipment ($10,000+)
- Power PC 7100
- 24mb RAM
- 350+mb hard drive
- CD ROM drive
- 17″ color monitor
- SyQuest 44/88 removable disk drive
 - or 230mb Magneto-Optical drive
- Desktop RGB scanner (600dpi optical resolution)
- 11″ x 17″ black-and-white postscript laser printer
- 14,400 fax modem
- Appropriate software and fonts

High-End Equipment ($30,000+)
- Power PC 8100
- 128mb or more RAM
- 2gb mini-array hard drive
- CD ROM drive
- 21″ color monitor
- monitor calibration device
- SyQuest 44/88 removable disk drive
 - or 230mb Magneto-Optical drive
- Optical drive (650mb or higher)
 - and/or DAT tape drive (for archive)
- 24 bit accelerated video card
- DSP card (image processing)
- Desktop RGB scanner (1200dpi optical resolution)
- 11″ x 17″ black-and-white postscript laser printer
 - (600 dpi)
- 11″ x 17″ color laser printer
- 14,400 fax modem
- Appropriate software and fonts

Software
- System (included with Macintosh computers)
- Utilities: SAM Anti-Virus; Norton Utilities;
 - Maclink plus translators; Microsoft Word
- Font Management: Adobe Type Manager; Adobe
 - Type Reunion; Suitcase
- Page Layout: Quark XPress; Aldus PageMaker
- Project Oriented Drawing: Adobe Illustrator
- Paint and Photo Manipulation: Adobe Photoshop;
 - MSC Live Picture

PC

Entry-Level Equipment (under $6,000)
- Pentium 60
- 256k secondary cache
- 16mb RAM (4x4)
- VESA motherboard
- 420mb IDE hard drive
- 24 bit video card
- 17″ monitor
- 8.5″ x 14″ postscript printer (300 dpi)
- 1200 x 600 dpi scanner
- Appropriate software and fonts

Mid-Range Equipment (under $9,000)
- Pentium 75
- 256k secondary cache
- 32mb RAM (8x4)
- VESA motherboard
- 850mb SCSI hard drive
- 24 bit video card
- 17″ color calibrator monitor
- 11″ x 17″ postscript printer (600 dpi)
- 1200 x 600 dpi scanner
- Appropriate software and fonts

High-End Equipment ($20,000+)
- Pentium 100
- 256/512k secondary cache
- 64mb RAM (16 x 4)
- PCI motherboard
- 1gb SCSI hard drive with I/0 caching controller
- 24 bit video card
- 21″ color calibrator monitor
- 12″ x 19″ postscript printer (1200 dpi)
- 1200 x 600 dpi scanner with transparency option
- Slide scanner
- Appropriate software and fonts

Software
- Microsoft DOS
- Microsoft Windows
- Adobe Photoshop
- Adobe Illustrator
- Quark Xpress
- Adobe Type Manager
- Type 1 or TrueType fonts
- Hijack Pro for Windows

THE BOTTOM LINE QUESTION

I once asked a designer why he spent $2500 to buy a fancy new laptop computer. His answer didn't surprise me. I've heard it before from other designers. "Because it's so neat!" "Neat" might be a good reason to buy a tie, but not a computer.

I have nothing against doing things for foolish reasons if it gives people pleasure, if they can afford it, and if it doesn't hurt anyone. Technology itself is very seductive, however, and the people who market the technology are quite good at making others feel like cavemen if they don't buy the latest gizmo. Unless designers begin to measure their investments in technology by the simple criteria of "Do I really need it to help make my business better?" they could soon find themselves surrounded by a whole lot of "neat" junk that's eating up their energies and their profits.

To take fullest advantage of the benefits of technology a designer has to look clearly at the relationship between needs and functions. Whenever the functions of a particular technology allow designers to satisfy certain needs more efficiently, effectively, or quickly, then the investment is probably a good one. Whenever a particular piece of technology merely duplicates functions without improving on the existing situation, the investment is probably a bad one.

If we look closely at the typical design studio, we see that, to function well, the studio is required to:

1. Provide creative thinking and aesthetic skills.

2. Provide tangible evidence of these thoughts and skills by way of written and designed products and persuasive presentations.

3. Keep precise records of everything: the status of all projects, how much time was estimated to be spent, how much time actually was spent, what out-of-pocket costs were accumulated, what work was done, by whom, for whom, for how much, what has been paid out, what has already been collected, what is still to be collected, what is still to be paid out, present clients, potential clients, legal and tax obligations, and so on.

There are two facts that every designer should be aware of:

1. You will win most of your clients and projects because of your performance on the first two items.

2. You will lose clients, projects, and possibly your business most often because of your performance on the last item.

Clients can be wowed by terrific design, great presentations and a strong reputation. They are even willing to put up with a certain amount of stubbornness and a "prima donna" attitude as long as the design studio delivers on its promises.

But the minute a studio begins to appear to be breaking its word, red flags go up in a client's office and the floor of trust and faith begins to weaken. Which is why the first investments in technology should be focused on creating a system that allows a designer to keep better track of everything that is happening in his or her business, as it is happening.

Although computers truly allow for far more exploration and experimentation than traditional approaches to design, nevertheless, designers got along just fine without them for a long time. Many still do.

But the computer was invented and designed to compute, and nothing can beat it at this. *The most powerful and dramatic effect of technology on a design business will not be in the way it affects the design, but on the way it helps designers gain control over all the complex forces and factors that make or break their business.*

So, step one in the process of taking control of technology is to focus on identifying and creating a computer-based record-keeping system that will allow you to track precisely everything you do and wish to do.

How large and complex your business already is, or how large and complex you wish it to be, will determine whether you need simple and inexpensive software, with little overhead, or large and powerful programs requiring several employees to monitor them. Getting your software selected, installed, and working will not be easy, nor will it be quick. But, sooner or later, your record-keeping system will be worth its weight in gold.

Jennifer Morla (pages 126 to 129) has a medium-sized design office of seven people, including three full-time designers. She swears by Filemaker as a basis for her database system. Jennifer had her system installed and customized by a consultant and hasn't regretted it for a moment.

But there are lots of other good software programs and lots of approaches to creating the right kind of information-sharing database system. Each designer has to decide, on the basis of his or her particular situation, whether an off-the-shelf program or a unique, custom-designed program is warranted.

Begin by identifying a consultant who can help you avoid expensive mistakes.

How do you find one? Many computer consultants are listed in any telephone directory. In Baltimore, where I live, they are listed under "Computers—Software & Training." Consultants also advertise in various computer magazines. To narrow your search to consultants who are trustworthy and knowledgeable, I recommend that you contact all the designers and all the design, computer, and user groups you know. Ask them for recommendations based on experience, not just hearsay. Narrow your list down to about five or six, check out their references, and begin to interview and receive proposals. Create a "wish list" of information you want to track and things you would want to be able to do with the system in a perfect world. Then choose a consultant much as you would choose any other supplier. Whom do you trust? Be careful, as this particular supplier could make or ruin your business. Don't choose strictly on the basis of price. The criterion should be, "Which consultant do you think will do the best *job* for the best price?"

Once you have your database system in place, you can begin to think about the rest of your technology needs: computers, software programs, fax machines, scanners, copiers, printers, modems. The list could be endless. But, keep in mind that anything you buy will rapidly depreciate. Within six months almost all technology is worth only about half its original cost. Within two years most hardware is practically worthless—in a financial sense, though not necessarily in a practical sense. If it's still keeping you competitive, then why get rid of it?

How much should you be spending on technology? Most design firms invest from 8 to 10 percent of one year's gross income in original equipment and from 2 to 3 percent of one year's income each year to stay current.

GETTING A FAIR PRICE

One of the most interesting developments has been the various ways design firms have tried using technology to increase their income and profits. Recognizing that they were capable of doing their own typesetting, many design firms tried at first to charge their clients for this function as if the work were still being sent out to an outside typesetting service. If the design firm figured that a typesetter might have charged $5,000 to set a particular job, the design firm might charge the client $3,500 as a line-item cost for typesetting, figuring the client was saving money and the design firm was creating another profit center. This lucrative arrangement would usually last only until the clients wised up.

Other design firms charged clients strictly on the number of hours spent on a job, whether the designer was doing pencil sketches, laying out pages, drawing on a computer, or setting and manipulating type.

This approach is perfectly rational, except that most firms who charge clients this way actually have no idea of the true costs of their technology and, therefore, do not reflect these costs accurately in their hourly rates. There is the cost of the hardware and software itself. In spite of the fact that millions of other taxpayers are helping to pay for these things, they still aren't free.

Then there is the cost of training and upgrades. If software isn't being used to the limit of its capabilities, then it takes more time than it should, and, as we all know, in the design business, time is money.

Add to this the far more unpredictable nature of electronic production (Murphy's Law seems to have been written for computers): You never can predict how much converting, manipulating, and modifying a client's text or graphics file will need; printouts always take longer than expected (if the printer doesn't jam); dealing with service bureaus is much more complex and takes longer than sending out for a stat. Moreover, now that they have the opportunity to do so, both clients and designers seem to spend more time making changes and refinements than ever.

There are several ways to deal with this problem, both short term and long term:

SHORT TERM:

1. Recognize the unpredictable nature of the process and add a decent contingency to every estimate. Depending on past experience, a designer may have to add between 10 to 25 percent to each estimate to be assured of making a profit on a job. (As has often been said, it really doesn't work to lose money on every job, but make it up in volume.)

2. Construct your proposals so that there are several points at which estimates can be adjusted to reflect the reality of the actual process. Break the proposal down into phases, each with its own range of prices (phase one should be a payment in advance of any work done, if possible, especially if the client is a new one.) Tell your client in advance that not only will each phase be billed as it is completed, but each phase will be re-estimated as you get to it. In some cases, this will reduce the total bid, which ought to please the client. In some cases it will indicate that you have underestimated or didn't anticipate something in the process. Either way, you have an opportunity to correct the bid, if you can justify additional costs, or to save some time or costs in the phases still to be billed.

3. Test the process early and in bits. Most of the problems that develop in the electronic production process are electronic in nature: Conversions don't convert, communication protocols don't communicate, platforms and programs are incompatible, designs and graphics don't output as conceived. As early in the process as practical, it pays to send a representative portion of text and graphics to your image-setting service, just to see if there might be problems later.

LONG TERM:

Of all the wonderful gifts the computer has given designers, the gift of eternal memory (properly backed up, of course) and almost instant access to that memory may be the most valuable. It is no longer necessary to guess how long a particular kind of a job will take to produce. The computer allows a designer to see how long similar jobs have actually taken to execute. By building files based on types of jobs, types of clients, physical characteristics or any number of parameters, it is possible not only to get estimates more quickly, but to assure a greater degree of accuracy, based on that designer's actual work habits and past performance. Not only that, if you create files that constantly update jobs and costs as they progress through the office, overhead percentages and basic hourly rates can be monitored and instantly adjusted, either up or down, if necessary.

POTHOLES ON THE INFORMATION SUPERHIGHWAY

Technology may be here to stay, but it brings with it lots of problems for designers. Not only has technology made it more costly to be in business, but it also has the potential to distract the minds of those who use it. And, where the mind goes, the business follows.
Here are some final words of advice:

1. Just because it can be done at all is no reason to do it.

2. Clients are buying you for your mind, your talent, your ability to solve their problems, and your ability to make them trust you and feel comfortable with you, not because you have great gadgets in your office.

3. Computers are tools that make it *possible to save time,* but you're the one who must make the decisions that *actually* will save the time.

Managing
People

I n these days of "downsizing" and huge numbers of young new designers graduating every year from design schools (only to find that computers have reduced the need for entry-level people to the point where only about 10 percent of those graduating from design schools actually find jobs in design firms), worrying about issues such as growth, attracting the best new employees, and managing a staff of designers seems almost like a waste of time. But designers who have learned their craft well and start their own businesses determined to do the very best work they can on every project and run their businesses as intelligently and as energetically as possible still find it difficult *not* to grow. And since design is a very labor-intensive business, growth usually takes the form of added staff, with all the problems associated with this.

Leslie Smolan, a partner in the firm of Carbone Smolan, tells of the day that she and partner Ken Carbone hired their first employee. A client of theirs, upon hearing this, told them, "Things will never be the same for you. You will never be as efficient as you were when you had no employees." Says Smolan, "He was absolutely right."

MANAGING CREATIVE PEOPLE
Persuading people, reading people, communicating with people, and managing people are at the heart of most businesses. Nowhere is this more true than in design firms. The firm's dependence on its ability to persuade clients to buy is obvious. More to the point, the product to be sold is totally dependent upon the talent, conscientiousness, and productivity of individual employees. The assets of a design firm are not machinery, or capital, or raw materials, or inventory; its only assets are its people.

No project-management system is better than the persons doing the managing or the persons being managed. Firms larger than one person can succeed only by effectively harnessing and harmonizing the efforts and talents of several individuals. That takes effective management of people.

Sad to say, even professional, trained managers have a difficult time attracting, supervising, and when necessary, replacing employees. Design firm principals, typically untrained and inexperienced are also uninterested in, and even a little intimidated by, dealing with personnel management. They can hardly be expected to do better than professional managers.

Managing people in graphic design is further complicated by the nature of the people attracted to the field. Graphic design appeals to a certain kind of personality that doesn't respond well to managerial techniques that work well in other businesses.

Creativity is an unpredictable process that cannot be easily programmed. It can't be turned on or off like a faucet. Sometimes the tap will bring forth a trickle of water, sometimes a torrent. Sometimes the torrent is brackish and unpleasant, while the trickle is sweet and clear.

Furthermore, designers themselves tend to be perfectionists who will, if given the time, tickle and refine a design forever. Some designers work slowly, some fast. Some designers feel more comfortable working on one kind of job while others work better on another. Often, because of the pressure of deadlines, a design firm can't always make a perfect match.

WHAT TO LOOK FOR IN EMPLOYEES

The personnel of a graphic design business should always reflect two parallel demands—the clients' needs and the design firm's needs.

Clients need the design firm...

to be creative and imaginative;

to be experienced and dependable;

to be responsive and flexible.

The design firm needs...

to give the clients what they expect;

to make a profit;

to produce materials that will attract more clients;

to create a working environment for themselves and for their employees that is pleasant and also creatively and financially satisfying.

These needs should guide the selection of employees. In order to have a creative, imaginative staff, obviously you must hire creative, imaginative individuals. Yet even more important, they have to be managed in a way that will encourage them to use their talents. Fortunately, creativity and imagination show up in a portfolio and in an interview more clearly than other factors—such as work habits.

You can't have an experienced, dependable staff if most of your people are entry-level designers. Entry-level employees pose other difficulties aside from inexperience: Their potential is difficult to evaluate; they need a lot of supervision and training (which cuts into the productivity of those supervising and training); and they tend to come and go quickly.

Nevertheless, for the health of the profession, even small design firms should make an effort to have at least one or two entry-level employees on their staff at all times, not merely because it is good for the industry to have a constant stream of new blood infused into it each year, but also because it is good business.

An aggressive search for talented entry-level employees forces a design firm to maintain contacts with the two best resources for experienced good designers—design-school teachers and young designers themselves. These contacts become valuable when a design firm needs to find and hire a good, experienced designer quickly. They will be aware of those young designers who are looking around and ready to move on. A large number of your best prospects will come from this group.

Entry-level employees also tend to keep the rest of the staff on its toes. The mere act of having to train and supervise people forces employees to learn to communicate, persuade, and articulate—to grow in managerial skills.

It will be this growth that will enable the design principals to delegate more tasks and to gain more time to concentrate on other areas.

To be responsive and flexible, a design firm must have a staff that is skilled in a variety of design specialties, large enough to be able to withstand the loss, whether temporary or permanent, of key people, and savvy enough to understand what clients are saying and to give clients the kind of advice that is tuned into the client's desires.

This requires the design firm to hire those designers who exhibit skills that go beyond having a good portfolio. They must also demonstrate that they have enough social skills to be able to work well with co-workers and clients.

GOOD MANAGEMENT BEGINS WITH GOOD HIRING

To perform well and to grow, if that is a choice the firm decides to make, a design firm must be able to attract and manage the best young talent in the field.

There are many ways to find talent. Ads, employment firms, and word-of-mouth all work. Most firms maintain a file of promising applicants who have shown their portfolios.

But a design firm shouldn't wait until the hour of need to begin looking for talented designers. Desperation often forces a firm to hire the best *available designer* instead of the best *designer available*—and there is a difference.

To find the best designer available, a firm needs a network of contacts that gives it instant access to the best young talent out there. It also needs a reputation in the field as a good place to work.

Contacts will come from a variety of sources, including some unlikely ones, such as clients and competitors. But the best sources will be your own staff and their friends, design-school placement officers and teachers, and professional employment counselors—in that order.

It is wise to remember that your staff and their friends are also the best sources of contacts for other design firms—designers talk a lot to other designers—and therefore, the way you treat your employees and applicants has a direct impact on the long-term health of your firm.

If your firm consistently produces good work, it will always attract a certain number of good entry-level designers. But if word gets out that your firm doesn't allow a designer to grow, uses designers only as extra hands for the principals, is unfair or discriminating in its pay or employment policies, or is only interested in what it can get out of an employee (not what it can give), the firm will find its sources of experienced talent drying up and its best people leaving for greener fields before long.

A good recruiting program should include:

1. A continuous, active dialogue with design schools and design school teachers. Teach a course in a local design school. Make friends with teachers and students and maintain those friendships. Get involved in portfolio reviews and seminars. Be visible in the community.

2. Hiring of interns, co-op students, and entry-level designers.

3. Making sure that your own staff understands your personnel policies and goals. Don't inspire an atmosphere of fear and insecurity that might encourage them to sabotage any attempts to bring in strong co-workers. Build pride in themselves and their co-workers.

The Selection Process

Once a number of candidates have been identified, the selection process involves four steps:

1. Portfolio review

2. Reference check

3. Personal interview

4. Follow-up interviews

It is smart to treat each step as separate and distinct. There may be rare occasions when a firm might choose to make an offer without going through each stage separately. Nine times out of ten, however, there is more to be gained by the slow, conservative approach than by rushing to make an offer.

1. Portfolio review

One good thing about the graphic design field is that so much of what a designer does can be seen, so it is relatively easy to evaluate a candidate's level of design talent. Design principals need no instruction on evaluating the quality of a portfolio. But there are some guidelines to bear in mind relative to the portfolio review:

Remember that the portfolio review is only step one in screening *candidates* for a job; it is *not* the time to make an offer, or even to do much in the way of a personal interview. Ask only those questions that pertain to the portfolio itself. Ask questions if you need information to explain what it is you are looking at, but try to limit your questions to those that help you evaluate what the applicant actually did or did not do on the pieces shown. Once you are satisfied that the candidate looks as if he or she has the design skills to do the work, move to the next stage: checking references.

The portfolio only shows what the candidate has *done,* not necessarily what the candidate is *capable of doing,* given the right training and environment. This information can best be evaluated in the next stages, the obtaining of references and the direct interviews.

The portfolio review is the time to have the candidate fill out an employment application. This way you will have information to use in checking references. Most applicants will provide you with a résumé when they show you their portfolios. Résumés are useful; they should be attached to your own application form, but they should not replace it. By asking each candidate to fill in your own application, you set your own priorities of information. And you have a consistent way to review the information and compare candidates.

If a job *is* available, and you decide, based on the port-folio review, not to consider an applicant for it, avoid the strong temptation to tell him or her right then and there. Always ask candidates to fill out an application and politely and graciously tell them that you will let them know in a few days—and do so. Have some standard letters ready for such occasions.

This is not only good ethics, but it's the best legal protection against charges of discrimination. In your letter, you should always say that the job to be filled didn't match up well, in your opinion, with the applicant's samples. *Never* say that the applicant wasn't suitable for your needs.

If there is *no* job open at the time, but you would be interested in the candidate, should a job open later, say so. Encourage good candidates to stay in touch and let you know where they can be reached in the future.

If there is *no* job open at the time, and the candidate doesn't appear to be one you would ever be interested in, merely tell him or her right away that there is no job open right now, but you'll be in touch should a suitable one be open later. Under no circumstances should you say any more, regardless of how hard the applicant presses for more information. *Don't* pass judgments on either the work or the person. Don't be tempted to give advice. It can't do you any good and can get you in trouble if handled poorly.

2. Reference check

After an applicant is identified as a good candidate, you should check at least three references before granting a personal interview. You need to do a lot of research if you expect to be able to conduct a good interview.

What you're trying to find out from the references is how well the candidate will fit into *your* situation, not how he or she fit into *theirs*. You can't assume because they say the person was terrific for them that he or she will be equally good for you. On the other hand, just because the candidate didn't fit in well at one place doesn't necessarily mean he or she won't fit in well at another.

Most personnel problems stem not from hiring people who can't do the design work up to standard, but from hiring people who are psychologically incapable of working well with the people they are required to work with. Few personnel problems are harder to handle than employees who are competent on the boards, but who constantly anger their co-workers, clients, and bosses. It is far better to identify these kinds of workers in advance and not hire them, regardless of how good their portfolios may look.

When questioning former employers, you should be trying to learn almost as much about them as you do about the candidate. What kind of work do they try to do? What is their approach to design? What is their work environment like? Ask yourself, "If I were in the candidate's shoes, would I have been happy and productive?" Other things you should be trying to find out from references are such things as how candidates handled pressure situations. Did they get more or less productive? Did they panic? Did the work suffer? How do they respond to criticism? Are they subject to great mood swings? Do they hold things in and harbor resentments, or are they direct and eager to get things off their chest? Are they basically pleasant and good-natured, or will they be grouchy and difficult for others to work next to?

3. Personal interview

Following the reference check, the initial interview is the next place to weed out those candidates who will be troublemakers, whose long-term interests don't match yours, or who merely don't match up well with your present needs.

The key to a good interview is getting them to open up and do most of the talking. The more you talk, the less you'll learn about them. Keep your remarks limited to asking questions, not pontificating about your design philosophy or describing the job in detail. That will come later. Ask them questions that will require them to express personal points of view and which reveal their own experiences and attitudes. Answers like "yes," "no," or "I like to do posters" don't tell you what you need to know. Build your interviewing vocabulary on phrases like "Tell me about...," "What do you think of...," "Why was...," "What if...," and so on.

You want to find out if their long-term goals match up well with yours—for their sake as well as yours.

You should also be examining them for possible personality problems. Are they unusually tense? Everyone will be nervous to some extent in an interview, but is their nervousness out of proportion to the situation? Are they unrealistically and perhaps dishonestly enthusiastic? Could this indicate a personality subject to extreme shifts of mood? Are they too wooden? Do they listen well? Make a statement calculated to elicit an

emotional response, and make a statement you know they'll disagree with. Do they disagree politely and matter-of-factly? Do they disagree at all? Save these questions until the interview has reached a level of easy, relaxed discussion. Otherwise the answer might only indicate a candidate's need of a job and their unwillingness to jeopardize the chances of getting it.

Try to avoid answering questions about the available position until the later stages of the interview. If an interviewee proves to be promising, you'll want to glean from him or her as much as possible to determine what part of the job would be most appealing—and it's best to get the information before you outline the position. In addition, you'll be wasting time describing the job should you decide not to move the interviewee into your final group of candidates.

Toward the end of the interview you'll decide whether the candidate belongs in the prime group. Should you decide not to consider any of the candidates for the job that is open, follow the same procedure as you did at the portfolio review stage—send a letter in the mail. If there is no job open at present, politely tell the candidates right away that you will get back to them if or when a suitable opening develops.

If you are interested in an interviewee, the end of the interview is the time to give some information about the job available. Make sure, before you start the interview, that you have all your facts together about your firm and the job itself.

Obviously the candidate will want to know what his or her tasks and salary will be and will, in all likelihood, also want to know something about your firm's benefits, what kind of growth to expect, what will be expected of the candidate, how many people he or she will be working with and be responsible to. The candidate might also like to see what the place looks like and where he or she might be working.

4. Follow-up interviews

If there is a mutual interest in pursuing the process further, you should then offer to set up some appointments for the candidate to meet other people in your firm. Try to arrange these as soon as possible. Furnish each person meeting the candidate with a complete summary of the candidate's qualifications, the job he or she is to fill, your own impressions and those of the people who gave references. You are not obliged to mention any salary or benefit details to those doing the interviews, unless you want these details to become common knowledge, as they surely will. Try to fit the interview sessions into strict—and short—time frames. Urge each interviewer to concentrate on his or her own range of likely interaction with the candidate, to spare the candidate having to answer the same questions over and over.

Make clear to those conducting the interviews that they are not to use the interviews to wash dirty laundry or make speeches about how they would prefer to see the firm operate. Their role is to listen, answer the candidate's questions politely yet carefully, and give you their impressions.

Schedule yourself for the last interview. Use this time to clear up any uncertainties or questions the candidate may have. Tell the candidate you will get back to him or her in writing in a few days.

Talk to your people and decide which of the candidates, if any, you wish to make an offer to. Then frame a letter to that candidate and that candidate only, which details as precisely as possible the job you are offering and specific terms of the job.

If the candidate accepts your terms, this letter is, in effect, a valid contract. So be prepared to live with it. You might want to have your first job letters reviewed by your lawyer before you send them, as there are any number of tricky issues to address. For example, should you make an offer in which only a yearly salary is mentioned, with no review period or escape clause also mentioned, you could be held liable for an entire year's salary if you discover after several months that you've made a mistake.

If your firm has a work contract, candidates should be informed of this in your letter. If you hire a person and later ask him or her to sign a work contract, it could be worthless, even signed for the courts would probably recognize the conditions of duress under which it was signed—the implied loss of job already held.

Do not send a letter to your second or third choices until your first-choice candidate has either accepted or rejected your offer. If he or she has accepted, send a letter out promptly to other candidates simply stating that, although they were among the final few candidates for the job, your people ultimately decided that the requirements of the job didn't match their skills quite as closely as another candidate's. Add that they would certainly be strong candidates for a similar job in the future, should an opening occur, and for this reason you would like to stay in touch.

File their names away for future consideration.

GOOD MANAGEMENT ALSO INCLUDES
FIRING WHEN NECESSARY

All business owners invariably have to fire someone someday, unless they are incredibly lucky, are always absolutely right in their judgment of both human beings and business shifts, or prefer to remain blind to the obvious.

For most of us, firing an employee is one of the most painful and difficult aspects of running a business. No one enjoys it. Small wonder most owners try to delay it as long as possible. Few people like to admit they made a mistake or to hurt others. Furthermore, very often many of the signs that might indicate the need to fire an employee or employees are ambiguous and difficult to recognize.

Employees get fired for one of two reasons: The business is not doing well and can no longer afford the overhead, or the business is doing well, but might do better with other people.

In the former situation, after all other alternatives to reducing overhead have been thoroughly explored, the reality that must be faced by both employer and employee is that, unless the firm begins to show profits, the jobs eventually will be gone anyway. Delaying the inevitable helps no one, while moving swiftly to reduce expenses is often the difference between being able to get through bad times and not.

In cases where an employee has clearly not been performing up to stated goals and expectations for a long time, too often one action of the employee so infuriates the owner or manager that the employee is fired impulsively and in anger. This is the worst way to handle the separation, both for employee and employer. For the employee, it can be devastating and unkind. For the employer, it can cripple morale by sending all other staff members the wrong message. They will tend to perceive the owner as short-tempered, arbitrary, and immature, which will make them feel insecure. If the firm acquires a reputation as a place where people are often fired abruptly, it will be very hard to attract good people. Furthermore, an emotional firing exposes the owner to charges of discrimination, which can be expensive and time-consuming to defend against.

If someone must be fired, the firing must be done as fairly and as humanely as possible for everyone's sake. What is the right way to fire someone? Even more important, how do you know when you should fire someone?

To answer these questions you should have a clear understanding of what is expected of you as owner and what you should expect of yourself.

As owner/manager you have an obligation to all your employees, including yourself, to make their jobs as secure as possible; to ensure their future and your own by guiding the firm surely and steadily in the right direction; and to give your employees the opportunity to make the most of their abilities and skills. Anything less would be wrong.

Your people expect you to reward good performance, not bad. By not rewarding good performance quickly and clearly, you encourage bad performance. By accepting bad performance, you reward it. Unrewarded good performers will soon leave to seek more promising opportunities, leaving you with only those who won't or can't perform.

If the deciding factor in who goes and who stays is to be performance, then it is incumbent upon the owner/manager to spell out clearly to the employees exactly what performance means.

Some measures of performance are true of all businesses and obvious—doing jobs correctly, meeting deadlines, working cooperatively with co-workers, giving a full day's work for a day's pay. In the graphic design business, however, performance can also be measured in purely aesthetic terms, which cannot be clearly defined. Often this is a more important measure of an employee's value. An employee who does everything else right, but can't measure up to the aesthetic standards of the firm, is a weak link and a serious threat to the firm's future.

When faced with an employee in that category, the owner/manager has three possible courses:

1. To educate the employee so that his or her work will improve and be brought up to standard. This should always be the first choice. The owner/manager should set some clear goals and definite time limits for reaching them, in order to have a way to measure progress.

2. To encourage the employee to pursue his or her own vision of what is good design until one of two things becomes clear: Either that the employee's interpretation is at odds with that of the design firm and should be pursued elsewhere; or that the employee's approach, while different, can nevertheless be useful to the firm. This course may be worth taking when it appears that a designer's solutions are not what yours would have been but are still professional and efficient.

3. To fire the employee. This course should be taken only after it is crystal clear to the employee that every effort has been made over a reasonable length of time to both train him or her and to permit personal growth.

Long before any decision is made to fire someone, the owner must be very careful to keep a record of each and every meeting with employees regarding their performance, including what was said and who was present. Send a copy of these notes to the employees and put copies in their personnel folders.

Should any problems arise which could require firing an employee, you must have good documentation of the events leading up to the dismissal to protect yourself against charges of discrimination. If you have been meeting continuously with the employee, your dissatisfaction should come as no surprise and neither should a decision to fire him or her. If your dissatisfaction is a surprise, you haven't been communicating as clearly as you should have been.

Once you make the decision, get the job over with as quickly and humanely as possible. Don't drag it out. Set some kind of policy regarding separation pay—the standard is two weeks minimum, but a week's pay for every year worked, with some maximum you think is reasonable, would be fairer for someone who's been working for the firm for a long time.

Bring the employee into your office. Tell him or her right up front what you are doing. Be considerate of the person's feelings. Discuss what he or she would prefer others be told. Don't get into disagreements over whether what you are doing is right or wrong, fair or unfair. Whichever it is, it is your decision to make, and you've made it. You will never be able to convince the person it's for his or her own good, even if it is. So don't try.

Make sure that any benefits or opportunities due the employee are discussed, including such things as any profit sharing or pension due the employee, any insurance or medical benefits that could be continued and so on. Try to ease the economic blow on the employee and his or her family as much as possible. The employee didn't twist your arm to hire him or her. You share the blame for making a wrong decision in the first place. Don't make that person alone shoulder all the penalties.

You could let the fired employee continue on the job briefly to finish work already started, if it won't cause too much of a problem with the other employees. As a general rule, however, a fired employee should leave as soon as possible. The others will have to be told, and it's better for you if they get the news directly from you, not from the fired employee or via the grapevine.

GETTING GOOD PERFORMANCES
Managing a staff of creative people places design firm principals in the peculiar position of trying to predict the unpredictable, to control the uncontrollable, to set a price on the priceless.

For this reason, it is even more important that design firm principals find ways to control and measure the performance of their staffs.

There are certain basic guidelines to bear in mind when trying to manage a creative staff:

1. At some point in the process of being creative, a typical designer will have to revert to a childlike state of being emotional, impulsive, and intuitive. During this state, he or she is likely to be a royal pain to others. Leave your designers alone. Don't force them to be both a planner and an analyzer at the same time. Learning to defer judgments while trying to create new ideas is the secret to being both prolific and original. Allow them to use their own judgment as to when to change roles.

2. Creative people need rewards and attention more than most people. Any attention at all is a reward. If they can't get these rewards by good performance, many will get them by bad performance. If your managerial style is to expect good performance as routine, but to criticize bad performance strongly, you are rewarding only bad performance with your attention. Bad performance will continue, because the attention it draws is better than no notice at all.

3. To improve performance you will have to define what performance you want to improve and be quick to reward any improvement, no matter how slight.
 For each of your employees, identify which of their shortcomings you regard as the most important one to be worked on—and work only on that one. Give suggestions; be patient. Rejoice with them over percentages of progress. Help them measure their progress. Think of yourself as a coach, not as a boss.

4. Keep people busy! Designers have a habit of working to the outer limits of any time restraints or budgets given them, so you're far better off being slightly understaffed than being slightly overstaffed. Get your staff to agree to deadlines and budgets for each mini-task rather than for the overall job. Don't tell them they have 40 hours to do the whole job; ask them when they can get the preliminary roughs to you. If they say four hours, ask them if it's possible for them to do it in three. Create a small sense of urgency on every task. Give them two or three projects to handle at one time. Don't let them get the idea that missed deadlines are what is expected, but tell yourself that an occasional missed deadline, when properly handled with the client, is not a monumental disaster.

5. Managing meetings: You will hold meetings for two reasons: to give or receive information, and to give or receive inspiration.

Information meetings tend to be most successful if kept small. In a large group of people, considerable time is wasted in role-playing—in trying to look smart (or at least trying not to look stupid). The human dynamics take precedence over conveying the hard facts you need to help make decisions.

On the other hand, there is probably no better instrument for creativity than a wild, fire-breathing, kickdown-the-doors, no-holds-barred brainstorming session. Toss a bunch of creative types into a room, throw in some food, tell them they've got three hours to come up with an answer to a problem, lock the door, and don't come back for three hours. I guarantee you the walls will be scorched with the creative fire generated during those three hours.

Try to use meetings with more than one person more as *creative playgrounds,* not reporting instruments. Try to get your hard information in private, one-to-one meetings. If you want to find out where a project stands or what went wrong, ask the same questions over and over again of different people within the company. They'll all give you different answers, but somewhere, hidden within the answers, you'll get the real truth.

Encourage your project managers to give you the *bad news* first. Make them understand that, for the most part, bad surprises will threaten your business most—and consequently their jobs. Don't discourage them from giving you the truth by trying to find someone to blame when things go wrong. Concentrate on looking for ways to fix the problem.

DELEGATING

Graphic designers, like most people, only have two arms and one head, which means that the only way they can handle more than one job at a time is by delegating some of the work to others. The more they can delegate, the more they are free to work on other jobs and other problems.

So it's for their own good that designers learn how to use free-lancers and develop good assistants. The ground rules are different for each.

When you hire free-lancers you really have no interest in whether or not they grow or don't grow. They have only been hired for one specific job. When the job is over, they are history until you hire them again. Your only obligation to both them and yourself is to help them get the job done quickly and well and to see to it that they get paid fairly and promptly.

But the same can't be said of an assistant. Assistants who don't grow to the point where they can relieve you of more and more tasks are not what you need. And they cannot grow without a lot of help from you.

There are dozens of books that have been written on the subject of managing employees, and most of them basically say the same thing: Give your people as much responsibility as they can handle and then keep giving them more.

There's nothing wrong with this advice, except that it doesn't work very well for graphic design firms unless the design firm principal who is doing the delegating accepts some rather difficult truths.

Hand skills can be delegated. Project management—watching the budgets and the schedules—can be delegated. Even client contact can be delegated. But art and creative vision cannot be delegated. If you hire designers to solve problems, don't hand them your solutions and also expect them to grow and be able to help you. Instead you'll have to turn over *problems.* You'll have to let them make *decisions.* Give them the freedom to work their way, not yours. Suggest methods, not answers.

Educate them to your objectives: serving the customer; making a profit. Set the example, and let them figure out the ways to follow your example.

Find ways for them to compete with each other, but make sure the competition stays focused on the jobs, not on the people themselves.

The bottom line is that by really having their best interests at heart, you'll be serving your own best interests. Ask yourself, "How good is your word? Would you work for you?"

Managing Time and Paper

Most graphic designers put in long, tough, and lonely hours. The 18-hour work day is not uncommon. Yet despite all this hard work, most design firm principals are barely scratching out a living.

The reason is seldom lack of design ability. More often, it's the inability to manage time well. In most businesses, profitable performance and successful time management are closely linked. In the graphic design business, the linkage is as close as Siamese triplets in an airplane washroom.

Frankly, much of the inability to manage time is a self-induced affliction. Too many designers wear their disorganized, undisciplined behavior like a badge of honor, an official certification of their artistic credentials. They fall under the sway of the popular but totally false idea that control and creativity are mutually exclusive qualities, and that an obvious deficiency of one signals an abundance of the other. In a profession based upon tangible results and measurable performance, this notion is downright stupid.

In point of fact, a graphic design studio's profits are a direct reflection of how well they use or abuse their time. If the principals can estimate their time accurately and perform the necessary tasks in roughly the time allowed for, their studios will show a profit.

The difficult part of time management is having to change bad personal habits. Most human beings would rather believe nonsensical ideas and dangerous myths than confront their own worst enemy—themselves.

Dangerous Myth #1: Using time well means putting in hard work and long hours.
Wrong. Being effective has nothing to do with how fast you are pedaling the bike. It has more to do with whether or not the wheels are on the ground.

Dangerous Myth #2: Pressure is a necessary ingredient in quality work.
Wrong again. There's nothing that a good designer can do under pressure that he or she couldn't do if they didn't put themselves in a pressure cooker. The strong possibility of serious errors cropping up in the job are hardly worth the momentary high that the designer gets from performing at high-pressure level.

It's far easier to believe that you cannot change the way you are. Reforming bad habits is hard work that doesn't yield results easily. But the potential benefits, both emotionally and financially, are worth the pain and aggravation. When doubts set in, take hold of the following truths, which happen to be self-evident.

Self-evident Truth #1: Time is precisely measurable and finite.

You can't add hours to the day; but you can make the hours you have more productive.

Self-evident Truth #2: Every hour that isn't being used to make money is costing you money.

This is not a case for sweatshops or personalized nose-grindstones. It is a reminder that time really is money; that doing work yourself is wasteful if you can teach someone else to do it more cheaply; and that doing work that doesn't pay you what you're worth doesn't help you get work that will.

TOOLS AND SYSTEMS

The first step in time management is the mental commitment to doing it. Once you've taken that step, there are a host of tools and tricks to help you do it. Although the tools and systems vary, all have certain common objectives.

The ideal system does the following:

1. Helps you plan and prioritize your personal time.

2. Helps you plan and monitor the time and work of others.

3. Helps you deal with information and correspondence.

To turn available time into productive time, you must develop a system to prioritize the tasks on your agenda.

The tools you will be needing to plan your personal time are:

1. A small notebook

2. A small tape recorder

3. A large planning book

4. A daily "to do" worksheet

THE SMALL NOTEBOOK AND TAPE RECORDER

I used to be one of those people who walked around with dozens of odd-sized pieces of paper in every pocket. Any time I needed to make a note of something, I would search through my pockets for a handy piece of paper and write the note down on whatever I found. Needless to say, when it came time to retrieve and act on these notes, I couldn't find half of them.

Then one day, while I was going through my paper-searching act in front of one of my friends, he asked me, with some amusement, why I put myself through all this. Why didn't I just carry one notebook instead of all those different pieces of paper? I looked at him for a moment, stunned and embarrassed. Finally I had to answer that it simply had never occurred to me.

I stopped in the next stationery store I passed and bought a small memo book. Using this memo book, and the dozens that followed it, did more to organize my time than anything else I have ever done. I carried it with me at all times—to work, to the bathroom, to the night table at bedtime. Anytime a thought occurred to me, I immediately jotted it down. Anytime I was given an instruction or request, I wrote it in the notebook. I always knew where to write a reminder. Even more important, I always knew exactly where to find what I had written.

Things improved for me dramatically and immediately. But there was still one problem in this area that I had to deal with. Like so many other business people, I spent a lot of time in my car, traveling back and forth to work and clients' offices. Since I'm one of those weird people who has a hard time driving and writing at the same time, I usually just tried to remember what it was I had thought of as soon as possible after I stopped the car, and I wrote it down in the notebook. Naturally, my best thoughts somehow never made it into the notebook. Then one day, I discovered the twentieth century. I bought a small tape recorder. I made it a habit, as soon as I got in my car, to remove the tape recorder from the glove compartment and place it on the seat next to me. Whenever I thought of something that I normally would have written in my notebook, I recorded it on tape instead. Back in the office, I could either play back the tape and jot the words down myself in my planning book, or turn the tape over to a secretary to be transcribed and typed, after which I transferred my notes to my planning book.

THE LARGE PLANNING BOOK

The small notebook and tape recorder help you retain and retrieve your thoughts and memos. By themselves, they can't help you become more productive. You also need to plan ahead.

To do this, you will need a large planning book. It should have room enough to write numerous notes on each date, and scope enough to allow you to plan weeks and months ahead. Every stationery store has dozens of such planning books.

THE DAILY "TO DO" WORKSHEET

The last tool for prioritizing your time is a worksheet of tasks to be done each day. The tasks should be divided into "must be done," "should be done," and, "would be nice if they were done" categories (or any other, 1,2,3/A,B,C, etc. designations you care to use.)

HOW TO USE THE TOOLS

The four planning tools work interactively. I've already described how the small "everything" notebook and tape recorder work. They are used to help you record and retrieve information and ideas. The large planning book is not merely an appointment book, although it is also used to record appointments. The book is your complete planning instrument.

To use the planning book, start by filling in all the tasks and time slots that are unbendable. I teach class every Monday and Tuesday evening from 5:30 to 8:00, for example. So these are time slots I start with.

Next I try to identify the most pivotal tasks or activities and add them to the schedule. Pivotal activities are those activities which you can do that will create work for many people, affect a small number of people for a very long time, or supply a crucial piece of information to your firm, such as what your present overhead percentage is.

These pivotal activities are penciled in, along with the estimated time it will take you to do them. All other less crucial tasks are added to fill in the spaces. It's wise to add about a 25-percent contingency factor to the time allowed for each task. Don't forget to add in time for planning and time for resting.

Plan to do your most important jobs during those hours when you are most alert. If you are not sure which hours are your best, try different ones.

The bottom line is that if you haven't allowed any time in your schedule to do the work, it's a pretty safe bet the work won't get done at all.

After you've identified the long-range tasks, set down those that must be done that day on your daily "to do" list, in order of priority.

Do the first one first, the second one next. If all of them don't get done by the end of the day, don't sweat it. If you're always concentrating on the most pivotal jobs first, at least the jobs that do get done will be the most productive ones.

When planning your schedule, try to identify the tasks that interest you most, that could possibly be delegated to others, or that are an unproductive use of your time.

SUPERVISING EMPLOYEES

There are only two ways a graphic design firm can make more money—by handling more jobs or by charging higher prices. Unfortunately, the ability to command higher prices is dependent to a large extent on factors that the firm can't control, such as how much in demand the firm is. The ability to handle more jobs, on the other hand, is strictly within the power of the design firm itself to control.

Increasing the amount of work will require finding ways to increase sales. But it also means that the firm will have to find a way to spread the work load beyond the principals—they'll have to learn to train and to delegate.

As sensible as this simple fact of life seems to be, an awful lot of design firm principals seem to make it their life's goal to resist delegating. They are afraid that the quality of their jobs will suffer. They are afraid that they'll lose control over their jobs and their business.

Good delegating begins with surrounding yourself with the right people. But even the best young designers need experience and training to provide you with real help. You must create systems and routines for them to work within that make life easier for you. You must specify precisely how you want your work to look; how you want your office to run; what your standards are. It doesn't make sense to reinvent the wheel for every task in your shop. Standard procedures help you avoid this.

Demanding strict adherence to standard procedures must not be viewed as putting designers in straight-jackets. It is simply good communicating. Like it or not, in the long run their future growth in your firm will depend on how well they live up to your standards and how much you are willing to trust them. So it is only fair to them that they know what the ground rules will be from the outset.

TOOLS OF DELEGATING

In the chapter "Managing People," beginning on page 77, we discussed the techniques of delegating. In this chapter we want to focus on the tools of delegating. These are the tools you will need to help you delegate and monitor the work of others:

1. Individual files for each person you work with

2. Individual files for each project

3. Your large planning book

4. Time sheets for each person

Any time you think of anything that relates to one of the people you work with, make a note of it to be filed in that individual's personal file. If the note relates to a specific project, file it in the appropriate project file. If the note refers to something you have to check or follow up on later, log it in your planning book to serve as a "tickler file."

Time Sheets

Time sheets are monitoring tools that are very familiar to most designers. They are vital to the bottom line; a design firm's profits begin with time sheets. If a designer's time isn't recorded at all, or is recorded sloppily, or is recorded too late to be billed, the firm will not be paid for the hours it has spent on a job. Worse, problems that may be occurring can go undetected until it is too late to correct them.

You must find a way to help your design staff attach real value to their time sheets. This cannot be emphasized too strongly. I've even been told of some design firms that hold their designers' car keys for ransom until completed time sheets are turned in. Perhaps that's a bit extreme, but somehow you must make your designers realize that profits help the designers, and that profits can't be earned unless the firm is paid for the designers' time.

Time sheets have another vital function. Good time records help build historical experience that improves your ability to estimate accurately on future projects—not only how much time a job may take, but what levels of experience should be involved, and who should be involved. Bad record-keeping, in contrast, could have disastrous results in estimating future jobs.

DEALING WITH INFORMATION AND CORRESPONDENCE

Handling information and mail can be aggravating and time-consuming. Don't let it be.

There are only four things you can do with any piece of information or correspondence:

1. Take action.

2. Pass it on to someone else.

3. File it.

4. Throw it out.

The first thing to do with any bit of information is to decide whether to keep it at all. Don't be afraid to be ruthless with junk mail or useless information. Both provide a ready excuse for procrastination. Don't yield to temptation. Your time is your most precious resource. You charge your clients enough for it. Don't charge yourself less.

Before you read or spend a lot of time on anything, junk mail or otherwise, decide whether it will be worth your time at all. If it can't inform you, make money for you, or relax you, don't bother with it. Chuck it in the circular file.

If you decide the information or correspondence is useful, get it on paper, if it isn't already, and separate it into one of the other three categories, using three bins or baskets. It is best merely to sort, not to make decisions, on the initial pass-through. While it may seem like a waste of time to pick up the same pieces of paper twice, and while some people prefer to make these decisions as they go through the sorting process, I believe that sooner or later you'll reach a piece of paper that will get you involved, hang you up, and slow you down. One exception to this rule: If someone else's work is held up until you take action, do it right away and drop that item in the "pass on" basket.

Information or a letter that requires an answer from you goes in the "act on" bin. If no reply is necessary, either pass it on for someone else's information, file it, or trash it. Put magazines and newsletters into the "act on" bin. Reading is an action.

Once your papers are sorted, return to the "pass on" and "file" bins again. Dump the entire contents of one bin on top of your desk and work your way down through the pile, piece by piece, putting the pieces back into their proper bin as you finish with them. Don't be afraid to change your mind about which bin they belong in. After you finish with one bin, start on the other.

If you have a piece to be passed on, write the name of the person or persons who are to get it right on the front of the piece itself, with an appropriate note from you.

If it is something to be filed, write the category it is to be filed under right on it, and toss it back into the "file" bin. Remember, *you* should be choosing the filing categories, not delegating this task to someone else to do. They are your files, and you have to be able to retrieve things from them quickly.

After you have been through the "pass on" and "file" bins, pick up the entire "pass on" bin, distribute its contents immediately. You owe it to others not to delay their ability to act on your requests too long. Wait for some later down time to do the filing.

Next deal with the "act on" bin. Dump it all out on your desk and separate the magazines, newsletters, and other such material from the pile. Put them on the bottom of the pile or in a holding area or bin. Work on all the rest of the mail first. Look through the mail with an eye to identifying all items that can be dealt with quickly and easily, such as "thank you" notes that have to be written and such. Do so immediately, right on the original sheet of paper. Next go through the pile to try to identify the most important tasks. Put all the rest of the papers back into the "act on" bin and put the important papers right on top.

Try to get rid of these first, then move on to the others. If you find you really can't act on something either because you need more information or you have to meet with someone else who isn't available yet, keep putting it back in the "act on" bin until you can get rid of it later. Flag the piece of paper somehow so that it gets moved up into a higher-priority category.

If some piece of information or mail demands a very large chunk of your time to act on, such as a detailed compensation plan, for example, slip it into a "holding" bin reserved for such items. Make sure you block out some time in your planning schedule to take care of such items, based on when the item is due, so that working on it doesn't fall through the cracks.

After you've gone through the important items in the "act on" bin, or when you decide to take a break, tackle the reading material. Quickly skim the magazines. Look for articles that you want to read or file away for further reference. Tear them right out of the magazines or make photocopies of them. Put the tear sheets or photocopies in a folder, and put the folder in your briefcase, which you should keep open by the side of your desk all day for just such a purpose. Anytime you get a few odd moments, pull out your "to read" folder and catch up on your reading.

Managing Money

W hat's the best way to show a profit in your business? The answer is simple. Some might even say it's simple-minded: Spend less than you make.

That is easier said than done. To spend less than you make, you must know exactly how much you have already made, how much you can reasonably expect to make in the next days, weeks, and months, how much you have already spent, and what you are obliged to spend in the near future.

The process of keeping this financial history and making projections of your financial future is called *accounting*.

One compelling reason for accounting is simply to keep from going broke. A second, equally compelling, is that banks, the IRS, and other governmental or institutional bodies expect you to provide precise proof of your fiscal situation whenever you have to deal with them. This is where your good friend, your accountant, comes in, the one to whom you must turn for advice on the best way to maintain your records.

In a previous chapter I advised you to find out which accountants were already working well with some design studios, and to find opportunities to try them out in small ways. If you have not yet begun to search, begin.

YOUR BOOKKEEPING SYSTEM

Your accountant will advise you on the details of setting up a good bookkeeping system for your business, but there are some general words of advice I would like to pass on.

1. CASH IS MORE IMPORTANT THAN PROFITS.

This means: Bill your clients fast, bill them often, and get as much money up front as possible. Use your client's money to make money, don't let them use yours. They have more of it than you do.

2. DON'T DO YOUR OWN BOOKKEEPING.

There are four people who could keep your books for you working either full or part time:

A CPA (Certified Public Accountant)

Someone who has been certified by the state to do this kind of work.

An accountant

An individual who can do the same work, but hasn't been certified by the state to do it. This usually means he or she costs less, but it doesn't necessarily mean the job will be less accurate.

A family member

Preferably one who can get all numbers right most of the time. A family member who has taken a bookkeeping course would be even more preferable.

A bookkeeper

Someone who can get all the numbers right and also understands what an accountant says, which isn't always easy.

One person, you'll notice, is conspicuously absent from this list. That is yourself. Of course, you should be deeply involved and interested in your firm's financial information, but you should not do your own bookkeeping. Your time is better spent as a profit center than as dead overhead.

Most designers know how to set a value on design and production services. But when it comes to financial services, many haven't a clue as to how to figure out what information they really need. Some designers may pay too little. As a result, they may not get enough information or the right kind of information. Or even worse, they might get totally inaccurate information. Others, recognizing how little they know about finance, will go to the other extreme and pay for far more information than they can possibly use.

Use your accountant or bookkeeper as an adviser, as a detective, and as a critic. If your firm is large enough to need these services full-time, then by all means put someone on your staff. Otherwise, contract for on-call services only.

The first on-call service you could contract for with your accountant would be advice on how to set up your system. To do this, your accountant will need a lot of information about you, your finances, your goals, and how you intend to operate your business. If you've already had the good sense to find a CPA or accountant who understands the needs of graphic design businesses, the job will be easier, and consequently, less costly.

Whichever system he or she recommends, it should be simple to use, easy to understand, accurate, and above all capable of providing you with the kind of information you need when you need it.

3. LET CHARLIE DO IT, BUT GET MARY TO WATCH CHARLIE—AND YOU WATCH THEM BOTH.

Remember, if something goes wrong, Charlie and Mary may lose their jobs, but you might lose everything you have, or even end up in jail.

For example, require two signatures on all checks. This reduces the chances of problems cropping up. Sign as many checks as possible personally. If you are out of the office a lot and can't sign every check, have a designated stand-in—but only if you first make it clear to that person exactly what you expect from him or her: A thorough understanding of the reason for every check he or she signs, and an instant alert of every problem he or she sees before letting the check go out. You might also consider making an arrangement with your bank that limits the amount that it will cash for your stand-in.

Also, don't forget to bond anyone who will be signing checks for you—anyone. Even the closest and most trusted people have been known to do some strange things where money is concerned. (Read Graffito's cautionary tale on pages 170 to 173.)

4. ALWAYS KEEP YOUR MONEY IN SEPARATE POCKETS.
Your clients may think that you and your firm are one
and the same, but you should never think of your
money that way. Think of your firm as someone who is
paying you a salary to handle his or her finances and is
holding your children hostage to see that you do it
right. You wouldn't put your money into this person's
checking account, would you? Don't do it! You would
be extra careful and prudent with his or her money,
wouldn't you? Do it!

5. DON'T LEAVE MONEY LYING AROUND, DOING NOTHING.
Put it to work as fast as possible. Every day you miss
represents lost money to you.

6. IF YOU HAVE A NUMBER OF PROFIT CENTERS,
THINK OF THEM AS INDIVIDUAL BUSINESSES.
Each of them should be monitored and measured by
what they cost and bring in individually. If you lump
them together you'll have a hard time evaluating their
performances.

7. NEVER FORGET THAT YOUR ACCOUNTANTS WORK
FOR YOU. YOU DON'T WORK FOR THEM.
If you can't understand the numbers, or if your reports
aren't giving you the kind of information you need,
don't be afraid to ask your accountants to change their
system to accommodate your needs. That's what you're
paying them for.

8. WATCH THE PENNIES AND THE DOLLARS WILL
TAKE CARE OF THEMSELVES.
For a design firm, this means look less at the big pic-
ture and more at each project individually. A design
firm lives and dies on whether or not it has enough pro-
jects to keep its employees busy, and (even more impor-
tant) whether or not it makes a profit on each of those
projects. You don't want to be in the position of losing
a little bit on each job, but making up for it in volume.
Design your accounting system to feed information
back to you as fast as possible about the financial sta-
tus of each project.

Make certain that your systems are structured to
receive all records of time, things paid for already, and
things contracted to be paid for in the future, as
quickly and as accurately as possible. If the information
doesn't get in fast or isn't accurate, either you won't get
it out in time, or it will be wrong.

Try to set up a system which automatically and quickly
flags those projects that are 10 or 15 percent over
their estimated budgets. If your system isn't structured
to isolate and identify this information, it probably
needs to be revised.

If all project managers are consistently going over their
budgets, the problem may lie in your firm's contracting
or estimating procedures, your firm's ability to track
additional work requested by the client, or any number
of basic internal procedures. If only a few are exceed-
ing their budgets, the problem may lie in their lack of
experience or knowledge of proper procedures. They
may be overworked, or they may be sloppy and disor-
ganized themselves.

9. IF YOU CAN'T PREDICT YOUR INCOME MORE THAN
A MONTH OR TWO AHEAD, YOU'VE GOT A BAD SALES
PROGRAM.
In order for a business to grow and be healthy, it can't
wait for trouble to jump up and bite it. It has to be able
to anticipate and plan. Owners who operate by "feel"
are usually owners whose business is running them. As
long as industry and economic conditions are good,
problems are hidden. When things turn bad, these
owners don't "feel" it until their competitors have
already blindsided them.

It isn't too difficult to predict expenses. Income is
harder, but just as necessary, if you want to survive.
You've got to work just as hard in setting up long-range
sales projection procedures as in setting up historical
number-counting procedures.

10. KNOW THE DIFFERENCE BETWEEN "CASH BASIS" ACCOUNTING AND "ACCRUAL BASIS" ACCOUNTING.

You probably should use the accrual method; otherwise, you should probably use a cash basis until you learn the accrual method.

A cash-basis method is pretty simple. It is set up to keep track of only the actual physical dollars and checks you take in or pay out—just like your own personal checkbook.

Because most design firms do most of their business on promises to pay or be paid, a strictly cash basis doesn't really reflect the actual financial status of a company. An accrual basis does. It forces you to record each and every time you contract either to get the cash and checks you pay out or take in. These have to be recorded as either increases or decreases to the promised monies. You can already see, in this oversimplified description, that the accrual basis is a far more complicated process that will demand more of somebody's time to keep up with. But, if you have the money, it will be well worth it. It's the only way you'll be able truly to measure your firm's financial health.

11. COMPUTERIZE YOUR ACCOUNTING SYSTEM, IF YOU HAVEN'T ALREADY.

Be sure the system you use is designed to work for you. A computerized accounting system, by its very nature, is designed to apply to a lot of businesses in a general way. Until you understand how your system should work in order to give you the information you need, you're not ready to make a decision on software or programming. You want a business and a system that make you master of your fate, not a slave to it.

The standard advice once was to design a manual system first, then computerize it. That may be outdated today. Inexpensive software packages on the market today are simple to learn, and an individual without much accounting experience can operate them with more ease and speed than a manual system. Often these packages have safeguards that prevent you from making certain kinds of errors, and many guide you step by step through the necessary procedures. The better advice today might be to begin with a prepackaged software program, try it out, learn what you can do with it, then adapt it or another system specific to your needs.

THE BOTTOM LINE

When all is said and done, being in business revolves around one thing: making money. Profit may be only a means to an end—personal independence, perhaps, or the freedom to produce quality design—but that means is absolutely essential. Businesses make money, or they do not remain in business. Period.

Your accounting system is your single most effective control over your entire business operation. It provides you valuable information about your anticipated income, which reflects on your pricing, your sales, and your marketing efforts. It keeps track of your expenses, which give you insights into the merits of your project-management and time-management systems and which in turn may reflect on people management in your firm.

Your accounting system cannot tell you whether you are succeeding as a designer. It cannot tell you whether your customers are satisfied. It cannot tell you whether you ought to be in the design business. But it can tell you whether your firm is succeeding as a business.

If you can succeed as a business, all the other things are possible. If you cannot succeed as a business, all other measures of success become irrelevant. In the business of graphic design, that is the bottom line.

Founded in 1989 in Minneapolis, Minnesota, Charles S. Anderson Design Company specializes in product design and development, consulting, naming, identity, and package design. Recently they worked with Turner Network Television to develop the on-air identity for their Turner Classic Movie Channel. They have also developed a line of home furnishings and other products through a licensing agreement with Paramount Pictures. In 1992, they produced a series of Anderson Design Company watches which are distributed through museum shops nationwide. In 1995, they established the CSA Archive, a subsidiary company that deals in original and historic stock illustrations based on their collection of thousands of images. They also produce and distribute a series of CSA Archive products.

Charles S. Anderson Design Company's work has been included in national and international design publications; the Library of Congress permanent collection; the Cooper-Hewitt Museum of the Smithsonian Institution; the Museum of Modern Art in Hiroshima; the Institute of Contemporary Arts in London; the Minneapolis Institute of Arts; the Visual Arts Museum in New York; the Ginza Gallery in Tokyo; and the U.S. Information Agency's exhibit on American design in the Soviet Union.

When I brought my portfolio to the Minneapolis College of Art and Design for my first review, I was told that I couldn't make it as a designer. This was understandable, since I had grown up in an Iowa farm community of about 12,000 people where no one had ever heard of "graphic design." But ever since the third grade I hadn't wanted to do anything except draw stuff. So, hearing that my career was over even before it had begun was pretty crushing. In retrospect, I think hearing those words actually helped me, because I spent every second of the next four years trying to prove them wrong. In fact, Peter Sietz, one of my instructors, gave me my first job after I graduated.

A couple of years later, I designed a poster for the Twin Cities Marathon as a free-lance project. I pulled three all-nighters to finish it, and it turned out to be one of the first decent pieces I ever did. I reprinted it myself and sold about $5,000 worth of posters the first weekend, which at the time was all the money in the world.

Back then, the poster really looked good to me. Now, it's like the worst. But it really taught me the importance of every piece you do. It also got me a feature in "Picture," the Sunday supplement to the *Minneapolis Tribune*. Four or five other posters of mine were also shown in that feature; the Marathon piece turned out to be my "in." A firm called Design Center hired me largely because of that poster.

During my second year at Design Center, I designed an annual report for General Mills. This turned out to be one of the most grueling projects of my life. I spent six months working on the report, and during that time I had to change the design dozens of times. I did 26 full-size color comps of the cover. Finally, they selected one. The rest of the book was butchered, so the cover was all I had left. When I went to the press check, I discovered that, at the last minute, the president of the company had changed his mind and used a new cover, thrown together in-house. I walked out of the printer's plant. It was very quiet at Design Center the next day. General Mills basically said that they didn't want to deal with me ever again.

Ironically, Joe Duffy had just called me to talk about a new venture with Fallon McElligott. My second meeting was with Tom McElligott himself. I told Tom the General Mills annual report story and laid all 26 of the cover designs on the table. When I then showed him the one they actually used, Tom went crazy and hurled the finished piece against the wall. He said, "That'll never happen to you here. Here, creativity will always come first." I'd never met any creative person with such integrity. I took the job, and Tom was right—that never happened at the Duffy Group.

In 1985, we only had five or six people at Duffy. Although Joe Duffy's background was in advertising, we soon realized that we weren't going to get anywhere by competing with Fallon's 70-person staff for ad work. Instead, I was pursuing an illustrative design direction. One day, Bruce Bigford, president of French Paper Company, walked in the door carrying one of our jobs and said, "We really love what you've been doing with our paper. We've come up with an idea for some new papers we're thinking about producing, and I'd like your opinions of them." The papers were what we now know as Speckletone. I looked at them and said, "These papers are great. Designers are going to go crazy over them."

I told French that, if they would agree to spend their entire advertising budget on the printing and production of a book showing the new and expanded line of papers, we would design the piece for nothing, a piece that would promote both us and them—our work, their paper. They agreed. In six months' time, 10,000 books were produced and distributed through paper merchants nationwide. Speckletone went from number six to number one for French sheets, and they had to drop other lines to make room for producing the paper.

That mailing piece really helped the Duffy Group to become nationally recognized. After that, French Paper became a kind of ongoing account on a project-basis. To this day, they continue to be a key client for me.

After about two years of working 12- and 14-hour days at Duffy Design, I began to think about going in on a partnership with Joe. After lots of negotiations, I finally ended up buying a percentage of stock in the company.

About nine months later, Joe began having discussions with Michael Peters, the British-based design conglomerate, about a buyout of Duffy Design. When I spoke to Michael Peters, it was clear that he needed lots of work from large corporations in order to make enough money to keep his enormous machine going. I felt that if he ever had to decide between making lots of money or doing quality work, he would be forced to choose the money.

A few months before, Peters and I had discussed his philosophy about moving companies forward. He believed that a designer is doing design simply by taking existing, even bad, package design, and making it 5 percent better. I thought, that's okay for you, the guy who cuts the deal. But I'm the one designing the project. If I start with garbage and make it 5 percent better, it still stinks. That's not what I wanted to do with my life.

I started to get very worried about what was going to happen at Duffy Design after the buyout—I got the feeling that I wouldn't have enough input in the direction the company went.

In the end, I finally decided that it just wasn't in my best interest to stay. So I sold back my shares of stock and rolled out of Duffy Design. I was terrified. I had very little money. I had a house I couldn't sell and a wife and three kids. No work, no equipment, and no clients. Nothing.

My first clients were my friends at the French Paper Company, who have stuck with me to this day. French is still my best client. We have a perfect back-and-forth-relationship, and I love their company as much as their papers. Today we are heavily involved in new product development as well as their promotional items.

Another major client of ours is Paramount Pictures. The work we did for Paramount was through a licensing agreement. We have also worked with national and international clients, including Polo Ralph Lauren; Nike; Levis; Pantone, Inc.; Fossil; Sierra Designs; Sony; The Distillerie des Aravis, La Clusaz, France; and Visual Message, Tokyo. We have also worked on a variety of of projects with such well-known advertising agencies as Wieden & Kennedy; Chiat Day; Fallon McElligott; Foote, Cone & Belding; DDB Needham; The Martin Agency; and Goodby, Berlin & Silverstein.

I try to keep the "business" end of the business to a minimum. We have an accountant, a separate bookkeeper who comes in every two weeks, and an office manager who does all the billing. Every two weeks our bookkeeper does a projection of what's coming down the pipe. All I want to know is how much money we're owed, how much cash on hand we have, and what our monthly expenses are. With those figures in mind, we're able to run this place. We don't keep time sheets, and pricing depends on what the market will bear. Clients don't care what our hourly rate is or how long it takes us to do the work. All they want to know is how much for the project. And they always have a cap on how much they want to pay. We try to find that out and then decide whether we can work with their budget.

It is scary sometimes. I try to keep the overhead in the office down as much as possible. I've also realized that we just can't do many small jobs. We get a call almost every other week to do a book jacket for $1,500, but these kinds of jobs take as much time as creating a poster, and, as much as we enjoy doing these things every once in a while, it's just not economically feasible. We're only able to handle about 20 or 30 jobs a year (if we're lucky). We just can't afford the luxury of getting bogged down in too many small projects.

My biggest project right now is the publication of *CSA Line Art Archive Catalog,* a visual dictionary documenting 20th century advertising art and intended to be used as a catalog to order stock images for use in ads, TV spots, etc. It's also just plain neat to look at—which we hope will make it collectible. The Archive has become so big, we've created a whole new division of the company to deal with it.

I'm convinced there's a lot of potential in the Archive. All the illustrations have been selected by me, and there's no other collection like it. It contains literally hundreds of thousands of historic and original line-art images, all fine-tuned, cleaned up, and redrawn.

Already, even without the catalog being out, we're getting three or four calls for image searches a week. Once the Archive book is out, we expect to be able to handle hundreds of those requests a year. We're also able to customize any Archive image for a specific client or project.

We're also working on a series of CSA Archive products that will be sold in museum shops and direct from us by mail order. These include t-shirts, watches, magnets, and whatever else we can dream up.

The idea behind all these ventures is to keep them small. The real danger with getting into products is that they can get out of control. Before you know it, you're not a design firm anymore. We never want that to happen. We're in the business of creating neat things to look at, and if some of these things can also be worn, eaten off of, or used to tell time, great.

Paul Rand said the business of design is solving design problems, not business problems. I've learned that. And I'm trying not to forget it.

Products from the CSA Archive (from left): Slacks cologne; boxed set of five tee shirt designs; and coffee table.

Cover of the CSA Archive Catalog, the most extensive collection of historic and original line art available.

A capabilities brochure for Print Craft, Inc.

Poster announcing the publication of the CSA Archive Catalog.

"1st Degree Burn," a poster aimed at design students addressing the over-saturation of the design field.

One of three posters designed to create an image for the Turner Classic Movie cable network.

Tee shirt designed to promote French's entire line of papers: Dur-O-Tone, Construction, Speckletone, Parchtone, Rayon, and Linen.

A poster/invitation/self-mailer for three design presentations in Australia.

Clothing hang tags for Chums, printed on recycled French Newsprint.

The first in a series of mini-books designed to highlight both an illustrator's and a writer's work on various grades of French paper.

One of a series of four books, each designed to promote one of the four Dur-O-Tone papers, a new line of industrial papers created for use by designers.

Shaun studied at Oxford Polytechnic and Hornsey College of Art before gaining a post-graduate degree at The Royal College of Art. She began winning awards and exhibiting internationally while still a student, and on graduation worked as an independent designer and visiting lecturer.

She joined The Partners, a London firm, on its formation in 1983, and became a partner in 1985. A frequent visiting lecturer to colleges and universities and a member of design competition panels, Shaun has won awards in several countries for work across a variety of disciplines.

Her clients include Arthur Andersen, The Body Shop, Bowater, Ciba Geigy, Costain, Minorco, The Photographers' Gallery, The Royal Mail, and Tesco.

The Partners was started in 1983 when three small design partnerships began to share the same space—a former warehouse in the East End of London. I joined the group as a senior designer about a month before it officially became "The Partners" and became a partner myself in 1985.

We started off with less than ten people and now have a staff of 45. While we often get involved in such projects as identity and signing, we've always concentrated on the single discipline of graphic design, which is slightly unusual in this country.

We set out very deliberately to establish a reputation for doing the best quality work possible. Everything we did was judged by that standard.

I think one of the things that helped us maintain the high quality of our work was—and is—that five of the partners are designers (our sixth partner is responsible for the financial and general administration of the company). When clients come to us, they deal directly with a designer. I have to admit that this isn't always what clients expect—we're not just "yes men" (or women!); we have an opinion and are prepared to fight quite hard for what we believe is right. However, I don't think this makes us difficult to work with.

I'm helped a great deal by the way the company is structured—we've set up a system of design "teams." In the past when a new project came in, one of the five design partners was chosen to handle it and then a team was assigned from a pool of designers with varying levels of experience and talents. This meant that designers were often working for several different partners on different jobs at the same time.

While this made for a good mix, and it was enjoyable to work with lots of different people, eventually the system became too difficult to manage. It often resulted in one designer being shifted back and forth from one partner to another, handling several jobs, all of which were urgent. It also became difficult for us, as partners, to judge how much work we had and how best to manage that work.

So we changed to a team system. Now I have a team of my own designers and it makes managing much better.

The possible downside of this system is that my designers just work with me, even though they might well enjoy working with the other partners. We've addressed this to some extent by creating a flexible system whereby two or three teams can come together to work on very large projects. Conversely, a single designer could be allocated to a smaller job. We certainly try to avoid the situation where one team is sitting there doing nothing while the rest of the studio is really busy.

We definitely feel that the team system works better, particularly for younger designers who come into the more nurturing environment created by a close working group.

To make sure that projects run smoothly from an administrative point of view, each team has a project coordinator. It's important that we offer clients the most appropriate resources for their particular job, so on larger and more complex projects, we also involve a project manager who works closely with the design team.

When a new client comes to us, we usually like to send two partners to meet them, together with our business development manager. Two partners because, with two people, there's a better chance that the chemistry will be good. We also think it's important to provide continuity so that the client ends up working with someone they met in that first meeting.

Lately we've had to put together larger, more complex presentations and written proposals. To do this, we work closely with the business-development manager. It's important in proposals that we focus on the individual needs of each client and the specific demands of their project.

Once we get the job, it is then decided which of the two partners will handle the work. We then agree on the final brief with the client and put together a detailed plan and schedule the work before starting.

Very few clients require us to sign a contract. Instead, clients receive our estimate, which details our terms and conditions on the reverse, and an implicit relationship is formed between our firm and the client. Occasionally a contract is insisted on, usually by larger clients, and very occasionally we are asked to sign away rights that we feel shouldn't be signed away.

There are inevitably occasions when a job takes more time to complete than has been budgeted for. If this is because of extra work requested by the client, or if they have departed from the agreed brief, we will discuss and agree on any additional fees with the client straight away. If, however, it's because we underestimated the amount of time it would take, we would still go ahead and complete the work for the same fee. I would never say to a designer that we have to stop working on a job because we're over budget. The quality of work is still the most important thing.

Our proposals break a project down into a number of stages, and we use these stages for billing purposes. As people work on the projects, they fill out time sheets; that time then gets entered on to a job sheet, along with all other outside costs for that job. Each week I get a computer printout of all my team's jobs that shows me exactly where we stand on every project. Printouts are also available on a daily basis, if required.

As far as fees are concerned, we record absolutely every hour. A working day consists of seven and a half hours and we expect our people to log all of those hours on their time sheets—even time that can't be charged to a project. Our fee rates range from £45 to £120 and hour (about $70 to $185 at time of publication), depending on the experience of the individual.

For large expenditures, such as photography and print, we always advise clients that they can pay the bill directly to avoid a handling and administration charge that we normally add to the cost of bought-in materials.

The concept stage of a project could be said to be the most important stage, for it sets the design foundations for the rest of the project. It very rarely happens, but if a client is concerned about our concept and asks to see some more ideas, we would always do this work within our original fee estimate. We wouldn't charge any more for the additional work.

Every week, the partners and the business-development manager get together for a business-development meeting. We discuss new business enquiries and decide which partners will attend forthcoming presentations and new business meetings. In terms of forward planning, we also look at how busy people are going to be for the next week and for the next month. We discuss the areas of business we ought to be developing and how we might go about trying to break into these areas. (We then go on to discuss the day-to-day management of the company, any personnel issues, and the like.)

In the company's first few years, all our projects came in by recommendation. We didn't have to do anything to bring in the work. Although that was wonderful, we decided to be more serious about seeking and getting business and, on the advice of a consultant, we hired a business-development manager whose only job was to obtain business. We also sought advice from a PR consultancy.

Our business-development strategy is to segment potential clients into sectors: arts and leisure; financial services; food and drink; high technology; manufacturing; property and construction; professional and communications services; retailing; and pharmaceuticals. We try to identify which sectors have the most potential for us at any one time. Our business-development manager then identifies appropriate companies in that sector and individuals within those companies for us to contact. Of course, much of our work still comes through recommendation, or by client contacts moving to new companies.

Until a few years ago, we deliberately chose not to have a capabilities brochure. Instead, we produced a quarterly, large-format news sheet. We'd also include an article discussing a more general issue that we thought was important—for example, "How to Write a Design Brief." The news sheet gave clients and potential clients a good sense of the range and quality of our work, as well as something of our company philosophy.

We ultimately realized that the news sheet on its own wasn't always going to be enough to entice a company to hire us, so we decided to create a proper capabilities brochure. The problem with most capabilities brochures is that they are very limiting and are therefore unlikely to have precisely what a particular client is interested in. We have created a flexible, modular approach to our brochure; by producing individual leaves of different client case studies, we are able to customize each brochure and target clients more precisely.

We have been working on Apple Macintosh computers for many years now. We see them as a useful, working tool, and every designer has one, unlike some companies where the production and implementation functions are separated from design. While computers have brought many advantages to the design industry, they can also create some problems. It's clear that some designers have become wedded to a particular software package and its inherent features or limitations. If we have an idea and the computer can't produce it, then we'll find a way of producing it that doesn't use the computer.

All that computers can really do is allow us to improve the service that we already give to our clients—and that's what's important to us.

I think the major difference between The Partners and some other design consultancies is that we always have a good reason for everything we do. We don't just choose a typeface because it happens to be the typeface of the month, and we don't have a house style. Our work is not only about how the finished piece looks—it's also about the idea behind the way it looks. When people describe our work, they also describe our thinking, the way we approach something, the idea.

The beauty of a good idea is that it lasts forever. The *way* that we've visualized an idea might date, but the idea itself is still there. And it's ideas that anyone, at any age, can appreciate.

A gift for clients of Westerham Press: a linen tester and a miniature brochure so small that it has to be read using the eyeglass.

Posters for the Association of Photographers, a professional association which promotes photographers through a portfolio service and quarterly exhibitions. Top: The "Shot in the USA" poster promotes an exhibition on American photography. Below: The Flower Show poster promotes an exhibit of work on flowers.

Promotional brochure for The Fountains, an office development. The brochure has a transparent double cover filled with water and coins which float around as the piece is moved.

"Colorful" theme for Harrods which included the idea of changing the world-famous white lights to colored lights and an in-store promotion.

Logo for Dorothy Perkins, the second largest women's wear retailer in the UK.

BOWATER

Logo for Bowater, one of the world's leading packaging, print, and coated products groups.

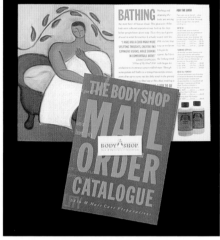

U.S. mail-order catalog for The Body Shop.

Signage for Butler's Wharf, a retail/ residential/ commercial complex.

Visual identity for Mencap, the Royal Society for mentally handicapped people. The logo works with a variety of positive images of people making the most of life in spite of their difficulties.

For the past ten years, The Partners has sent an annual "book" to clients and friends to display creativity and wit, and as an alternative to the usual holiday card. Past books include (clockwise, from upper left): 1985–Cotton (made out of cotton material in the form of a child's book); 1988–Wood (incorporates a wooden cover and focuses on our dependence on wood); 1990–Wool (an illustrated Seven Deadly Sins); 1992–Pottery (a loving cup and a piece of pottery were included with a book on pottery); 1993–Tin (a book in the form of a time capsule was filled with The Partners' visions of what everyday life would be like in 2003).

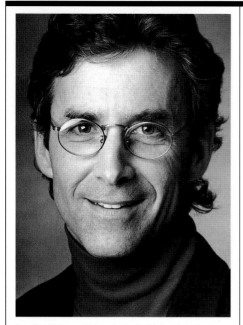

Joe Duffy's work has included brand and corporate identity development, literature, and packaging design for clients such as Chaps/Ralph Lauren, Giorgio Armani, Porsche, Timex, Lee Jeans, Jim Beam Brands, and the Stroh Brewery Company.
Joe's work has received numerous design awards from leading national and international design organizations and publications.
Joe holds a firm commitment to environmentally responsible design. He has served as chairperson for the Environmental Committee on the Board of Directors of the American Institute of Graphic Arts (AIGA) and has served on the board of the Minnesota Department of Arts Education.
Both The Gallery Von Oertzen in Frankfurt and the Victoria and Albert Museum in London have exhibited Joe's work. He has lectured on design and the environment throughout the U.S., Europe, and Australia. His company is located in Minneapolis.

The key to my design business is collaboration. I've always believed—particularly for a small group—that designers shouldn't concentrate on things that they are not necessarily good at. So, in addition to designers, we have a writer, a production coordinator, a production artist, and a client services director on staff.

I know that lots of successful designers start out by pretty much doing it all themselves; they write copy, do their own mechanicals, handle client contact. For some, it works well.

I'd rather bring people on board who are very good at what they do and then work in a collaborative setting where the whole group handles virtually every project from concept through execution. Designers design; writers write; and client service coordinators are the primary contacts with clients. At the same time, we are constantly meeting as a group to make sure we're all on the same track.

I've always acted as creative director in the collaborative effort, overseeing the direction of the design on projects, making sure that we're doing the right thing for the client as well as the right thing for the company, every step of the way. The fact that I have other people on board to execute the production and client services allows me to spend most of my concentration on the creative work.

I started Duffy Design Group in 1984 with the four partners who owned the advertising firm Fallon McElligott (FM). Duffy Design was set up to create graphic design for FM's clients. I had total say about which clients I would work for, who I would hire, and so on.

All five of us put a small amount of money into Duffy Design. The thing that really got us going and made the difference was that we had clients ready and waiting—not just any clients but clients like U.S. West, AMF Athletic Goods, and First Tennessee Banks, clients who had worked with FM and had already bought into their high standards of creative excellence.

I think that one of the things that hurts start-up creative companies most is that they're often undercapitalized. The designers don't have work and they end up having to go out and literally beg for projects in order to get themselves established. But in order to get yourself established, you have to do your best work. And usually when you're begging, you're not going to attract the kinds of clients who will give you the respect you need to do your best work.

About six months after I started Duffy Design Group, I hired Chuck Anderson. He is a very good designer. I learned a lot from Chuck and he learned a lot from me. We did some great work together.

I also hired a writer, which was rare for a design firm, especially a start-up one. Because of my background in advertising and my concern for the verbal part of communication, I felt it was important to have a writer on staff. Working from an idea, as opposed to a design or a visual concept, helped us get started on the right foot. Another strategy that helped was trying to establish long-term relationships with clients as opposed to one-shot deals where you design a poster for this client and a package for that client.

We were paid on a project basis, but because of our relationship with FM and because of the fact that we emphasized long-term relationships, things haven't been as rocky for us as they have been for many other design companies. And that's always been a major problem with the graphic design business: You can't staff up for the boom times because you might get killed in the bust times. I've always run my business very lean. Until very recently, when we became a part of FM and staffed up to about 21 people, I've never had more than 10 or 11 people working for me.

New business has come in mostly by word-of-mouth or because of our affiliation with FM, not from cold calling. We sent letters and samples of our work to targeted, prospective clients, but it wasn't a significant new business effort. Again, starting off with good clients who allowed us to do good work that then was successful in the marketplace was critical.

In 1989, the Michael Peters Group bought controlling interest in Duffy Design Group. Michael Peters was setting up an international network and we wanted to be a part of it. It soon became obvious that, due to serious financial problems, Michael wasn't going to be able to do what we had set out to do. So within a year, I told him that I wanted to buy the company back. Things got continually worse for Michael's company, and they filed for bankruptcy. My whole buy-back situation was in limbo for almost two years. My attorneys and I determined that the only way for me to get out of the deal was to literally shut the company down and start over again. So, in 1992 I started a new company—Joe Duffy Design. In 1993 Joe Duffy Design became a part of FM.

We continue to concentrate on projects that, for the most part, concern themselves with brand identity, packaging programs, and pure graphic design. Yet I want to do more than that. I want to do a more complete job of marketing communications for our clients. One of my frustrations has been not having greater control over the development of a brand and the execution of the various applications of the identity. So I have been focusing on doing more applications for point of sale. For select clients, we have even created the entire advertising campaign. Our resources at Fallon McElligott allow us to approach brand work in an integrated, holistic way. We have far greater control over the brand "personality" than we did when we were on our own.

My goal is to try to eliminate the roller-coaster effect and to emphasize our role as long-term design consultants for clients who need several services. These clients don't need just one or two applications a year; they need someone to deal with them virtually every month.

In order to be profitable in the future, I think that designers will have to be multidisciplined. They will have to look at a client's needs and consult with them on anything that affects their image, their identity, their brand. Then they will go about developing that work in one of two ways. They will either increase the disciplines that their own company handles or they will align themselves with other like-minded creative people, who may be advertising agencies, interior designers, product designers, or whatever, and work with them to establish a brand's identity or a company's identity. I want to do both. I want to handle more disciplines here, and I also want to work with people on the outside to provide the client with the total package.

One of the most exciting projects we are working on today is one we are doing for Coca-Cola, which encompasses everything from packaging to identity to advertising. We are working closely with one of their advertising agencies, and I believe this collaboration might be a preview of the kinds of new relationships that all design firms are beginning to forge, and will have to forge, if they wish to survive and grow in the future.

As to the way we run the business on a day-by-day basis, I don't think we're really too different from a lot of other firms. There is no science to the way we estimate costs. Basically, it comes down to who will be working on the project, what their hourly rates are, and how many hours it will take to complete the project. I've established different hourly rates for my employees based on the amount of overhead that we have—salary as well as fixed costs.

When we write a proposal and estimate everybody's time, nine times out of ten we end up spending more time on the project than was estimated. I think one of the things we're good at is going back and looking at a job after the fact and figuring out profitability and whether or not we should have charged more, spent less time, and so on.

With newer clients, we may find ourselves giving more away if we feel the potential for a long-term relationship exists. Yet you never know how much hand-holding is going to be involved, how many times a new client is going to ask for revisions, how difficult or easy they will be to deal with, or how tight the comps have to be. For some clients, we just do a sketch and they know how we plan to execute the idea. For others, we practically have to print the job before we can present it to them. With a new client, you obviously don't know all those factors.

Other aspects to consider when writing a proposal and pricing jobs include: Is it a slow time—are there three or four people sitting on their hands? Is this a category we want to get involved in which represents potential growth for us, something that we've never done before that could lead to additional business? And—this is one of the most important things—is there potential for a long-term relationship that will allow us to get off the roller coaster?

Again, we don't work for people who won't allow us to do our best work. I'm really proud of that. I don't want to work for a client who says, "Make it blue" or "We've always done it this way." We take an awful lot of time and care before going to work for someone to determine what their needs are, what they want from us, and why they came to us in the first place. And even during the slow times, I've rejected projects when I sensed we wouldn't be allowed to do our best work.

It's so critical that a designer be both a designer and a business person. I believe that's why our profession doesn't have the respect that it deserves. In general, designers just don't pay enough attention to business. If you can't run a design business, create relationships, and manage people, your company is not going to be successful. It's as simple as that.

Understanding business and people is really key. I would like to see design programs with an almost equal emphasis on business, rather than programs that just teach students to design on computers. But business in a creative sense. I don't think that designers should follow formulas from a textbook. I think you have to be as creative about structuring your business and handling the day-to-day aspects of the business of design as you do in establishing your identity through your creative work.

Commemorative poster for the Memphis Chicks baseball team.

Revised brand identity and package design for Diet Coke.

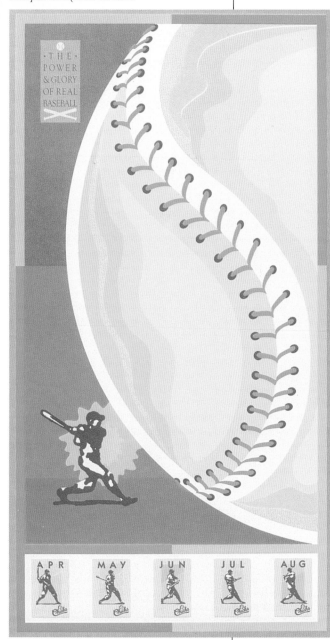

Brand identity and package design for Fruitopia from Minute Maid.

Product brochure for the Porsche 928 S-4.

Brand identity and packaging for Trail Mark, a retail chain of outdoor active clothing shops.

*Commemorative poster
for Fallon McElligott's
fifth anniversary party.*

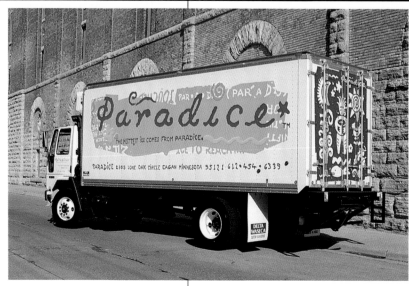

*Brand identity and
truck design application
for Paradice ice.*

*Brand identities and
packages for the Small
Batch family of bourbons
from Jim Beam Brands.*

*The 1987 US West
annual report.*

*Brand identity and
packaging program
for Toulouse, a French
take-out deli.*

Craig Frazier is the owner and principal designer of Frazier Design, a full-service design firm founded in 1980 and located in San Francisco. The firm provides marketing communications services in the areas of corporate identity, brochures, posters, annual reports, packaging, and advertising.

Craig's work has received awards and recognition from most of the major design organizations and has been frequently published in Communication Arts, Graphis, Print, *and* How *magazines.*

A frequent speaker and juror for design organizations around the country, he has also been an instructor at the California College of Arts and Crafts and a guest lecturer at the Kent State Summer Arts Program.

I began my career in a small firm in Palo Alto in 1978. The firm had just started and I was immediately over my head in projects. By default, I had quickly become a senior designer. I was just out of school and had few responsibilities except my work. I designed 15 hours a day. I thought I was in heaven.

Within two years I had become frustrated with my job and decided to start a partnership with a friend, who was also a designer. We started a company and moved to San Francisco. We put everything we had into the business— about $4,000 each. The best thing we ever did was to develop a business plan. We estimated our overhead and salaries, and figured what we needed to bill in our first year. Every day we'd trade off, and one of us would go out and show our portfolio to get business. Because we were just starting out, getting work and contracts was a major part of our business activity. We didn't realize we were developing pretty good habits from the start.

As a result, we made much more money that year than we had projected. We learned the value of our services and our potential. We learned a sense of self-respect early on that has seemed increasingly valuable the rest of our years in business.

After two years, the partnership dissolved for traditional reasons. It was a traumatic time because we were such good friends, but ultimately it was necessary. I've never had the good fortune of another partnership since then, and I often miss the camaraderie and sense of support that we had.

The new firm became Frazier Design. At the time, we had three employees. Since then, we've had as many as six employees, and now we're steady at four. One of the natural advantages to being as small as we are is that we don't need a lot of clients to meet our overhead. We are able to selectively build relationships and keep focused on the quality of our work.

I've always had an office manager who helps me run the office. She does all the transparent duties that allow us to function smoothly day-to-day: reception work, bookkeeping, accounting, payroll, taxes, collections, health insurance negotiations, contracts, mailings, and managing my schedule. Because I've chosen a route where I'm selling, negotiating, and designing for other businesses, I have to be assured that the responsibilities of running my own are being met. For all of the design decisions I don't relinquish, there are as many of the operational details that I do.

We're not able to bill directly for this kind of administrative time. And that's the difference between being a freelancer and running a firm. The benefit, however, is worth the cost tenfold—I spend much more of my time doing what I do best, which is ultimately more profitable and satisfying. As for clients, they know and appreciate the difference.

In terms of our actual business arrangements, I've always believed in contracts. In the event that there is a dispute, they are a requirement in resolving it successfully. And the mere action of having a contract tends to limit the likelihood of those disputes. They serve two very useful functions: They define exactly what the assignment is, what we'll be providing, and the exact cost and terms of payment. We have always asked for one-third of our fees at the onset of the project, another third upon completion, and the final third in 30 days. This immediately gains the client's fiscal commitment and makes for a more predictable cash flow for us.

As for our process, we try to set up the project so that we aren't brought in to simply create a design treatment. Instead, we hope that our clients expect us to bring them design for the purpose of satisfying real business issues. If we can't help them express something better than they could by themselves, there is no value to our service. If we can help them develop a way to communicate their advantage clearly and with originality, then we can become an asset.

For example, if we've been hired to design a brochure, we don't talk a lot about its layout. We talk about what the brochure might do, what it's got to express, who's going to read it, and how we will converse with that audience. When we all know what the expectations are, and the framework we are working within, the chances for doing good work really increase.

I always ask a client, "When this piece is finished, how will we know if we did a good job?" I hope the answer will be something like: "It should distance us from our competitors." This orientation tends to get the process away from fussing about typefaces and the size of pictures and onto making something happen for our client's business.

Throughout the design process, we keep focused on our client's participation and support of the evolving design. After our initial input meetings, all our presentations and evaluations refer back to a creative platform that we've established. Each decision along the way is staged to narrow the focus to a final design. When we stay on this course, we reduce revisions—those back-to-the-drawing-board kinds of things, which make us lose money and our clients' trust.

If we've been successful in our business over the years, it's because we've consistently kept project revisions to a minimum. Projects generally move through the studio pretty quickly and smoothly. When we do have to make revisions, it's because the project has assumed new purposes or has been redefined in some fashion. Because of our process, this is usually evident to the client and is not an issue if it requires more time or money. I've learned that our regular attention to keeping the assignment

focused helps us anticipate and usually prevent restarts.

Over the years, the nuances of the design process have changed. In the old days we used to do elaborate "show" comps. I really prefer doing tissues now, just rough tissues. Sometimes I'll sketch during a meeting, lay it on the table and say, "Does this make any sense?" I've found that clients love to see several ideas and participate in the exploration of options at a very early stage. Early comps tend to rush that process and reduce a client's sense of participation. Clients still expect comps, though, and we do them because they are a clear way to demonstrate what the final piece will look like. But again, we aren't invested in something that is going to be a surprise. It's just a development of an original idea. This type of staging keeps the client on board with us, and us on track with them. A sense of trust and respect is the real benefit to everyone.

We are completely computerized, as I suppose we have had to be. There is no question that it has changed our operation and the profession as a whole. It has certainly speeded up the production process greatly. I really miss many of the "traditional" ways that we did things, not just for their craftsmanship, but for the time that they gave us to think about the work we did. But those days are gone, and I am always ready to remind our clients that the "roots" of our discipline go back to those days and that our principles remain the same.

Corporate image advertising
campaign for Steelcase.

Cover and spread from a
western furniture product
catalog for National
Upholstering Company.

Computer animation
corporate trademark
for Magico.

Poster for UNESCO's poster show.

Imaging software trade-
mark and packaging for
Xaos Tools.

Spread from an annual report
for The Energy Foundation.

Customer service product
poster for Oracle Corporation.

Cover and pages from
The Alphabet Critter
Playbook, *a children's
alphabet and book.*

Customer service
product brochure for
Oracle Corporation.

Mike Hicks, president of Hixo, Inc., Austin Texas, grew up in West Texas and, at the age of 12, found himself in the music business. At 22, he decided that he had had it with bands and a life on the road and switched to a career in design, first in Houston, and then, in 1976, in Austin.

Mike has been on the faculty of the University of Texas School of Art, and taught at Kent State University and Montana State University. The founding president of AIGA/Texas and a board member of the Texas Fine Arts Association, he is an Advisory Board member for How *magazine and has written articles for* Texas Monthly, AIGA Journal, Communications Arts, Graphis, Eye, *and* The New York Times.

Mike has won countless design awards, judged dozens of design competitions, been a featured speaker at numerous design conferences and seminars, and was a co-chair of the AIGA National Conference, Miami, 1993.

He has also written two books that most clearly define his unique brand of humor: How To Be a Texan *and* Yankees Made Simpler/The South Made Simpler.

From 1978 through the early 1980s it was impossible not to make money in Texas. We never promoted ourselves. We never had a portfolio. It was a 24-hour-a-day party. And when I came to Austin, the company was running rampant by itself like a rogue elephant.

That terrific era came to a grinding halt around '85, and I suddenly came face to face with the reality of how loosely I had been running the company. It was like a $500,000 college education. Because a lot of our clients were developers who, like a lot of other developers at the time, were going under, we lost hundreds of thousands of dollars. Fortunately, I had already seen what was likely to happen to the real estate market and had begun to concentrate on the health care and hi-tech markets. Nevertheless, our staff was reduced from 15 people to the seven we now have.

It was painful, but we managed to pay off all our bills. Luckily, we had never operated by borrowing money. That philosophy had slowed our growth when the times were good, but it also kept us alive when the times got bad. I don't like running a business based on the risky premise that you'll only be able to pay your bills if everything goes right all the time.

In this small market I deal every day with people who know nothing about "good design." Most of my clients think of design services the same way they think of a concrete supplier. They want complete and total documentation of every detail, including logs of every telephone call. So we've gotten in the habit of presenting job and project estimates with very specific wording. I want clients to know exactly what we charge for and what we don't charge for.

Clients are fully aware that if it goes through our books, it's going to be marked up. If they don't want it to be marked up, they will have to handle it themselves. We reveal everything up front and bill jobs in progress whenever we can.

Our full-time bookkeeper handles all our billing, estimating, collections, taxes, and anything else that pertains to money. Every ten days she prepares a report that tells me exactly how much cash we have on hand, how much money we've collected since the last report, the salaries we've paid, the billables, accounts receivables, and the net working capital.

We don't carry any more overhead than we absolutely have to. I bill directly to the client whenever I can. Otherwise we mark up 20 percent. We don't buy media, and I avoid buying printing if I can. If I mess with it, I bill for it. And if they bill it through us, I want half the money up front and half on delivery.

I've always been an optimist, and believed that people will do the right thing. Of course they don't. I should have known better because of all the years I spent in the music business. So, in the last five years we've had to institute a no-nonsense collections policy that to me is brutal, but is pretty common in most businesses.

We're probably the highest-priced design firm in Austin, and, since most of the clients here are pretty naive about design fees, we have to constantly go out of our way to explain the basis for our fees to them. My personal philosophy is that if their eyes roll back, I'm overpriced. If they don't blink, I'm underpriced.

We charge a minimum of about $6,000 for a corporate identity for anyone. I don't care if a client has only one product or if they're just a Ma and Pa brand. That's our base.

I'm fast. But if I only take four hours to design a logo, it still may take 40 hours to convince a client that the logo will do the job for them. There's no way I'm going to charge a fee based solely on the four hours of design work I've done. I think this is perfectly fair because if it happened to take me 300 hours to design the same logo, there's no way I would bill the client for the 300 hours of work I've put into the job.

We believe our fees should reflect the value the design represents to the client, but I think there's also a judgment to be made. A fellow I know once advised me that I should charge based on the ability of my clients to pay. In other words, charge as much as possible, every time. I know he must be right, because he's always faxing messages to me from his new Ferrari. But I don't agree with him. I think large corporations *should* pay more for design, but not because they happen to be large and have lots of dough, but because, in most cases, they need so many more applications, market research needs, and design considerations.

Of course, we are always pursuing large clients because that's the only way to ever get one, but we realize that working in such a small market limits us in this area. For instance, we just finished a giant project for a monster company, and it's the worst thing we've ever done. Although the project was worth a fortune to us, I don't think that I would want to spend my life doing those kinds of jobs. On the other hand, we do a lot of pro bono work for different groups, and we like doing them. They allow us to do better work than we might otherwise do.

In a market as small as Austin, it's important to maintain a national profile, which is one of the reasons I've been so active in the AIGA. Still, I have to admit that self-marketing is our major weakness. Sometimes our business is down, and we ask ourselves, "Do we really want to spend another $30,000 trying to put together a self-marketing piece that might take months to produce and may never pay off?" But, if you don't do these kinds of things when you're slow, when are you going to do them?

Although all our work comes in through referrals, about two years ago we hired a person who's job it is to go out and search for business, make calls, listen to people, see who's doing what, and write letters. Occasionally this person might decide to try to get us into a particular industry, like computers, for example. He or she will start calling the marketing directors of some computer companies and try to set up appointments to show our work. This is as close as we come to cold calls.

Thus far, I'm way behind the curve, as far as computers are concerned. But I'm determined to get real good on these things. Every large studio has its "propeller-heads," the people who know almost nothing about design but know everything about computers. They ultimately have an iron grip on the whole group, because they are relied on day and night. They know the programs. They know where everything's stored. They are the librarians. They are the design firm's hands. Sooner or later these people say to themselves, "Hey, I can leave tomorrow, no problem. I want to be a partner." You don't want these people to leave, and you don't want to be forced to make them a partner, which is why I'm convinced that I have to learn everything there is to know about computers myself. I've been so dependent on people who are doing it for me that it makes me nervous. It's like borrowing money.

The problem is that we've now become typesetters, and most of us are not qualified to be typesetters. This has made designers focus on type, which is good, but it's also made designers spend an inordinate amount of time doing this, which is bad. I'm interested in computers more for what you can do at the design/creative end and less because of the typesetting. For us it's been a benefit, because it's more hands-on. It's more craft.

I would like designers to become more concerned with the work and the art and have less of a focus on money. I love

things, and I love having them just as much as the next guy, and I think that it's awful that most of the designers coming out of this era have no security. But if design has a purpose, it should be to further the aesthetic of the culture. My hope is that the recession will make that the burning issue instead of acquisition and materialism.

I think it's always a mistake not to try to walk the higher road. While I believe that you have to run a tight ship with your business so you don't tempt clients to be mean to you, by the same token I'm convinced that you shouldn't lower your design standards so that your clients aren't tempted to go the bad way aesthetically. If they insist that you change a color to blue, for example, you can always go back and make it blue. But first do it in the color it should be so that you don't tempt them to take the low road. Try to inspire them. If you don't offer people the opportunity to do the wrong thing, they just might end up doing the right thing.

While there are a few designers who are pretty well off, I think you'll find that the majority of designers are extremely talented, work like dogs, and aren't very rich. It's a business to be in if you want to have control of your life; it's not a business to be in if you want to make money.

I think designers need to be a bit wary regarding how much focus they place on the business side of the business, because too much emphasis on money can be a distraction. It can occupy your time and your mind and thereby diminish your ability to do the work as well as you can. In a pure sense you should never have to worry about the business side of our business, but we don't live in a pure world. The truth is that if you worry about it a little bit, you won't have to worry about it a lot.

A grocery bag featuring a products list to create mainstream appeal and awareness for a health-oriented grocery chain.

Even a blind hog finds an acorn some days and one day I caught a big salmon.

A spread from The Macallandar, *a calendar for* The Macallan, *a company which produces single highland malt scotch whiskey. Proceeds benefitted the Atlantic Salmon Federation.*

Graphics and signage developed for TravelFest, a retail travel superstore.

Logo for Motivision, a video training company.

Logo for a retail store featuring stationery products.

Logo for a group of cardiologists.

Series of print ads stressing specific health programs of a major hospital.

SETON
CARDIAC
CLASSIC
APRIL·5

THE SETON CARDIAC CLASSIC. SUNDAY, APRIL 5, 1987 IN DOWNTOWN AUSTIN. THE LAST STAGE OF THE WORLD-CLASS BRANDERS JEANS TOUR OF TEXAS. BENEFITTING THE SETON CENTRAL TEXAS HEART INSTITUTE.

Logo for IntelliQuest, a technology research firm.

Poster for a bicycle race benefitting cardiac research.

Logo for the entertainment law department of a law firm.

SMALL, CRAIG & WERKENTHIN ENTERTAINMENT LAW DEPARTMENT

Cover of a promotional brochure for IntelliTrack IQ.

113

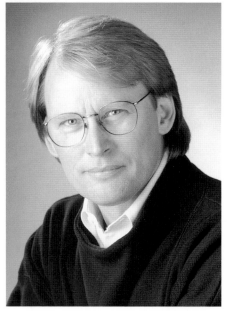

Eric Madsen is the president of The Office of Eric Madsen, a graphic design company located in Minneapolis. Born in Texas, Eric holds a bachelor of arts degree in graphic design from the University of Houston and also did post-graduate study at that institution.

His work has been recognized nationally and internationally by such organizations and publications as The American Institute of Graphic Arts (AIGA), AIGA/Minnesota, the Society of Typographic Arts, the Society of Publication Designers, Communication Arts magazine, Idea magazine (Japan), Graphis magazine, Print magazine, as well as the Art Directors Clubs of New York, Dallas, Houston, and Minneapolis.

He is a frequent speaker at, and has served as a judge for, many regional and national design, advertising, and communications events. Eric is a past vice president and founding board member of AIGA/Minnesota, and currently serves as chairman of the national nominating committee of AIGA. He is a member of the Board of Trustees of the College of Associated Arts, St. Paul, and of the Board of Directors of the Minnesota Center for Book Arts, Minneapolis.

After my second year in college, I started losing interest in becoming a doctor. What I really enjoyed was folk music. It was the mid 1960s, and I had been playing the coffeehouses and clubs with a friend for nearly seven years. I think music and the guitar gave me a way to express myself artistically, because growing up in a rural environment like the Texas Panhandle hadn't given me a clue as to what I could do with my early interests in drawing.

To seriously pursue folk music would have meant dropping out of school to devote myself full-time to traveling and performing. I wasn't willing to make that sacrifice, but since I always seemed to be drawing I did change my major to art.

I had absolutely no idea what I would end up doing—possibly something in the fine arts. I wasn't even that aware of the illustration field. Changing majors so late left me with fewer studio classes, so I finished with a B.A. degree with a major in art. Looking back, I think the additional liberal arts courses I took helped me tremendously with the business side of design.

One required class for my degree at the University of Houston was a course in advertising design. It was taught by a respected art director in Houston, and he really challenged us. He also did us an invaluable service by bringing in other working professionals from the advertising and design community. That class was my first exposure to this business.

A classmate told me about a job opening at Culberson, Glass & DuBose, a Houston design firm. I interviewed and was selected for the job.

The firm was one of the two larger design firms in Houston at that time. They were very good about giving the young designers on staff time to work on our craft, and as we gained experience, they taught us estimating, proposal writing, and organizing and managing large projects. It was a great business foundation for me.

We worked long, hard hours, and weekends quite regularly, but we always found time for fun. As designers we did our own production. The group of people I worked for and with in that firm were a tremendous influence on my career and have remained close friends. I was drafted by the Army in 1967, but I'll always remember the day two years later when I walked back in and Jim Glass asked me how soon I could start working.

Considering the friends and contacts I had established, the decision to move from Houston four years later was difficult; also, the early '70s were a great time to be a young designer in the growing Texas design community. But I felt it was time to make a move, and I decided to look in Minneapolis, having made many summer trips there as a folk-singer.

I moved in 1973 and was offered a job shortly after arriving with Fernandez & Rubin, a firm doing primarily industrial design. My role was to add a stronger graphic design component to the company. A few months later, an opening created by the departure of Glen Smith at Smith & Frink (a firm just featured in *Communication Arts* magazine that year) led Bob Frink to call me. I accepted an offer and two years later bought into the company. The firm became Frink, Casey and Madsen.

The first three years in Minneapolis were tough. I made one to three cold calls a week, showing the work. It took me four and a half years of calling on one particular client to produce a large corporate identity program. I kept looking back at what was then a still booming economy in Texas, thinking: "Why did I leave that?" I had no idea the bottom would fall out of that market a little later, and that Minneapolis-St.Paul would become such a strong creative community.

My two partners were primarily committed to work from two large clients, so I set out to broaden the client base. We were structured so that each of us dealt with our own clients, doing the administrative and creative tasks, overseeing the production, then handling the billing and follow-up.

I was a minority shareholder in the corporation, but for the first time I began to see what one could earn in this business. I was making over $50,000 and had a company car and yearly bonuses. It was an exciting growth time.

After seven years with the firm, I left with Kevin Kuester to form Madsen and Kuester. Among the many things we did right was to do our homework on how to start a business. We even attended an eight-week night class on the subject. We isolated all the tasks, such as legal, insurance, office space, financial, and so on, and assigned ourselves deadlines to accomplish each task. We were totally committed to doing the best work we could and to running a professional design firm. We even took office space in a modern office tower to further align ourselves with the predominantly corporate marketplace.

Our planning and strategy paid off. We started with only two employees and about 1,100 square feet of office space. In eight years we grew to 16 people and 10,000 square feet of space. Although we divided the corporate administrative duties, initially we each did marketing, administrative, creative, and billing for our own clients. As we grew we realized the inefficiencies of this and split those responsibilities as well. Kevin took new business development and I was responsible for overseeing creative.

We were together nine years when we reached a point where our interests seemed to be going in two different directions—mine was to be smaller and to personally design more, and Kevin's was to grow the business even larger. I sold my half of the corporation.

The experience of running a large firm was valuable, but I also realize the successes we achieved didn't quite address everything for me. For one thing, I learned that I enjoyed design more than management. My decision to downsize was never based on the economy or economic reasons; it was more about getting back in touch with the feelings I had when I just sat down and drew or designed something, when it was all for the love of that moment.

One of the most satisfying results of my move was the design of my office. Before opening this office in January of 1991, I spent a lot of time thinking about the kind of office I wanted to have, about what I liked to do and what I didn't like to do. Working 22 years gave me some perspective on that. I had the chance to be a client for a change and to draw on my feelings as well as my experience. I spent two months with my architect in planning the new space. We talked about attitude, working philosophy, and the importance I place on my space as a working environment. I told him of my personal interests and the feelings I wanted people to have when they were here. He did a beautiful job of translating philosophy into reality.

I have one full-time employee, even though the office is large enough to have six or seven people here in various free-lance capacities. I currently work with additional production, research, bookkeeping, secretarial, and copywriting support on an as-needed free-lance basis.

I devote time each week to marketing, although most of the work I have comes as a result of referral. Slightly more than one half of my work is from out of town. My marketing effort is very much a rifle approach, very specifically targeted toward the types of clients and projects I want. I follow up with letters and calls, and I send samples to prospective clients who might find them relevant.

By choosing to stay small, I am on the board more and in better control of my time. I have become more efficient and organized out of sheer necessity. I've been learning how to operate simply, such as using only one multipurpose form four or five ways for time sheet, estimate, billing, and other purposes.

With a Canon color copier and computer work stations, I am more cost-effective than I ever imagined. Previous outside expenses such as typesetting and color layout materials now stay inside and become a profit center for the office. Instead of lowering my hourly rate when I started, I raised it.

I estimate projects based on what I think the project should cost. I never do spec work, and I usually decline to get into bidding wars. I prepare as few layouts as necessary to sell the concept for a project. The computer and copier allow me to prepare these completely internally, with the exception of a few outside materials such as paper and board. I keep track of my time, which helps me estimate future projects. Even though I believe in a value-added component for my years of experience, the time records show me how I'm actually doing.

The first work station I put in place consisted of a Quadra 800, a QMS 860 600-dpi printer, an Epson color scanner, a Hayes high-speed modem, and a MicroNet SyQuest. I have CD-ROM capability as well. The entire system cost me about $18,000. A second and third work station, each built around a Power Mac 8100/110, cost less than one half of that first system.

I rarely work on the computer, though, except for my marketing efforts. It is usually manned by my production artist who has much more computer skills than I will ever have.

A very important factor is that I now build in some self-indulgent time in this new operation. I leave time to develop ideas for personal design projects that I would like to bring to the marketplace, time to play the guitar, and time to work on my artwork/illustration ideas.

One of the nicest compliments I've had recently was from someone who toured my office and said, "I feel like I've just had a tour of your soul." This feels right for me, and it has been rewarding to see the reactions my decision and this office have had upon others.

Exhibition catalog, Bruce B. Dayton, Fifty Years a Trustee, *for the Minneapolis Institute of Arts.*

Spread from a brochure for Weyerhaeuser Paper Company.

Cover of the exhibition catalog, Visions of the People, *for the Minneapolis Institute of Arts.*

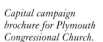

Capital campaign brochure for Plymouth Congressional Church.

Capital campaign brochure for United Theological Seminary.

Spread from a capabilities brochure for Decision Systems, Inc.

Corporate symbol for Decision Systems, Inc.

A series of spreads from a commemorative gift book for Canon, Inc.

Jenny McChesney is president and design principal of McChesney Design, Inc., in San Antonio, Texas. Specializing in print graphics and signage, Jenny works in the areas of education, health care, corporate communications, and in-store retail graphics. In addition, she collaborates with architects to create signage packages for civic, institutional, and retail clients.

After receiving a BFA in graphic design from Carnegie-Mellon University, Jenny worked in Philadelphia for Katz Wheeler Design and the Philadelphia Museum of Art before establishing her firm in San Antonio.

She has served on the Board of Directors for the Texas chapter of the American Institute of Graphic Arts (AIGA) and is a member of the Historic and Design Review Commission for the City of San Antonio. Her clients include Southwestern Bell Corporation; the City of San Antonio; The Psychological Corporation; VideoCentral, Inc.; H.E. Butt Grocery Co.; and Souper Salad, Inc.

College was the beginning of my career. The experience at Carnegie-Mellon was intense, nirvanic. Passion for "getting it right" ran high. Every available tool for creating images and typography was right at our fingertips—the nirvanic part. So I was frustrated when I moved to San Antonio, a small design market by national standards, because I was not able to find an equally nirvanic job into which to pour all this passion. But I was enchanted with my new sunbelt home with its perpetual top-down weather and wanted to make a place for myself. So, in 1984, I opened McChesney Design.

During the first two years, my clients varied in nature and the workload was unpredictable. Public relations and advertising agencies brokered some work to me; these were often worthwhile projects. I also met quite a few new clients at business mixers, art gallery openings, and the like. When I look back at my old sketches from that time, I can sense from the energy in the drawings how excited I was with my new business.

In 1986, I got a break when I landed the job of art directing the city's lifestyle magazine, which gave me the opportunity to work with a changing roster of illustrators and photographers. From the editorial staff, I also learned newspaper-based ways of treating page layout. That experience still heavily influences my work; publication design drives this office. Our greatest strength is working with clients who have a lot of information and ideas to get on a page in an attractive, accessible form. We often test our roughs by posing the question, "If I couldn't read the language, could I still get something from this page?"

I am a linear thinker and an even-keeled person on the surface, but these qualities are not contradictory with being creative. I have to believe that my steady personality has been an asset in running a successful design office. But in spite of my mild-mannered businesswoman demeanor, some clients are still eager to peg the wigged-out "arty" side of a designer. It's as if they're waiting for Lois Lane to take off her glasses. (Yeah, I know Clark wore the glasses, but give me a break.) It's true that I have two distinct sides. Days when I am heavily involved in paperwork and schedules, I find it hard to switch gears to creative, generative thought, and I have little patience for talking through abstract ideas. To protect my real creative time, I sometimes have to compartmentalize my schedule in hours or days.

We share open offices with an architecture firm of about 14 people, and the combined feeling in the two offices is energetic, upbeat, boisterous; it is uncarpeted, noisy, somewhat chaotic, but a great place to be. Our office decor

does showcase what I would like to think is our great sense of style, but, first of all, it's inexpensive and practical. We started out in business during the last surge of the Texas economic boom, stayed lean during the ensuing bust, and are still skittish about overextension and debt. So, there's microwave popcorn for everybody, but there's still no wall-to-wall carpeting. I honestly think that clients like to hang with the "artists." Especially, if we've just made popcorn.

How do you price creative services? This is tricky, in part because while we know it's highly skilled work, it looks like fun and computer games to the average design client. And portfolios may open the door, but most clients don't have much confidence in their abilities to evaluate one portfolio against another. Understandably, decisions almost always come down to cost. We get work when customers feel good about us *and* the price is right. I prize my repeat clients who are knowledgeable about buying design; they spare me wear and tear on my delicate ego.

I love/hate sales. Promoting myself is definitely my weak point, so I accept the fact that I won't land all the work I want. But, after ten years of being in practice, I respond to fee negotiations less defensively and I offer more options. Also, I get great peer support from my architect office mates, who fight some of the same battles and have even more piranha-toothed competitors. Architects have successfully structured ways to price design work in three basic phases: Schematic, Design Development, and Construction Documents. They use a percentage of completion scale to do phased billing—also useful. I phase work similarly, into Concept, Production, and Pre-Press/Printing Service.

Our projects are seldom of the complexity that require the language, structure, and licensing terminology set forth in the AIGA standard form—it's too bulky. I tried it once and will probably never try it again. Instead, I work from simple budget estimates and company purchase orders, and I request 50 percent deposits and retainers whenever possible. I maintain Minority and Women Owned Business Enterprise (M/WBE) status with the City of San Antonio and State of Texas.

Looking back, I would do less myself. I love the process of designing and producing the work. I admire other professionals who can limit their involvement to just what they do best, leaving as much as possible to other capable, faster, more efficient hands.

I was really worried that my work would suffer if I had a child. So when I knew I was expecting a baby, I waited as long as possible to tell co-workers, had private lunches to preview the big news with clients, and had everyone on board with a shared "secret" at first. Even after I was obviously pregnant, I politely ducked the inevitable questions about sonograms and breast-feeding and insisted on sticking to business. I still think this was the right approach; clients got the message.

What have I done right? Given every last ounce of energy to every project I have ever worked on. Held on to some heroes, like people I have met through school and AIGA. Even though I work in a small regional market, my references are national and international. We think big, and I still work on a level of care and thought that satisfies my need for authenticity in our work. I just assume that tricks are tricks and sooner or later people see through them; it's better if the substance is strong, even if style takes a step back.

My advice to younger designers and students: Come to your first job ready to dialogue, to become a true pluralist about visual expression, and learn to work about 200 times faster than you did in school. Cultivate your gifts, worship your heroes, whoever they may be, get your hands in everything, and, finally, pour insane amounts of energy and lots of extra love into your work.

A classroom poster for The Psychological Corporation, promoting an upbeat attitude about testing and school in general.

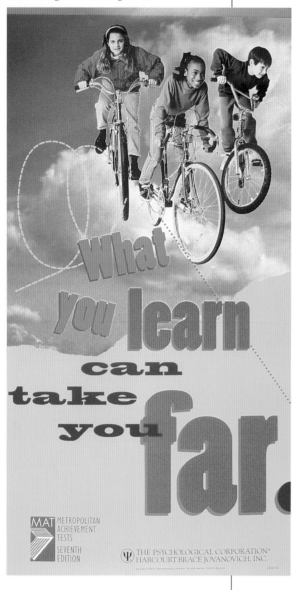

A poster celebrating the lively "patchwork" of historical contexts represented within the historic districts of San Antonio.

Logo for the San Antonio Children's Museum.

A calendar for classroom use serves two purposes: it offers a playful range of study tips for middle-school students and it promotes the Psychological Corporation's testing products.

A series of covers for MAT 7 Achievement tests for The Psychological Corporation.

A panel from "On the Move," the story in pictures of Southwestern Bell's move from its headquarters in St. Louis, with narrative and quotes from participants in the 600-family relocation.

Promotional brochure for employer's bus pass programs, "An Added Perk."

Basic wayfinding system for the Alamodome, with special consideration for the newly created ADA guidelines—notably, raised characters, Braille, and hand-height signs.

Logo for Locust Street Bakery, a fine bakery offering international breads and haute cuisine pastry.

After receiving a B.A. in advertising design from Iowa State University in 1981, Deb Miner went to work for Meredith Corporation in Des Moines as a graphic designer for Better Homes and Gardens books. In 1985 she moved to Minneapolis to take a position with McCool & Company (which in 1986 became an affiliate of Fallon McElligott), where she worked on a variety of projects as graphic designer and art director. In 1991 Deb left McCool & Company to start her current business, Deb Miner, designer. Deb's focus is on coming up with good ideas that result in unexpected, appropriate, and successful solutions for her clients. The areas she currently works in include publication design and promotion, retail point of sale and promotion, corporate and retail identity and communications, and print advertising.

Deb's honors and awards include those from Communications Arts, Graphis, New York Art Directors Club, The Type Directors Club, and AIGA.

I took a leap of faith when I started my business on the second floor of my house in June of 1991. The only capital I had was a profit-sharing plan from my previous employer, McCool & Company, plus a small amount of personal savings. I used part of the profit-sharing to buy computer equipment. It was somewhat risky, but using my creativity and resourcefulness to make the best of what I have usually pays off for me.

Before starting my firm, I had worked for only two companies: Meredith Corporation and McCool. I love variety, and I had gotten a lot of experience in many different areas at these two companies: advertising, corporate design, retail design, and publishing.

I come from a rather unconventional, entrepreneurial family, and deep down, I always felt that someday I'd be on my own. When I look back, I realize that during the times when I was the most dissatisfied or having the hardest time working for previous employers, I didn't choose to leave and set up my own shop. Instead, I chose to learn more about how to work with people, take care of myself, and deal with difficulties. I ultimately learned how to feel good about my work, even when others didn't see things the way I did. I learned to follow my own path.

When I started my business, I had just two clients. I had been doing free-lance work for American Airlines: editorial spreads for their in-flight magazine. My contact there was a friend and co-worker from my first job straight out of college. It just goes to show that you can never underestimate how important those first contacts are. (Thanks, Alisann.) My other client was a financial planner. And that was the extent of my client base.

I've been active in the design community since I moved here in 1985, so I have some connections that have been very helpful. I've gotten quite a few referrals from my contacts—other designers, art directors, photographers, and so on.

I also feel fairly comfortable picking up the phone and calling a design firm or an agency to show my book. Currently, about 50 percent of my work is subcontracted work from agencies and design firms. They have the client, and they hire me as designer/art director for a particular project. I'm also slowly increasing my own client base.

To solicit brand-new clients, I'll send out samples and call people up—people I'm interested in doing work for—and make appointments. Then I go out and show my book. But I've been fortunate—most of my present clients have contacted me through referrals.

I like having a combination of short- and long-term clients, some who are consistent and keep coming back, as well as those with one-time projects, when that seems appropriate. The whole *process* of design is fascinating to me and is another reason why I like being on my own: the freedom to move in whatever direction I choose to apply my creativity. Having my own business is less isolating, too, because I meet a lot more people than when I worked for others. Even though I used to work around more people on a daily basis, they were the same people every day. Now I feel I'm part of a bigger world—not just a "design world."

Since starting my own business, I've consciously changed the way I work. For a long time, my life *was* my work. I often spent every night and every weekend working. I learned a lot doing that, but my priorities have changed.

Going into business has meant letting go. My life isn't my work as much as it used to be, and I like that. I really care about my work, and I love being creative, but I have a more balanced life now. I know that some people who go into business for themselves find that they're working twice as hard, but I went the other way—consciously, very consciously.

After two and a half years, I still rarely work evenings or go upstairs on the weekend. That was another conscious decision—situating my office upstairs, so that even though I work out of my house, I feel my home and office are separate. That's been refreshing. And it's freeing, because even though I'm responsible for myself and to my clients, I've also chosen to make being human (and humane) toward myself a priority. *Everyone* benefits from that!

It's been a slow build. I haven't pushed myself a lot to get a ton of work. I didn't make much money my first two years. Between savings and the income I brought in, I had just enough to pay the mortgage and the bills. Even so, I didn't take everything that presented itself, because I wanted to do work that felt right to me. And now I can see the business growing—this year I made more than my salary as an employee, I've invested in more computer equipment, and I have my own Simplified Employee Plan (SEP).

I base estimates on my hourly rate, but I also take into consideration the inherent value of a project based on both the client's size and the project's use. I usually quote a total estimated range. The way I break the total down on the estimate depends on the type of project and information provided by the client.

It's important to me to feel I'm getting paid for what I believe the value of a project is, but it's a tough call. I think pricing is an ongoing evolution—things are always changing. I do my best to stay aware of standard practices in our business and of my responsibility to communicate the value of the work creative people do (through pricing and discussions). At the same time, I value understanding clients' varying circumstances and staying human in an increasingly technological, speed-oriented culture. A lot of choices I make depend heavily on my personal sense of ethics, values, and intuition.

I generally do my own typesetting on the Mac now (with text supplied by a copywriter on disk). The cost of my typesetting time is usually part of my overall estimate. Getting the type right takes time—mine or a typesetter's. And I still appreciate a typesetter's training and ability. For some projects (especially those with a fair amount of body copy needing kerning), I've found a good solution is to set the file up but send it out to a typesetter (who's now working with Mac type and software) for fine-tuning before final output.

As for technology, my advice to other designers (who choose to take advantage of computer technology) is to buy as much computer as you can afford, and know that it's not a one-time cost. I started my business in 1991 with a Macintosh IIci5/80, a SyQuest drive, a Microtek 600ZS scanner and an Apple Personal LaserWriter NT. I also absolutely had to have a copier and fax machine—these I lease. This summer, I upgraded my ci to 20/500. Now, six months later, I've replaced the ci with a Quadra 650 24/500 with CD, plus an external hard drive, and I've added a modem. I came into this profession with no computer training or background, but I embraced the technology when it became available to me (about 1986) and saw it as a tool with lots of potential to explore. I started by using it for layouts, comps, and copyfitting more than for final production, and these are still my favorite uses. I still come up with ideas and concepts the way I always have—the computer doesn't do that!

And it's my belief that the computer can't *control* my design unless I let it. Also, the technology enables me to work out of my home (which isn't very "techy") and makes it possible to work with anyone, anywhere.

I enjoy a variety of work, but I also need to feel good about my client. I like to feel that we can communicate, and that we respect each other. These intangibles are extremely important to me.

Running your own business and developing relationships is also about learning to read people. Some people are very honest. Others are not. Some just tell you what they think you want to hear. Awareness of these realities helps me recognize which situations can benefit from discussion and which are best to let go of and move on.

I think that if you don't get too large, if you keep your overhead low, if you don't tie up too much money in debt, if you're honest with yourself and your clients, and remember to balance it all with faith and some patience, it's possible to make a decent living as an independent designer and be happy as well. I am working by myself, for myself, out of the second floor of my house; I am able to be somewhat selective about the type of work that I accept; and I feel good about the choices I've made. I also realize I've been blessed with abilities and talents I'm able to take advantage of. I'm grateful for that.

If I had the chance to do things over, I guess I wouldn't do anything differently. I feel thankful for every experience I've had—even most of the mistakes I've made and difficulties I've had. I've learned and benefited a lot from working for and with others. And I believe it's important to *keep* learning.

Cover and spread from a promotion for Weyerhaeuser web papers aimed at catalog and magazine publishers.

Logo for retail center promotion (a contest to correctly guess what store the clothing items on display came from).

Information/appreciation/annual report publication for A Chance to Grow, a nonprofit group working with developmentally disabled children.

Logo and materials for DataCard Corporation's annual sales meeting.

Invitation and at-camp materials for the 1992 AIGA Minnesota Design Camp.

Feature photo essay for American Airlines' in-flight magazine American Way.

Point of sale poster for
Donaldson's Department
Store dress department.

Ski Magazine *direct mail
promotion to advertisers
for their summer edition,
"Mountain Summer."*

Logo for Twin Cities
Gay Men's Chorus.

Hangtag promoting
Thinsulate LiteLoft
Insulation.

Personal piece sent to
friends announcing a
new golden retreiver.

Jennifer Morla is president and creative director of Morla Design, Inc., San Francisco, a multi-faceted design firm offering creative services which encompass print collateral, identity design, video art direction and design, packaging, architectural design, and signage.

Jennifer's unique style, innovative concepts, and technical expertise have established her as a design leader. Her work has been honored by virtually every graphic design organization. She has been published extensively and has been the featured article in several national and international magazines. Her work is part of the permanent collection of the San Francisco Museum of Modern Art and the Library of Congress. She has been the recipient of the Margaret Larsen Designer of the Year award and declared one of the Fifteen Masters of Design by How magazine. A featured speaker and frequent national show juror, she also teaches Senior Graphic Design at California College of Arts and Crafts.

Recent projects include annual reports for the San Francisco International Airport, broadcast and animation design for MTV, identity and signage for a shopping mall, record album packaging, commissioned silkscreened AIDS posters, and Swatch watch designs, as well as extensive identity campaigns for experimental art organizations and museums.

Originally from Manhattan, Jennifer received a conceptual art discipline from the Hartford Art School/University of Hartford and her BFA in graphic design from the Massachusetts College of Art in Boston.

I moved to San Francisco from the East Coast in 1977 and got a job at the local PBS station as a senior designer, designing titles and openings for shows, creating animated logos, and working on posters and brochures. Three and a half years later I was hired as art director for Levi Strauss & Co., where I was in charge of all print promotional work. Because I had no staff, I would hire free-lance production as needed. I learned something invaluable from my experience at LS&Co.: The more management understood design, the better they got at knowing how to use it. But it's always an education process. I found that the biggest obstacle to creating excellent design is not being able to find a way to give your client the confidence to go with a daring or unusual idea. More often than not, clients have to learn how powerful design can be and how much it can work for them.

In 1984, I left Levi Strauss & Co. to start my own studio. The thought never even entered my mind that opening my own business would be a risk. I had confidence in my creativity.

Because I was certain that I didn't want to do everything myself, I opened my firm with three people: a production designer, an administrative person, and myself. I presently have seven people working on staff, and I don't want the office to grow any larger. I have three full-time designers, one intern, one part-time model maker and two administrative people. Almost everyone has worked here for at least three or four years.

We have a diversified product and client base, which helps us avoid some of the problems more specialized design firms sometimes have. We design furniture, packaging, annual reports, identities, books, and even Swatches. We also do store design and television videos. Often, when one area slows down, another picks up. We keep our options completely open. The diversity is important, both from a business perspective as well as keeping me excited about designing for different clients.

We usually have about 30 different projects in our office at any given time, and approximately 30 percent of our work is pro bono. I'm very specific about the type of work we take on. It has to be a good job, meaning that I like the client and see great creative potential.

We got our first computer, an IBM, early in 1985, and we used it strictly for word processing, not design. Now we have seven Macs, including a Centris 650 and a IIcx, which is ancient but completely loaded. We don't have Quadras yet, because the other computers we have are fairly new and can accommodate almost everything we need. We have two computers with 20-inch monitors dedicated to design work, a color flat-bed scanner, and external drives. Everything is saved to the hard drives or SyQuest cartridges. Our computers are networked and running on System 7.

When managing a project, I start by assuming "x hours," which includes every step of the process. The client must sign an estimate for a job to be considered active—we never proceed on a job without a signed estimate. And our estimates are very specific. Clients know exactly how many mechanicals they will be getting, how many roughs,

how many comps. Everything is spelled out in great detail. According to the terms and conditions on the back of our estimates, we have an allowance of 10 percent. If the client makes a change causing us to go over that 10 percent, we immediately issue a change order, fax it off to the client, and mail the hard copy. The client must sign the change order before we will proceed. If we make a change for the sake of improving the design, we don't charge the client. And, of course, that's the only reason we would ever make a change.

Generally, after the first client meeting, I have a good idea of what direction we should be going in. I usually do some quick, rough sketches articulating the design concept, which I present to the client as soon as possible. After the client understands my ideas and gives us the go-ahead, the designers scan in the sketches, prepare the comps, and handle the projects through to completion. The designers really project-manage from beginning to end. They calculate the amount of time it will take to complete the project and, with the use of our FileMaker database, they can track their hours and be responsible for managing their time and budgets.

Although I believe in sharing information via our computer network, no designer shares a job with another designer. Of the 30 projects in the office at any given time, each designer is actively working on four or five current projects (the remaining projects are pending or historical). Once a designer is assigned a project, he or she never shares that project with another designer. The designers also do the production work themselves on the computer. It's so much faster that way. If they find they need some help with production, they simply hire a free-lancer.

We do all our own typesetting and request all copy on disk. Although we hire proofreaders for annual reports, we make it clear to our clients that final proofreading is a part of their approval. We don't, however, do our own separations on the computer, because I don't think it's worth our time to do them. We send our separations to an outside service, which, quite frankly, does a better job than we would. I think that a lot of design firms might be trapping themselves by being seduced into investing in a lot of expensive equipment, only to realize one day that what they used to be able to send out and mark up has now become an internal cost, which can be difficult to track.

My full-time bookkeeper/office manager does the books. On a day-to-day basis—or on an hour-to-hour basis—I know exactly where any project is at any given time. Our accountant prepares monthly reports for us, so I always have current knowledge of the state of our financial affairs.

We charge a flat fee for our design work. How we get paid depends on the client. With new clients, we bill 50 percent up front and 50 percent upon delivery of mechanicals, not upon completion of the job. With existing clients, we are much more flexible (net 30) although I have to say that we have wonderful clients, and the majority pay in full in under 30 days.

We charge our clients for press checks and color proofing, but we usually have large printing jobs billed directly to our clients. It's not to our clients' benefit for big printing bills to come through our office because we have to mark them up. And I don't believe that our income should be based on printing mark-ups. Our income should be based solely on the value of our design work.

FileMaker is the backbone of our database system. In my opinion, it is by far the best for the design profession. When a job comes into the office, we issue it a job number and a job name. It automatically goes into about twenty different layouts. The job information can be accessed by separate databases for production schedules, job worksheets, estimates, invoices, change orders, printing specifications, timesheets, and design orders. All these files are networked, so that everybody in the office has access to all the appropriate information. Although we keep ourselves visible, we rarely solicit work. Most of our business comes by word of mouth, possibly because I do a fair amount of public speaking and judging. I don't think that we have a distinctive style. I don't use just one typeface. I don't use just one color palette. Each client and each project is different. My primary goal is to understand our clients.

If I am successful (and what measures success?), I think it's because I try not to compromise. I'm convinced that design integrity is the backbone of success for a designer. You have to love design. You have to be very organized, or set up systems that organize for you. We are not salespeople, selling a product we have no connection to. When clients understand this, they respond and become part of the design process. It's also important to articulate beyond an aesthetic so that there is never an issue such as "I like blue and you like green." The issue should be, "Do we understand your product/service and do our ideas address these needs?" These are our minimum criteria. Our benchmark: to strive to go far beyond the client's expectations.

A watch design for Swatch.

Product packaging system for Cocolat gourmet chocolates.

A book celebrating espresso.

Stanford Conference on Design poster uses architectural shapes, regional images, and human forms to reflect the theme and ambiance of the upcoming event.

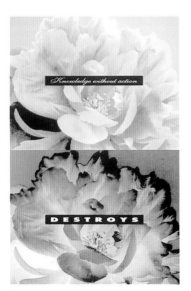

AIGA Environmental Awareness Poster educates the public and promotes individual action regarding environmental issues.

American President Lines 1993 calendar.

Levi's Silver Tab collection brochure informs department store buyers about the different styles of Levi's jeans.

Album packaging for Tuck & Patti, inspired by "Dream," the title of the recording.

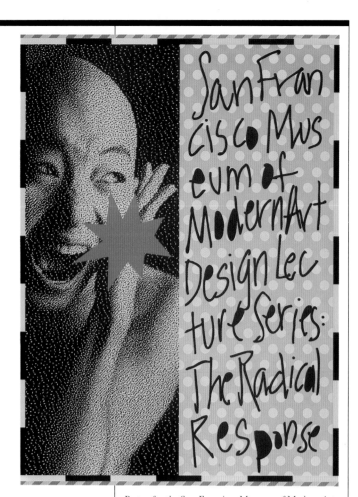

Poster for the San Francisco Museum of Modern Art series investigating the qualities of radical design.

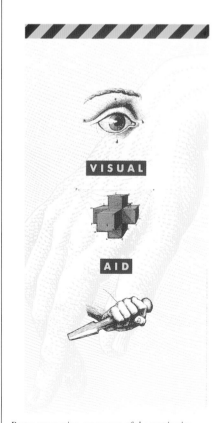

Poster promoting awareness of the continuing tragedy of AIDS in the arts community.

Lewis Nightingale and Michael Hice formed Nightingale Hice, a design, advertising, marketing, and PR firm located in Santa Fe, New Mexico, in 1990.

After working for several years in New York as an employee, a free-lance designer, and a partner in a design firm, Lewis left New York in 1986 and traveled for a year in Southeast Asia before settling down in Santa Fe in 1987.

Michael is a native New Mexican who, after graduating from Tulane University, spent 14 years as a teacher and in various sales and marketing positions in Houston and northern California before moving to Santa Fe in 1983, where he joined a partnership in a new radio station. Michael is a contributing writer to several local and regional publications.

Lewis and Michael have received scores of design and marketing awards and have donated their time to dozens of community and charitable organizations in the Santa Fe area. In 1991, Michael was honored as one of "Ten Who Make a Difference" in Santa Fe. In 1994, THE Magazine, which Lewis designs, was honored as Best Consumer Tabloid by the Western Publishing Association.

Nightingale Hice's clients include: Southwestern Association for Indian Art; Eight Northern Indian Pueblos; Santa Fe Chamber Music Festival; New Mexico Community Foundation; THE Magazine; and many local businesses including banks, radio stations, furniture designers, jewelers, and realtors.

LN: It's better to start by being a small fish in a big pond, to work in places like New York, L.A., Chicago, Atlanta, or Dallas first. That's what I did. I worked in New York for 13 years before moving to Santa Fe.

MH: Doing that gives you a more realistic perspective. We've met designers who have never even been to a big pond, much less worked in one. They often have a highly inflated opinion of themselves and their work, because they've never been exposed to real competition. We hear all the time of design or advertising firms who have made working for them a very unpleasant experience. We don't think it should be that way. We've always been committed to excellence and to making our office a pleasant place to work.

LN: I think one of the reasons we've been successful is that we really respect our clients. I come across too many designers who always take adversarial positions with their clients. I don't mean to say that designers should pander to everything a client says, but we believe we can learn a lot from our clients. And they seem to respond to our attitude.

MH: I think another reason we've been able to stay out of trouble is that we've always tried to carefully choose the clients we work with. There are people in new businesses who have said to us, "We don't have any money to pay you now, but if you help us, we'll all get rich later." It's pretty seductive, but we've resisted the urge to find the next Xerox or Nike or Apple Computer. Most of the time they just want you to bankroll them.

LN: With some clients, we have a formal contract. With others, we'll send a letter that describes the work to be done, the time frame, the schedule, the pricing, and the payment terms. The client usually signs a copy of the letter, and that's the agreement. With ongoing clients, simple verbal agreements are fine, except with those who frequently change their minds. For these, we keep very careful notes, send memos of content and pricing changes, and get signed approvals.

We contract for and buy media for our clients and take a standard commission for doing this. Things that we buy for a client, like color separations, printing, illustration, and photography, we add a mark-up, which ranges anywhere from 15 to 25 percent, depending on the size of the project and the costs.

We try very hard to pay our suppliers quickly, which makes it difficult if we have to wait 90 days for our clients to pay us.

MH: To prevent that from happening, we usually ask our clients to pay media costs up front. It might have been better for us in the beginning if we had thought more about the differences in the specific areas of business we were planning to concentrate on. But, because of my community connections, the work piled up on us before we had a chance to put project-management systems in place. So it's taken us a long time to refine that.

LN: Because of New Mexico's poor economic conditions and a certain "third world mentality," the prices being charged for work here do not bear much relation to the prices being charged elsewhere.

MH: Take a logo, for example. We hear all the time of design firms that charge $4,000 to $5,000 and much more for a logo. If you try to charge $1,500 for a logo here, people faint. Even $1,000 is a stretch.

LN: There's a lot of price resistance here, so we have to charge what we think the market will bear. The computer has allowed us to become the typesetter, but we still set our prices as if we had to buy the type outside.

We have the hardware and the software to do everything but separations, and we use a service bureau for all our high-resolution output. As of now, we have three Macs: a IIci, a Quadra 800, and a Powerbook 230 Duo Dock. We also have two SyQuest 44-MB external hard drives, a Umax 630 color scanner with transparency attachment, three 19-inch color monitors, an external CD-ROM drive, and a LaserWriter IINTX. We're considering adding a color printer.

I would say that the basic computer needs for designers just starting out would be the most powerful Mac they can afford, an external hard drive, a scanner, and software like Quark, Pagemaker, Photoshop, and Illustrator.

Working with a computer can totally change the way a designer approaches a page. For one thing, it allows you to be your own typesetter, which makes it simple to make as many changes and refinements as you wish. I often end up designing more complicated pages than I might otherwise have done, but I don't think this has hurt my design or made it look "computery."

MH: You can often tell when a design has been done by a designer who's learned the craft working totally on a computer. The work can look pretty mechanical, with everything looking alike.

LN: A lot of it is what I call "geek design"—design that's intentionally obscure, fussy, hard to read. Lots of kitsch, camp, and appropriated imagery. Garbage fonts. Layers and layers of "stuff." It's "bad boy" design, thumbing its nose at the reader. Design meant only for other designers. I hate all that. And I think consumers and readers hate it, too.

MH: I think a good analogy is what happened to horror movies when moviemakers discovered all those techniques to show gallons of blood pouring out and skin splitting apart. They began building the movie around the effects, rather than the story line. I think that's exactly what has happened with the computer. It has no message of its own, really, but unfortunately many designers seem to think the medium actually is the message.

LN: Computer skills are fairly important, but when we hire we look for the skills appropriate to the position. And since all our employees get directly involved with clients, the most important skill we look for is the person's ability to be a "people person."

MH: Here in Santa Fe, an experienced designer is paid about $25,000 to $30,000 a year. An entry-level person makes $10 to $12 an hour. Things have gotten better in the last few years, but hourly rates are still below national levels. Experienced free-lancers can get $15 to $25 an hour from agencies and $30 to $40 direct from clients. We tend to pay towards the higher end of the scale.

People look at our work and say, "No two pieces look the same." We like that. From a marketing standpoint, we don't want all our work to look alike. I see a lot of designers who make every piece

look similar. You can always tell who the designer is, but you can't always tell who the client is. The finished piece should look like the client, not like the designer.

LN: We've tended to work like a law or architectural firm. In one project I will be the principal, and in another Michael will be the principal. In New York my partner and I divided up responsibilities along pretty traditional lines. He was the account exec and had all the client contacts. He got all the work, met with the clients, took the information, made presentations, and had all the fancy lunches. I was stuck in the office all the time. One thing that was important to me when I came here was that I have client contact.

MH: You have to know and respect a partner's work, and I recognized in the beginning that Lewis was a designer who understood marketing, which is pretty unusual. But if you're both going to get involved with clients, I think it's also important that you share the same attitudes and philosophies, too. It may be concerned with ecology or abortion or whatever issues there are.

LN: I think it's also very important to be aware of your partner's needs. If I had a partner who had six children, two ex-wives, and an aging parent, his financial needs might lead him to make choices that I wouldn't make. Michael's life-style and my life-style are very similar, which makes it very easy to work with each other.

The design of our office has also been a real key to our success. I think that having an office rather than working at home is important because it shows you've made a real commitment and because an office expresses something about you. I've seen lots of offices that made me feel very uncomfortable. I hate walking through offices and seeing walls literally covered with awards. So you win awards, but that isn't really the whole deal. It just seems so needy. We've won lots of design awards, but they're put away in bags.

MH: This place used to be occupied by a furniture manufacturer. We warn clients and other visitors that they have to go through the furniture store to get to our offices. Here in Santa Fe, that's no problem. In other places that might not be as acceptable.

LN: In the last two to three years, I've seen an influx of designers from other

places who move to Santa Fe looking for a nicer place to live. Moving here isn't usually a smart career move, because the opportunities are so limited. They are usually disappointed with the amount of work available and the low rates, and many leave after a few months.

Our biggest problem in this area is the lack of staff positions open at any given time, especially at the entry level. There isn't much expansion among agencies and design firms. Designers really should get experience somewhere else first. I see two or three new designers a month who have already moved here or are considering it. I tell them to have at least six months of living expenses in the bank.

I keep my eye on the local magazines and newspapers, brochure racks, and publication shelves to see what's happening and who's doing what. New designers are definitely bringing higher levels of creativity—as well as higher rates—to this area, and I think that's good for the market. And clients are more sophisticated, too. Many business owners and marketing directors have come from other markets, so they're more knowledgeable about working with designers—and more comfortable with paying higher fees.

MH: In the four years we've been in business, most of our work has come in by referral. We don't even have a capabilities brochure. Since our work is seen all over the Santa Fe community, about the only proactive thing we do to get work is put our name on a piece if we think it's going to be really good. We sometimes put a design credit on ads too.

LN: We talk about expansion a lot. It's tempting to go after more and more work, and I'm pretty aggressive in following up leads and keeping in touch with the business community. But we don't really want to get so much more business that we'd be forced to hire more employees. We're happy at the size we are now. It's a comfortable, human scale.

Living in Santa Fe means you've chosen a simpler life. Of course, there are trade-offs, and from time to time I drool over *Communication Arts* annuals and yearn for big-city clients—and big-city budgets. But I like it here. I think a lot of people would try to create this kind of life, if they could.

Cover and spread
of annual publication
devoted to Native
American arts.

Cover of monthly publication focusing
on the arts, Santa Fe, and beyond.

Logo for Santa Fe
Chamber Musical
Festival, suggesting
adobe walls, moun-
tains, and string
instruments.

Direct mail piece for New
Mexico Repertory Theater.

Cover of Eight Northern
Indian Pueblos Guide.

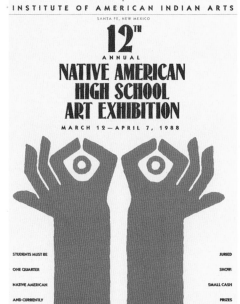

Poster for Native
American high school
art exhibition.

Logo and invitations
for annual holiday gala
to benefit local AIDS
Wellness Clinic.

TRICK OR **T.R.E.A.T.**

A BLACK & WHITE MASQUE PARTY TO BENEFIT THE RESOURCES FOR EXPERIMENTAL AIDS THERAPIES

OCTOBER 31, 1991 SANTA FE, NEW MEXICO

Poster for a Halloween benefit for
local AIDS organization.

Logo for "California
cuisine" restaurant,
Nectarine.

Cover for fine arts and
crafts catalog promoting
New Mexico artisans.

Logo for northern New
Mexico radio station.

Richardson or Richardson is a positioning and image consultancy, with a diverse client base and a wide range of project experience. The firm, based in Phoenix, has created advertising and packaging programs for such clients as Apple Computer, Disney, The News Corporation, and The Phoenix Zoo.
The firm and its clients have been recognized in various international awards programs and have been featured in publications such as Communications Arts, Print, How, Identity, *and in numerous books.*
In addition to his role as a creative director for Richardson or Richardson, Forrest is a golf course architect for Golf Group Ltd.
Valerie's key role, beyond her creative responsibilities, involves directing the design and operations team and encouraging the delivery of effective work to their clients.

VR: I never planned to be a graphic designer. I went to school to learn to be a court reporter. Then I realized that really good court reporters only hear the sounds, not what's being said, which didn't appeal to me. Instead I started taking graphic design classes while I worked for the Madison School District, where I did everything, including all their design work. It was so diverse that I was forced to come up with lots of different design solutions to lots of different design problems on a daily basis.

FR: I didn't go to a four-year design school either, but Phoenix Community College, where I studied, happened to have a really good program in visual communications.

My television experience proved a good training ground for me. The art director and I were in charge of everything from set design to vehicles to billboards to *TV Guide* ads. We started building a pretty good reputation as writers, designers, and creators.

VR: If I had to do it all over again, I would go back to school to learn more about business. There's a lot of bad work out there, because some people are better at sales than they are at design. At the same time, no matter how good your work is, if you can't go out there and sell it....

FR: You have to have some ability to communicate, "This is what I want to do, here's what I have done, and here's what I'm worth." All of those things require salesmanship, excellent presentations, and personality.

There are four ways we get business. First, from existing clients. We become a valuable part of their team, from designing their image and marketing tools to the experience of their product or service itself.

The second way work comes to us is by word of mouth. We're always getting calls from someone who happened to see something we did for one of our clients and is interested in working with us. We keep incredible sample files just to be able to respond by sending a packet of articles, samples, client lists, and bios to the caller, and we follow up with a phone call or meeting.

The third way is by deciding that we are interested in a specific potential client. For example, we might decide that we should be doing some work for a developer of shopping centers, and we will work out a deliberate strategy to find and work for one. We have a book we call the "potentials book," and it's full of clients to whom we've already sent proposals. We're constantly using this book to secure new clients.

The final way we get business, and one of the most exciting, is through various ventures and partnerships. Golf Group Ltd., for example, is pretty much just me and another golf course architect. I spend about 30 percent of my time designing golf courses.

We have a lot of irons in the fire. Right now about ten percent of the work we do is environmental graphics, which includes signs and three-dimensional applications. Ten percent is consulting work. The other 80 percent could be divided between marketing assignments (an advertising or direct mail campaign), collateral design, packaging, or identity work.

Our goal is to surround ourselves with the kinds of people that will help us grow in a sensible way and be profitable—clients and support people whom we can trust, and who trust us.

VR: Honestly, we use the past as an education. We've gotten a lot smarter about how we work. From getting retainers and billing "upon receipt," to choosing our clients wisely—and saying "no" to people we shouldn't be working for.

FR: We have really fine-tuned our accounting system to accurately capture time and expenses. We begin with a worksheet called a "launching pad" to estimate our time. Either Val or I will estimate how much time we think will be needed on a project in each area of service. From there, our project coordinator creates a confirmation form that goes in the file and is also sent to the client, so the client has a precise estimate of the number of hours we expect to spend on the project, along with estimated expenses.

VR: Three years ago we created a "chit" form that is kept by the project manager. One section of it includes miscellaneous or clerical services. Another includes the electronic network services, whereby we charge for using the computer in addition to our hourly rate. These services do not get marked up. Each time copies or supplies or Polaroids or layout boards are taken out of stock, they are recorded on this chit form so that the costs can be billed to the client. The client usually pays for the printing directly, although we will charge for the time it takes us to secure and negotiate prices and then oversee the work.

FR: Ideas and concepts are integral to our work. We're not project-oriented. I always tell students that if you become known for being able to generate really good ideas, no one will be able to put a price tag on your work. It becomes like "Madonna" or "Disney." The name itself is worth something.

VR: Frankly, when we fill out one of these launching pads, and the bottom line turns out to be $1,000, but we think that solving this problem should be worth $2,000, we'll go with the $2,000 figure. Overall it's what we think is fair to charge.

Of course, we base our billing on what we think is reasonable. If we think this project is going to take ten hours to do, and a junior designer takes 20, we're not going to bill the client for 20 hours of work. We take all things into consideration, and charge what we would pay if we were the client.

FR: Eighty percent of our work is work that is being done for clients on an ongoing basis.

VR: We have five full-time creative people, an office manager, a project coordinator, a part-time bookkeeper, a part-time assistant, and an outside accounting office to help handle all this. The office manager is basically responsible for making sure the office operates smoothly.

FR: The project coordinator is a jack-of-all-trades, beginning with project coordination. She has PR responsibilities, such as writing standard press releases. In certain instances, as when she does creative and small-scale market research before we work on projects, she is also billable.

VR: The biggest question that people ask us is, "How can you work together as husband and wife, both being creative people?" Our answer is not complicated. We love each other as husband and wife, and we respect each other as partners.

We have divided our clients by deciding who is the better partner to handle each client. If there is a client that we meet with, and I am particularly excited about that person or company, I'll follow up with them. It's the same with Forrest.

FR: That's what we find is most different between us and other couples in our business. With Michael Cronan, for instance, Karen, his wife, pretty much runs their business. With us, the differences have been in additional responsibilities. Val is in charge of the operations of the design business, and I am in charge of Golf Group Ltd. We are both creative directors, and we both write, design, and manage.

VR: The biggest challenge about our being married is that we don't look at our business partnership the way other partnerships do. Although our entire life seems to be our work, we rarely have true partner meetings, for example.

Because our offices are so cramped, Forrest and I have, in the past, been forced to share an office, which, I have to admit, was challenging at times. If I was talking on the phone, Forrest might have overheard what I was saying and have thought I should be saying something different. That, at times, was very frustrating.

When I'm writing copy or really concentrating about a creative solution, I tend to take my Powerbook and go home or to the library.

FR: In this field, you have to have an appreciation and an awareness of the whole world, not just design.

It's balance, and the days are gone when you would hire someone just to hold a pen or paintbrush and design or write. Innovators like Pat Fallon hire people who are scuba divers and sky divers, people who raise ferrets and do all of this imaginative stuff. Because they are real people, they can communicate better with real people.

If you're designing a cereal box, you need to learn everything about the mechanical process. You need to understand that the client can't buy a design that won't mesh with the price of the cereal. You need business sense. At the same time, you can't let creativity be lost in that.

VR: Designers need to think about the big picture—not to be decorators, but to be conceptual people. The cereal isn't going to sell just because the box is beautiful. When the company asks you to design a cereal package for them, you need to taste their cereal.

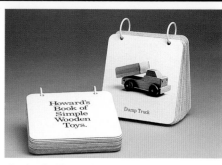

Catalog for Howard's Simple Wooden Toy Company. The design uses materials and bindings similar to children's books.

Corporate image and marketing materials for Access Laserpress. The boomerang icon establishes the essence of the firm's benefit: "Where printing comes back easier."

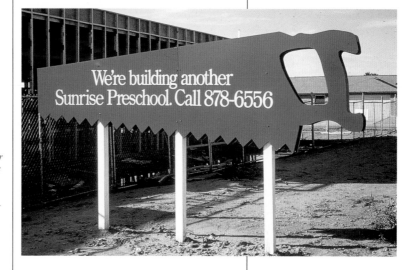

This construction site sign for Sunrise Preschools duplicates the shape of a die-cut cardboard "door hanger" delivered in the school's neighborhood to publicize its coming attraction and to encourage pre-enrollment.

A series of emblem designs for Disney Development Company. The designs are part of a comprehensive program encompassing print graphics, merchandise, and environmental design for a 550-acre golf resort and preserve.

Disney's Bonnet Creek Golf Club entry sculpture for Disney Development Company.

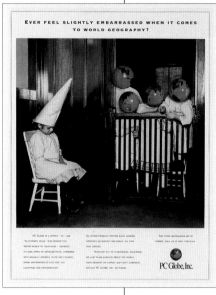

"Globeheads" magazine ad campaign for PC Globe, Inc.

Promotional items and packaging for PC Globe, Inc., publisher of geography-based software for education, business, and travel.

Annual report for the Phoenix Fire Department/ Fire-PAL.

A software package designed for Pinnacle Peak Solutions. A tassel hangs from the box.

A line of recycled papers for desktop publishing from Four Corners Paper Company.

Greg Samata, founder and a principal of Samata Associates, began his career as a designer over 20 years ago. Upon graduating from the Chicago Academy of Art with a B.F.A. in design communications in 1974, Greg formed Samata Design Group which, in 1980, evolved into Samata Associates. He is a member of the 27 Chicago Designers, the American Center for Design, and the American Institute of Graphic Arts, and has served as a national board member of that organization. Greg and his wife and partner, Pat, lead Samata Associates' 14-person staff and reside in Dundee, Illinois.

Pat Samata, a designer and principal, joined the firm in 1975 after graduation from the Chicago Academy of Art with a B.F.A. in design. She has taught design communication at the Institute of Design, IIT, and has judged numerous national and international design competitions. She is a member of the American Institute of Graphic Arts, the American Center for Design, and the Chicago chapter of Women in Design which named her Woman of the Year 1990–1991. Pat has lectured extensively throughout the country and, along with Greg, has produced work which has been honored by many of the most prestigious and competitive design forums in the world.

GS: A partner and I started our own design business in 1974—right out of college. We didn't know how to run a business; we had no money; and we had no clients. All we knew was that we wanted to be designers—whatever that meant. Eighteen months later we were in debt, broke, and almost out of business. My partner left, and I stayed with the firm.

PS: It was 1975, at the height of the '70s recession, and I had just graduated from college. All the firms were laying people off. And I was sending out résumés and going on interviews, and having a terrible time finding a job. I had heard that Greg had a design firm, so I wrote him a letter, and he wrote back. He told me later that that was the only time he ever responded to a résumé with a letter. He typed the letter himself, and it was funny because he typed in the small initials of a secretary who didn't exist. I came in for an interview and started doing free-lance work.

GS: Our biggest client was Kemper Insurance, which was a big deal. I think that we were able to do as much as we did with Kemper because we took those little jobs—the 3″ × 8″ insurance stuffers—that no one else cared about. But we cared. We did everything we could to make those little jobs outstanding. And we were actually winning awards and getting recognition.

PS: Getting work was difficult, though, because unlike most young designers who usually work for one of the bigger firms, gain experience, get a few clients, and then branch off, we were truly starting from scratch. We didn't have some of the benefits of working for a larger, more established firm.

GS: We made a conscious decision after three years to break into the annual report market. We made the decision, but how do you get the business? How do you get the job without the experience? Finally, through a friend of a friend, we were introduced to somebody who had a PR firm and hired us to do the annual report for Helene/Curtis. That was the first big annual report we designed.

PS: With the Helene/Curtis annual report in our portfolio, we were able to walk into the door at Illinois Bell. That was an interesting story, because we've always been located outside the city of Chicago. We started in Barrington, and

then five years later moved to Dundee. Illinois Bell wanted to hire us, but they were concerned that we were located so far outside of Chicago. So we rented a tiny space in a Chicago photographer's studio, printed up business cards with our Chicago address, and Illinois Bell hired us.

GS: We used the small studio space to get work. People said that we would never get annual report work if our studio was in Barrington or Dundee. We said, "Why not?" They said, "You have to be here." So we rented this space for $200 a month and equipped it with a phone, conference table, and two drawing boards. We could tell clients that we had a service office in Chicago. I think we actually went to the studio ten times in six years.

PS: It's interesting how fax machines and Federal Express changed all that. Now it doesn't seem to matter where you're located.

GS: After we designed our first big annual report, the ball started rolling, and we designed one after the other. But we didn't know how to charge for our time. We didn't know how to structure a quote for a job. We just had no idea. Once Pat and I were in a meeting with Illinois Bell, and we gave them a quote. We were afraid that we bid too high, but we got the job. It was only later that we learned our quote was half that of the competition. At the time, the money seemed like a fortune. It was six years into the business before we were making any money.

PS: More and more companies sought us out to design annual reports. Ninety-nine times out of 100, the clients found us. We did not cold call. Although Chicago is a big city, it has a very small design and PR community. So word got around.

We moved into a bigger office (400 square feet instead of 250) and hired a secretary and a production person. In addition to designing annual reports, we were doing identity work and brochures. Now we've grown to a 14-person office, and we're pretty comfortable with this size.

GS: I think personality has 80 percent to do with our ability to get work. I grew up in the restaurant business and have been in front of the public since I was eight years old. The customer was always right, even if they were dead wrong. It has a lot to do with personal-

ity and being comfortable with yourself. We're not afraid to be ourselves in front of other people. What you see is what you get. I think people feel comfortable with us, and then they like our work.

PS: The comfort-level thing is everything, and clients love the fact that we're a husband and wife team.

GS: You might think that we don't have anything to talk about. But when you're working together, building something together, it allows you to focus more on your personal relationship instead of focusing on politics at the office and problems with your boss.

PS: Once, we were designing a big book at Herman Miller. They said, "We'd really like both of you to come in." I said, "Well, we have the baby." They said, "Bring the baby with you." So we brought the baby on the plane, and they had a babysitter there for us. He came to half the meetings.

GS: Having a family and running a design business does work. Designers think that we have to work 24 hours a day and live and breathe design. And we do, but having a family is such a big part of life, and you can really spend time with a child in this business. Even if you don't own your own business, people today are open and understanding. There are many ways to work out the situation. I would tell anybody that they're making a big mistake by not having a family if they think they can't work out the details.

PS: My priorities have shifted since we started our family. My career still means a lot, but not as much as it used to. The children mean more. And it's hard: I juggle a lot and sometimes I feel that I spread myself a little too thin. But if I had to do it over, I'd probably do the same thing.

GS: Caring for a child is a much bigger responsibility than doing an annual report. And that was a lesson I had to learn. I have to continually make sure that I don't fill my schedule up to the point where the family gets no time.

PS: Technology has allowed us to design more accurately, more efficiently, and more profitably. We always said that we didn't want to be typesetters, and now we are. We hated it at first, but now we love it, because it gives us more control over the end product and is an extra source of revenue.

We charge separately for typesetting—just the way a typesetter charges. We develop a quotation for each job and present it to the client up front. Each function in our design and production process has a different billing rate. So if we spend 12 hours typesetting something, we charge for 12 hours at the typesetting rate. We're really up front about money, what we bill, and what we think our work is worth.

Clients usually send text files on disk. Sometimes they do all the inputting and keystroking. The downside is that we aren't proofreaders. Proofreading is the client's responsibility. Of course, we're willing to hire an outside proofreader if clients ask.

GS: The technology is a big financial commitment, and it's constantly changing. We've spent over $420,000 on computers and software in the past six years—that's $70,000 per year. We've invested $8,000 in fonts alone. We recently spent $55,000 on an 11″ × 17″ color printer. And this year, we invested another $150,000 in Power PCs, printers, and a broadcasting-quality editing suite for motion picture and interactive work.

Eventually, we'll do color separations here, too. The next few generations of high-speed scanners will allow us to do that. There's no question in our minds that this business is going to generate less paper and more celluloid—and film and motion are going to become a part of this in a much bigger way with the CD-ROM technology. In a few years, our firm will probably have another million dollars worth of motion picture technology.

I believe that in five years any design firm without a background in technology will have a very hard time competing and making a living. We're already hooked up to clients on ISDN outline, which is a direct-digital fiber optic line. We type something on our screen and it comes up on our client's screen at the same time, real time. The future is no meetings and no art boards, but video conferencing and transmitting everything over the phone line.

PS: Technology has made us more productive in our accounting area, too. Our bookkeeper used to do all the accounting by hand. Then we bought her a computer and the proper software, and now she is doing the accounting for a 14-person office effectively and efficiently.

GS: If I were starting my business today and didn't have any money, I would rent computer time and figure that cost as a business expense. Or I would buy used equipment for about $10,000. That's still a lot of money, but there are finance and lease options available. You have to consider the equipment as a fixed cost, as overhead. Five years ago I would have said differently. Before, hardware meant a drawing board and chair. Today, it's a computer, and I would suggest that any designer start at the Power PC level, because that allows you to do everything you need to do. Make the investment, because it will make a difference.

PS: Although technology has many benefits, I think that there are also some downsides. First, it is expensive and changes rapidly. Second, so much of today's design looks like it was done on a computer. We have a rule in our firm that if a design looks like it came off a computer you had better start over, because we don't want the technology to get in the way of the idea.

GS: What we're selling is the thinking, not the technology. The typewriter never made anybody a better writer. The computer's not going to make anybody a better designer, and more technology isn't going to help solve design problems. More technology is going to make solving design problems easier, faster, and more profitable.

PS: Although the most important aspect of design for us *is* the idea, you still have to learn how to run a business—it took us years to figure that out. You have to learn what you're worth in the marketplace and what your client thinks you're worth. You have to have a good bookkeeper who knows how to collect invoices. You have to learn all these things. But more than anything for us, it is the focus on the idea and the problem solving and trying to create something that's never been done.

GS: If you listen to your client and create a successful solution to their problem, if you really solve the problem, it doesn't matter how radical the solution is. It doesn't matter how wild the design is. If you solve the problem—no matter how conservative the client is—they will buy it, and it will work for them.

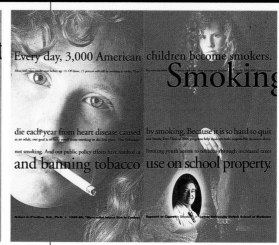

Brochure for the American
Heart Association of Metro-
politan Chicago.

Spread from the 1994
Sensormatic Annual
Report.

Spread from the Gendex
Annual Report. Gendex is
the largest producer of
dental X-ray products in
the United States.

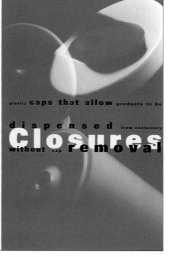

A cover and spread from
the 1993 AptarGroup
Annual Report. The
company manufacturers
a broad range of dispens-
ing products worldwide.

YMCA of Metropolitan Chicago annual report features children from around the world who are involved in programs sponsored by the YMCA.

An annual publication of Simpson Paper, Neo celebrates individuals and companies dedicated to innovation and rediscovery.

A cover and spread from the 1994 IMC Global Inc. annual report. The report tells the story that mankind's most basic need—food—will be met.

A holiday greeting for an engraving company expresses the fundamental message of love and good-will through the artwork of children at risk.

A 3⁶/₈″ × 4″ announcement welcoming son, three-pound Parker Hart Samata.

Ellen Shapiro, a graphic designer and writer, is president of Shapiro Design Associates Inc., the New York firm she founded in 1978. A native of Los Angeles and graduate of UCLA's College of Fine Arts, Ellen was UCLA's art director for alumni and development publications before coming to New York in 1972 to assist the late Herb Lubalin, one of the world's most influential art directors and typographers. In 1989 she won an international competition to art-direct several issues of Upper and Lower Case (U&lc), *the publication Lubalin founded. Increasingly involved with design issues, Ellen regularly writes for professional magazines, including* Communication Arts, Print, *and the* Journal of the American Institute of Graphic Arts. *She is the author of* Clients and Designers, *published by Watson-Guptill, a book that features interviews with CEOs and managers responsible for some of the most successful marketing communications of the 1980s. For the past three years she has been contributing the "Clients and Designers" feature series to* Communication Arts. *A frequent lecturer and competition judge, she has taught at Parsons School of Design and at Pratt Institute, and has served on the board of the AIGA New York chapter.*

In 1994, Shapiro Design celebrated its eighteenth birthday. Sometimes it's hard to believe. Especially the fact that I'm not regarded as a "young designer" any more.

All of us who survived the recession have been through a lot since the first edition of this book was published. The repercussions of the 1987 stock market crash—seeing client companies merged or acquired, budgets cut, communications departments closed—were tough. But those aftershocks finally seem to be receding, at least in New York. The design business is starting to feel good again. Good, but different. And I think I like it better.

In the last few years I have downsized the company, focused more on work that I personally enjoy, created an office space that I find a pleasure to work in, and made a total commitment to computers.

Although the computer has streamlined the way typesetting and production is handled here—and allowed us to create complex information graphics—I don't think it's affected my overall design sense. I admire the best work that's being done in many genres—from modernist to new wave. But I've continued to work in my own mode, which is probably best characterized by words like "clean" and, I hope, "classic." I'm interested in crystal-clear communication, fine typography, and first-rate illustration. I most dislike imitation—bad imitation of current popular styles. All clients deserve better than that. The intent of my work is to advance my clients' positions, not necessarily to look good in design annuals. And I spend as much effort refining the words as the design. Everything produced here has a purpose: to get people to change their minds or take action; to build a brand or build consensus. I can't produce unreadable design because I want people to read every word I write.

We're working on corporate identity, advertising, sales promotion, and capabilities and recruiting brochures. I think my firm is able to attract and keep clients because they can count on me to manage complex projects from concept through production. We'll study a client's market position, conduct informal surveys, and submit recommendations on positioning and strategy before any design work begins. I write the copy for almost every piece we produce, and I believe this capability gives us an edge. It's interesting that people rarely criticize writing the way they do design. They don't say, "What about this verb?" or "Why is this comma here?" the way they criticize color or layout. Thankfully, there aren't any software programs—yet—that advertise: "With absolutely no talent you can write this beautiful paragraph in seconds."

When I started in business in 1976, my capital investment was $2,500, a gift from my parents. In those days you needed a phone, typewriter, drawing board, rubber cement bottle, some pads, pencils, and markers. I think the most expensive piece of equipment we invested in was a Rapidograph set. Today I can't imagine operating without a Mac Quadra work station for each employee. Now, like other new business owners, graphic designers have to make a serious financial commitment; it's impractical to think, "I'll work out of my apartment, and if it doesn't work out I can always get a job."

Most of our firm's work comes through referral. It's true that if you do good work, your name gets around. Not only within the client company, but also to the client's colleagues at other organizations. That doesn't mean that I don't go out on presentations any more. I probably do so more than ever. At one time, like many designers, I thought the secret of success was having a salesperson in a three-piece suit. But I learned the hard way that it just doesn't work. It's important to meet potential clients personally. They want to meet, size up, and get to know the designer, not a salesperson. This involves a lot of time, but it's the most crucial time you can spend. If you're not happy with the way something looks when you come back to the office, you can always change it. But if someone's out there representing you and says or does the wrong thing, that opportunity is lost forever.

Cultivating industry specialization is helpful. If you can speak intelligently to managing directors and senior vice presidents about their business concerns, that expertise can lead to key assignments. For example, 90 percent of our clients are in service areas such as financial services, law, accounting and health care. Rarely are there glamorous products to photograph, but I find it challenging to come up with visuals for concepts such as "channeling anger," transportation law, private banking, and credit card acceptance.

I never show a comp I wouldn't want to see printed. My rule of thumb when working with employees—and freelancers—is: I won't show a client a concept that isn't as good or better than if I'd done it myself. And I've been lucky enough to have employed some talented people who've produced some very strong work. I also think it's terribly important to give them proper credit for it.

One of the most important lessons I learned about the creative side of this business was from a communications director at a Fortune 100 company where they let design firms "try out" for major jobs by giving them the opportunity to work on the smaller ones first. I was called in about 15 years ago to design a four-page newsletter for a Midwestern division that makes plastic films for wrapping meat at supermarkets. The newsletter was called "The Cryovac Plastic Rap," and I thought the whole thing was beneath my dignity. So I assigned it to a new junior designer. He did several front page treatments, none of which I was in love with, but I thought they were "good enough" for this particular project. Well, when I brought them to the client, she looked me right in the eye, and announced, "Ellen, you didn't do these, did you?" I admitted I hadn't. She gave me another week to work on the project, saying, "Let me give you a few words of advice: Never let this happen again." I didn't, and will always thank her for that.

If you are a firm principal, your first responsibility is to your clients, not your employees. This may sound somewhat heartless, but I've learned that if you can't handle it, you shouldn't be in this line of work. Being a good manager means getting exactly what you want, exactly what the project needs. It also means being able to sell the concept to the client. It's great to bring in one comp and get immediate approval. But on many occasions I have to explain why something will work or why the client shouldn't muck up the design or the copy.

The most important thing I've learned about the business side sounds painfully obvious: You've got to bill and collect enough each month to pay all your overhead expenses and have a little left over! Since 1989, when we experienced what is politely called a severe cash-flow problem, I've maintained a strict monthly budget that lists our fixed expenses (rent, utilities, leases, service contracts), salaries, insurance, taxes, monthly average of supplies, T&E, postage, and so on—that is, every dollar it takes to keep the doors open and the business running. The budget is set up in a spreadsheet so that if a number changes (like an increase in health insurance rates), a new total is automatically generated. We've got to bill at least that total *in fees* every month. I know this seems almost simple-minded, but it's a real key to survival. Design firms can get into trouble when the money clients paid for printing or other reimbursable expenses is used to pay the rent or other operating expenses. Or, worse, Uncle Sam's money that was withheld for payroll taxes or collected as sales tax is used for overhead. This can only go on for so long.

By 1989, the problems caused by the economy were compounded by certain errors I made. Maybe because I'm a woman, I didn't have quite enough confidence in my own abilities and common sense, and when I got to a certain level of success, I thought that I couldn't manage it "all by myself" any more. So I turned to "experts," such as consultants, when I should have been out there pitching myself.

I ended up turning things around by cutting back on every expense, taking a hard look at what clients want and need, and offering services that reflect what I do best, not following some abstract notion of "what a top design office is like." For example, I recognized that companies with in-house desktop publishing departments need guidelines. They need design—and editorial—standards, style sheets, and templates. We have been developing automated proposal formats for professional service firms who typically respond to ten to thirty requests for proposals a week. I will work with clients to organize the material, edit the copy for clarity, develop prototypes, adapt the format to their own software, and produce a manual.

I designed our new offices myself. This was an eye-opening lesson. No one understands your needs better than you. And perhaps you, the designer, can begin to master a new design discipline. I found myself drawing electrical and ceiling plans and deciding where walls should be demolished. Not only was the process satisfying and enjoyable, I will never again have to ask myself, "Why did they put the supply closet right here?" I am much happier with the way the space functions, the color scheme, furniture selection, and lighting. I can't imagine now how a designer could let someone else make those choices.

I've also been spending a good deal of time researching and writing about professional issues. *Each* designer's problems are *all* designers' problems. There's much work to be done raising standards, learning how to be professionals, and educating the public about what graphic design is and can do.

Logo for The Singers Forum, a New York training and performance center for opera, cabaret, musical comedy, and jazz vocalists.

Fundraising brochure and logo design for The International Association of Women Chefs and Restaurateurs, of which Shapiro Design is a founding corporate member.

Capabilities brochure and series of inserts— each illustrated by a different artist—for Richard A. Eisner & Co., an accounting and consulting firm.

Platinum Card Fine Hotels & Resorts Worldwide Directory for American Express.

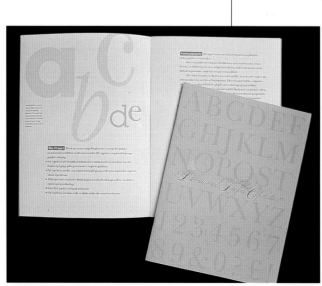

Capabilities brochure for the International Typeface Corporation.

Shopping bag with logo design for Century Time Ltd., Biel, Switzerland, a maker of hand-faceted sapphire watches.

Bouncing Back

Logo for The Institute of Mental Health Initiatives, Washington, D.C. Bouncing Back is an educational program about what it takes to come back stronger after experiencing adversity.

Dialogue, *published by the Institute of Mental Health Initiatives and sent to screenwriters, producers, and directors, encourages film and television shows to "portray positive modes of human interaction" and thus influence public attitudes and behavior.*

Annual report for Electro-Biology, Inc., a New Jersey manufacturer of electronic bone-healing equipment.

GRAMMY WEEK
DINING
IN NEW YORK

Logo (right) and guide (below) for an American Express dining program in conjunction with the Grammy Awards in New York.

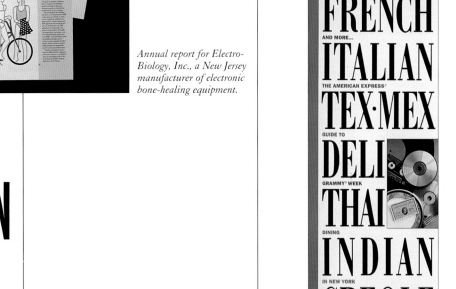

FLATIRON GRILL

Logo for a restaurant in the Flatiron Building, located in the Manhattan district with the heaviest concentration of design offices and ad agencies.

photo: Greg Samata

Born in New York City and raised in South Africa, Jilly Simons now works in Chicago. This international perspective gives her a special sensitivity to the nuances of individual corporate cultures, reflecting her belief that, in a quickly shrinking yet expanding world, design is essential to communication and, therefore, a powerful responsibility.

Jilly's work has been honored, exhibited, and published nationally and internationally, and she has frequently been invited to lecture and to judge design competitions in the United States. She is on the Advisory Board of the American Institute of Graphic Arts, Chicago, and on the Executive Committee of the American Center for Design as well as an elective member of the 27 Chicago Designers.

Concrete opened in December of 1987. The name was a very serious and deliberate choice. It was important to me that it have meaning, and I spent a considerable amount of time researching it. I was looking for a name that was urban and that would reflect a certain simplicity. I also looked into the way I was working at the time, which was using words to create form. Then, of course, there was concrete poetry and all the rest of the natural associations. It was only later that I learned that Chicago is actually considered the concrete capital of the United States.

I am still in the same office I started in. It hasn't changed much, except that now we have three computers and an additional small work station. When I decided to go into business for myself I looked for very economical space so that I would be flexible enough to accept small jobs. Even today, our average project still bills for under $15,000, excluding production costs.

In the years since I opened the business, I've discovered a lot about my fears. Initially, I was concerned that I might not be able to live up to the standard of living I had become accustomed to or that I wouldn't be able to deal with an income that changed every month or with a loss of money some months. But, happily, we haven't had a quarter yet where we've lost money. I've learned that if you just use some common sense in the way you manage things, you can really stretch the dollars. It's simple: Keep your overhead real low. Don't buy cheap, buy smart. Don't buy equipment that you have to fix or replace all the time. Make sure that whatever you're investing in is rock-solid.

We have probably invested about $35,000 in computer hardware and software. I try to follow the advice of an accountant who once said, "Always buy the best that you can afford when you start. Otherwise, don't buy it at all until you can afford it." In retrospect, the only thing I would do differently is to buy a second color monitor right away, instead of the black and white monitor I chose to buy. I was so nervous. And, even though I was liquid enough to pay for all the initial set-up, I was so concerned about cash flow that I took out a bank loan instead. So far, it's the only loan we ever took out.

I must say that I would not have had the courage to start my company if some of my former clients had not expressed a desire to stay with me. When I entered my previous design partnership, I insisted that my partner and I include in our contract an agreement that, should we split up, we would offer our clients the choice of continuing to work with either one of us or going somewhere else with their work. It turned out very well, because all my clients came with me and most of my partner's clients stayed with him.

I have three wonderful and talented full-time employees working for me. When we're busy, my administrative assistant is here more often; she works two days a week when things slows down.

I'm amused when people call and say, "Oh, you're a leading-edge designer." They seem to think we're a real crazy group here. But, we're actually fairly rigid. My day-to-day operations and my business philosophy are simple—extremely simple. We're very traditional in terms of keeping our time sheets, and we are really precise about the way we fill them out. I'm quite pragmatic. I like things to have real beginnings and real endings. Concrete is a congenial place, but it's also very tight. It's lean and it's mean. There's no fluff, and there's no padding. I don't spend hours and hours writing huge reports. I try to keep all paperwork to a minimum. And because we don't have fluffy, padded budgets, we're good at doing low-budget work. We're able to wheel and deal and get the most out of the dollar.

When a call comes in from a new client, I set up a meeting to show our work. I enjoy bringing new or prospective clients to our office so they can get a sense of who we are. This can work against us, because clients sometimes say, "Oh, you're so small." When this happens I show them complex, larger projects that we produced. I also try to open a dialogue about other designers the clients might have seen; this gives me some perspective.

We don't usually produce big show-and-tell performances, nor do we try to create things especially for prospective clients. In most cases I can't really afford to do that. I really don't push the company's philosophy and strategy. I spend more time finding out about the client. I explain that I am usually the person that the client will be working with initially, but they'll have access to everybody here. Every employee here will know or have access to what's going on with most projects because the office plan is so open.

We usually prepare only a cost proposal and schedule, unless the client specifically asks for a more formal and comprehensive proposal. Once I've been awarded a job, I'll put together a more complete study, if required. I base the cost proposal on previous projects we've done and on the type of client we will be working with. We have pretty good documentation to keep track of our time and profits on finished projects, so I'm able to refer to these records when we develop new proposals. I aim for a 20- to 30-percent profit margin on each job, but it varies an awful lot. I particularly enjoy working with small, nonprofit clients and start-up companies with limited budgets who need design solutions that are realistically tailored to their resources. Because of our size and low overhead, we have the flexibility to respond to these situations creatively and still make a decent profit on the projects.

Sometimes, a more formal proposal or marketing study is required, in which case I often hire a writer to work with me on the proposal. I brainstorm with the writer and provide most of the necessary information.

If a client accepts our proposal, we go to work. What I find so thrilling about all of this is process and intuitive thinking. I always try to let the human element emerge. We do a lot of research and use many resources. We're dedicated. We're excited. If we find that we have to spend twice the time we had allowed for, we do it, because we are determined to give the client the very best we are capable of. And none of this extra energy, determination, and dedication is usually reflected in our final billing. But we are also equally determined to have a good time doing the job.

Historically, we haven't done big "show-biz" color presentations. However, this is changing. With the help of the computer, it's become a lot easier to do color comps at a reasonable price. I prefer to use QMS Canon laser prints because the work still looks like it's in process. It gives you a chance to nurture. I like to feel that there is some room for the idea to grow, live, and develop.

Although we now do most of our type-setting in-house on the Macintosh, we still send some work out to a local type-setter. It depends on the job. For example, we send a magazine to a typesetter who has all our coding and styling down pat. The client knows the system perfectly. It's gotten to the point where we barely have to mark up the copy. If we typeset that job in-house, it would really jam things up. And the typesetter does a beautiful job—book publishing quality. In this case, it is also a unique cut of a font that we can't match on the Mac.

I usually break out typesetting on our proposals and invoices as a separate line item. And we always keep track of time spent typesetting as a separate item on our time sheets. But I have to admit that, nowadays, it's hard to define where the line between typesetting and design is drawn. I also have to admit that the typesetting part scares me somewhat because we have a tendency to make errors in both the typesetting and the proofreading. It can be an absolute nightmare. It would be a mistake to count on the client to always pick up the errors, which means that every now and again mistakes will creep in and go all the way through. To try to deal with this possibility, we insist that clients sign off on all the typesetting. We make it clear that we do not take responsibility for proofreading. If a client is not confident about their own proofreading abilities, we will recommend hiring a proofreader. If I had a larger office, and I was specializing in larger manuals or annual reports, I would definitely hire a professional type-setter/proofreader to do the typesetting in-house.

I bill in phases, based on the terms of the proposal. With most clients, I require an advance up front, usually one third with an ongoing client, one half with a new client. I've also learned to be sure to build in all the conceptualizing

in the early phases of a project, rather than pad the end.

I have to say that we rarely exceed a budget. If the client requests changes that cause us to go over budget (we have a contingency of 10 percent), the overage is documented and faxed to the client immediately. Then the client must approve the overage before we will proceed.

We have no room for mistakes. I'm set up as a sole proprietor because I've been advised to use this structure for tax purposes. And I do have considerable liability insurance.

If I'm asked to bill large print jobs through my company, I request that clients advance me enough to cover the entire printing bill, which I set aside in a separate account until the printer bills me.

I rely almost completely on referrals for work. I refuse to do speculative work, and I've probably lost some accounts because of this. When a prospective client requests that I do work on spec I tell them, "In order to solve your problem I will have to learn everything I can about your company or your institution, which means I will have to spend a lot of time investigating and researching. And there's absolutely no way I feel confident developing an intelligent position without this research. I can tell you what I think the job should look like, and how I would approach the project, but I will not be able to stand behind any of my suggestions." I'm always available for dialogue, but I value what I do and don't believe I should give it away, unless it's to a just cause I would like to help.

My advice to designers just coming into the field is first to find out if you're even good enough to stay in the field, because there are a lot of people who aren't qualified. I think the competition is going to get a lot tougher than it already is. The other thing that I would tell a student is to have a ball and experiment as much as you can, but learn how to do at least one thing really, really well, especially if you're not a strong conceptualizer. Learn to be highly competent at technical and production skills initially, so you can secure that first job. After you're in place, start showing your employer how you think, which, in the long run, is probably what will be the most valued thing in you.

Series of covers from
Reserve/7, a quarterly
publication of The
Federal Reserve Bank
of Chicago.

Cover and wrapper for "Things Are Going to Get
Ugly," a promotion for Mohawk Paper Mills'
line of unique, imported papers. The promotion
alerts designers to expect the unexpected and warns
that their perceptions may be altered.

Cover from a lingerie
catalog as fine art piece
for New York artist Sarah
Schwartz.

Letterhead and business
cards for Chicago photog-
rapher Peter Rosenbaum.
The address block forms
a typographic portrait of
Peter.

A Concrete brochure,
espousing a hard-working
philosophy in a numbered,
limited edition.

"Over My Head" double-sided poster playfully expresses the serious roles of fear and risk in the creative process.

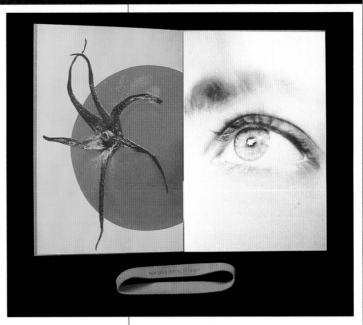

This brochure, published by Concrete, challenges viewers to stretch logic and create visual associations of their own.

fax > 3008
312 337 tel > 0008

craig bauer

320 WEST OHIO STREET
seventh floor
CHICAGO, ILLINOIS
606

HINGE

Business card (with the ability to hinge) showing naming and identity for a Chicago recording studio.

An announcement for a legal practice concentrating on matrimonial and family law.

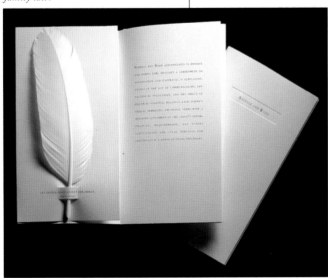

ST AND

1 north state street | suite 1100

chicago illinois 60602

tel 800 257 8263 | fax 312 642 4467

sheryl i. tucker president

Business card showing the identity for Sheryl Tucker, STAND, a company specializing in unique projects on which the owner works in close conjunction with other individuals. The company name combines the initials of the owner's name and the word "and."

© John Goodman

Tyler Smith is a creative director and graphic designer in Providence, Rhode Island. He has won numerous national and international graphic design awards, including a gold and silver medal from the New York Art Director's Club. His career has encompassed both design and advertising.

Feature articles on his work have appeared in Communication Arts, Art Direction, Photo/Design, Graphis, *and* Print *magazines. He has lectured at The Smithsonian Institution and has judged design, advertising, and photography shows throughout the country. Several posters he designed are represented in the permanent collection of the Cooper–Hewitt Museum, New York. In 1984, he designed the "Health Research" postage stamp for the U.S. Postal Service. In the same year, he was named Rhode Island School of Design's Alumnus of the Year.*

His specialty is fashion, primarily menswear. His clients have included Joseph Abboud, Ann Taylor, Barry Bricken, Ermenegildo Zegna, Evan Picone, Luciana Barbera, Southwick, Ferrel Reed, The Gap, and Louis, Boston. Others have included Ropes & Gray, Estee Lauder, Reebok, Toto Ink, Mead Paper, and Rhode Island School of Design.

Projects have also been done for artists Gretchen Dow Simpson and Sergio Bustamante.

It's very simple: I don't have a portfolio. I don't want tons of work. I don't want lots of employees. I've always liked to be self-sufficient and wanted to have my own identity. It's me. It's my nature.

I've already tried this whole thing with lots of employees in big organizations, and it never worked for me. I'm sure it works for some people. Some people love to have lots of little elves scurrying around, doing things for them. But you've got to be very honest with yourself about what you want to do in your business and how you want to spend your life. If you want to run a business like Pentagram, you can create this thing, have power, and be a real force in people's lives. You're the dad. You give them money and bonuses.

I never was turned on by that stuff. If you get into a situation where you're forced to keep generating work, you become controlled by the work instead of controlling it. Then you have to hire more employees. Then you have to get more work just to feed the machine. It's a vicious circle. I've got lots of employees, but they're called "free-lancers." I find that free-lancers, who have their own businesses, work harder than employees, anyway. They get things done on time, and they don't take you for granted. It's a hundred times better than having employees, because employees get complacent, ask for raises, demand more benefits, and try to make their personal problems yours.

I like to be my own person, and I hate the idea of being controlled by anything or anyone, especially employees. So, for me, this works best. I do everything myself and I do it immediately. Whether it's wrapping up a box to send to someone or faxing something to a client, I just do it. I answer the telephone myself. It's not that hard to do. I find that when you delegate tasks to others, you still have to spend a lot of time checking their work. You say, "Did you do that?" and maybe they answer, "Oh, I wasn't able to get to that today. I'll do it tomorrow." And it stays on your mind all day and all night.

I work very loosely. From the very start I learned that clients—at least my clients—don't really expect comps. On the first project I did for Mead, for example, I talked to them about my idea and showed them some wonderful paintings of Native Americans I wanted to use, and that was it. No drawings. No layouts. No comps. Pure concept. Later, as I worked on the actual design, I faxed sketches and pages to them as the job progressed.

Actually, I don't do everything myself—all my production is done by a free-lance studio. I usually come up with ideas and concepts, and the production studio takes it from there, doing all the mechanicals and typesetting. I'm still a designer, though, and I concern myself with the small details. So, the production studio faxes things to me and I'll fax things back, making changes and corrections until the job is just the way I want it. I even have them send their bill directly to my client, with no mark-up from me.

I don't work on an hourly basis. I don't even keep time sheets. My larger accounts are billed a monthly fee because it's an ongoing image thing. If the job will extend over a year's time, we say, "Well, it's worth about this much money." Then we simply divide the total by twelve and I bill them every month. I probably put in more work than I was paid for by some clients. For others I probably put in less. For me it averages out.

Because I've chosen to work this way, I've had to figure out how to do it efficiently. I don't like generating layouts, for instance—they take up too much time, restrict your flexibility, and are usually an unnecessary expense.

I've sort of fallen into a mode where most of my clients are very high-end, very expensive. I believe the best thing a designer can do is to find a niche and to do something very good and very visible. Then other people in that specialty will see it and want to work with you. That's how you get out of working for only local clients.

Right now I've got four or five different projects going. A shirt company wants me to do some packaging for them, I've got to see someone tomorrow about a TV commercial, plus I'm involved with a health care company, a corporate identity project, the Mead project, and a shoe company. Sometimes a potential client will ask me, "Would you send me some of your work?" So I'll put a few things together that I think are appropriate and mail them off.

Then little spokes go out from there, like working with paper companies and printers. That's a little area that goes directly to designers. So I can design for designers or for artists. The thing students ought to know, though, is that they shouldn't fall in love with the computer and the tools of design. These tools—layout and type and paper and sometimes even photography and illustration—are the ingredients used to create a piece of communication. The communication itself is the main thing and idea.

Yet in order to build a reputation, you have to take chances. And you have to convince clients to go with your ideas. Fortunately, I have clients that are willing to do things that are unusual. Maybe that just reflects the attitudes of the fashion industry. They're open to new ideas.

Every designer wants to do good work, but he or she also should want the freedom to be able to choose. Do you really want to work on this account, or don't you? In the beginning I was very conscious about having to make every project profitable, plus do an incredibly good job. Now I find that freedom is the most important thing for me. If I can have that, I'm happy.

We are in a very, very unusual field, because we end up spending so much time arguing with the very people who will be paying us. No one else does that, no one in any other profession. We tend to be very idealistic and really get into our work. You can do the greatest stuff in the world, but it's over if you run your business poorly. You have to be a business person. You have to make a living, a good living, or else it all falls apart. You have to think in terms of making a profit. If you have to do some work at times that isn't that exciting but that subsidizes other work, you should do it. I'm very pragmatic about that. You can't do good work if you're out of business. So yes, by all means, take a job if it pays well, even if it's not going to be a winner. Do it. Then find people who appreciate good work and do good things for them.

We also tend to think of our income as having to come out of the business itself and nowhere else. Sometimes you need to get out of that kind of thinking and invest in other things. I'm involved in a health care company. I'm involved in a bed and breakfast and real estate venture in Costa Rica that allows me to visit that country a couple of times a year. You should also travel and read and see movies and talk to different kinds of people and taste different kinds of food. Have a family, too. That's important.

These are the things that enrich you— different kinds of thinking and different kinds of people, creative people who are not artists or designers. Creative executives, creative lawyers. It actually enriches this business to do that, but you also learn about people and how people think in other ways.

Ad for Louis, Boston.

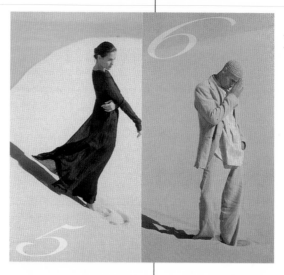

Spread from a brochure
featuring linen clothing
for Louis, Boston.

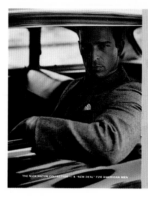

Spread from a
fall catalog for Louis,
Boston.

Cover and spread from
a brochure for Ropes &
Gray, a law firm.

Cover from a jewelry catalog for Mexican artist
Sergio Bustamante.

*Cover and spread from
a paper promotion for
Mead Paper Company.*

*A spread from a catalog
for clothing designer
Joseph Abboud.*

*Covers from a pair of
brochures for clothing
designer Barry Bricken.*

Calendar for Universal Press.

153

When Rick Valicenti, of the Chicago-based firm, Thirst, was asked to furnish the author with an up-to-date bio, he requested that I simply use the words: Rick Valicenti's bio goes here.

In a profession that has long taken itself too seriously, Rick Valicenti's self-deprecating humor and determination to let self-expression drive the work of the studio are a welcome breath of fresh air.

After graduating from Bowling Green State University, where he studied painting, Rick worked in a Pittsburgh steel mill before earning an M.A. and an M.F.A. in photography from the University of Iowa. Before starting his first business, R. Valicenti Design, which he began in 1982, he worked for the famed Chicago designer, Bruce Beck, for four years.

In 1988 Rick completely reinvented his business and emerged as "Thirst," or "3st," as Rick sometimes likes to spell it. Rick's unique blend of manipulated "audio-typography" and rampant images has made Thirst one of the most successful and highly imitated design firms in the world.

On April Fools' Day, 1982, in the middle of that last recession—which tells you a lot about me—I started my first business, creatively called R. Valicenti Design. I had been working for Bruce Beck, a first-rate Chicago designer. Bruce and I had talked about all kinds of collaborations, but in the end I chose to pursue the path of least commitment and courage, and open my own business. I had no clients, very little cash, and a wife who wasn't working because we had just had our first child. I guess it was a stupid thing to do.

From a distance, I looked to designers a little bit older than I to see how they were managing their businesses. I would call people like Michael Vanderbyl or Woody Pirtle and ask them questions like, "How many projects do you have to do in a year for ten of them to be wonderful? One hundred? Two hundred?" They would reply, "No, no, we only do 20, but we make sure that all of them are really terrific." I would think to myself, "My average project bills for only about $200. I couldn't possibly make a living billing only 20 projects at $200 a project."

My naive observations had led me to a distorted definition of success. From hanging out a bit with designers at cocktail parties and the cheddar cube routine, I thought that success was defined by how busy I was, how many annual reports I was able to attract, how large my office was, and how many employees I had—as if they were trophies on a book shelf.

I tried to fit myself into that mold, but the more I tried to fit in, the harder it became to feel comfortable and satisfied. In 1987, I realized that I just could not play this game any more. By then, I had about eight very energetic and talented employees working for me. We were doing very good work, service was impeccable, and my follow-through was really good. But I wasn't really happy. I wasn't happy because I wasn't doing the work. I wasn't enjoying the intimate, hands-on, collaborative experience of design with both my clients and those I chose to collaborate with, which is the way I like to work. The whole process had become very painful. In the end, it wasn't my choice of clients or employees, it was me.

So I decided to work for people who would respect me for my ideas instead of just for my ability to get a job done. I told my corporate clients that I wanted to change the name of my firm, that I wanted to set up a studio with a different tone, a studio where people came from different disciplines, a studio where we were energized by our differences instead of threatened by our similarities. My clients thought I was coming from left field, and most chose to leave me and pursue work with designers who, in their opinion, were more "service-oriented."

Professionally, I wasn't any less service-oriented, I just wanted to be more involved in the conceptual phase of a project. I was interested in discussing what it was that *really* needed to be done, what needed to be said, and how it would be said—the essence.

In addition to losing most of my clients, I encouraged all my employees to pursue change. Later, when I welcomed new collaborators, the most important difference was that I didn't seek them out, they came to me. They went out of their way to work with me. They came in with the knowledge that I was going to be the director of every project, and that I was going to ask them to reach inside themselves as much as I reached inside myself, and that we were all going to subscribe to this intangible idea called *thirst*. The *thirst* for the elusive solution. The *thirst* for the ideal.

The word *thirst* became the foundation of the philosophy. Today we don't use it as a stylistic judgment. We use it as an assessment of whether what we're doing is the "real deal" or not. We ask ourselves how it feels inside. "Is this the best we can do? Is this an idea that belongs to our time, to ourselves, to this project?" We try to find clients who realize that the journey and the process can be as exciting, exhilarating, and challenging as the final product.

Thirst's first important design project —I remember literally giving it away— was the *Tannhaüser* poster for the Lyric Opera of Chicago. After this first project, I did more work for other cultural groups, small projects mostly. This phase lasted for a couple of years. Then a few local Chicago manufacturers asked me to do some projects for them. I said to them, "Here's what you can expect from me. Here's what I need to have from you in terms of a dynamic, in terms of an exchange. Are you interested? Because if you're not, it won't work. If you wish, I can suggest the names of three or four local designers who would be better suited to work with you." Surprisingly, the clients came on board, the work I did for them made some noise, friends, and money, and, as you know, success generates work.

It's an intense game, though. The way to play it is to be prepared to perform. You have to be as smart as the MBA across the table. You have to make your shortcomings invisible in light of your contributions in either common sense, creativity, the use of language, or the development of a strategic image that might be more provocative than just twelve paragraphs of copy. You have to be prepared to challenge the status quo … and not with mere lip service.

When you get right down to it, my objective is to accomplish something special for the client, by being as smart and as important to the process as I possibly can. My reward comes from being able to make the process yield a fantastic result.

Thirst has enjoyed a steady, gradual upward curve in billings since the day it opened. There are six of us working together. Every Monday I prepare a schedule listing our projects in order of priority, then we meet individually to review this schedule. Each day I touch base with everyone—either to conceptualize, critique, or to take over at the computer. I'm almost as well-versed with the equipment as everybody else. Almost. I'm *really* well-versed on the telephone.

The whole process becomes very collaborative. I bring to that collaboration information I have gained on the outside; my collaborators share information gained on the inside.

We all keep time sheets so we always know where we stand in relationship to what we're able to bill or what the job is really totaling. We track our time in quarter-hour increments; 8.25 hours a day is the required amount of time that we need to post, with no more than 1.75 hours in office administrative time.

Administrative time gets billed just as if it's creative time, because "producing" is just as important as preparing the art work. We do the invoicing every two weeks. We compare the invoice or the posted time against the proposed time. We charge one third down, and we bill monthly until the job is finished. We don't get caught up with transmittals or revision notices, and we don't write a lot of memos. We try to keep things as personal and as "on the telephone" as we can.

If there are major changes in the direction of any given project, we use this metaphor: "You have asked us to take you in a taxi to O'Hare Airport and now you want to go to Kennedy. At this point, the meter is running. How much is that going to cost? I really don't know. Do you want me to give you a number now? If I must, it will be higher than what it will actually be, because I'm going to overestimate. I have no idea where you're going to ask me to go next."

We got our first Macintosh computer in 1987, about two months after we moved here. We grew from a little SE (which just sat there for the longest time) to a IIcx to even more powerful machines like our two Quadra 950s. Except for an occasional sketch or two, 99 percent of our work is done on computers now. But, after working this way for so long, I have to say that it doesn't feel too different from the way it did when we did all our work on drawing boards.

On the other hand, the work itself has changed dramatically. The emphasis has shifted from creating type-driven solutions to creating image-oriented, moving, auditory solutions. As we've learned new ways of doing things, our thought processes have also evolved positively. I think we're beginning to get closer to graphic design the way it must be, rather than just typographic design or the "type in a column, picture over here" kind of thing. "Design Secretaries" (designers who merely pick up a phone and coordinate) have the commodity jobs of tomorrow.

Some firms bill separately for their computer time or for their typesetting. We don't do that. We just bill everything by the time it takes to do it, and by the value it represents to a client.

I see designers scratch their heads and wonder, "How are we going to bill for typesetting? That used to be a line item. How are we going to recoup those costs? Should we add it to our costs?" For me, the answer is "no." We don't add typesetting on top of our design time because it has become fused with our design process. Just because the typesetting is done by us doesn't mean we should bill a typesetting charge on top of our design charges. If designers do this, just as the typesetter went out of business and became an unnecessary commodity, designers too will be seen as piranhas. And clients will eliminate them! Designers are going to have to change and continue to change in a changing world. They can't survive or contribute by old ground rules, on every level of making a living.

The essence of staying in business and remaining successful, personally fulfilled, and in demand comes down to designers being able to convince their clients that they see the world in a special way, can think, and have the brains to deliver, because everything else can be equal. Good designers will continue to separate themselves from their competitors because they have and share the most knowledge, the clearest vision— and the most courage.

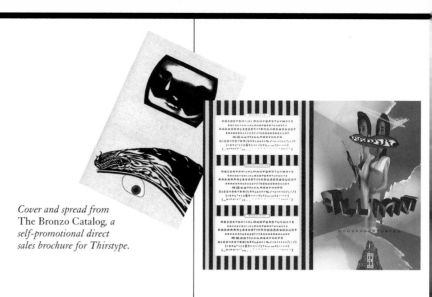

Cover and spread from
The Bronzo Catalog, *a
self-promotional direct
sales brochure for Thirstype.*

*A poster for The Amer-
ican Center for Design/
Apple Computer–spon-
sored conference on new
technologies.*

*Billboard in Germany
for West Cigarettes.*

Cover for Creativity
Magazine.

Cover and spread from
Emigre #26.

Poster for the Arts Club of Chicago, which held a month-long celebration of the Fluxus movement.

Spread from Confetti magazine for a series of articles featuring type designers, commenting on their current feelings toward the profession.

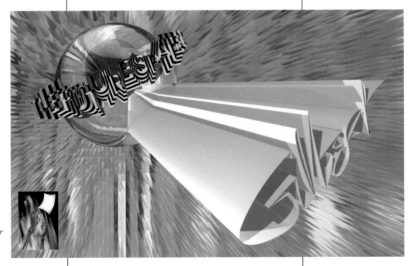

Double page ad for Gilbert Paper in Wired magazine.

Spread from a course brochure for The Color Center, a company providing electronic prepress education and training.

Cover from a holiday card for AGI.

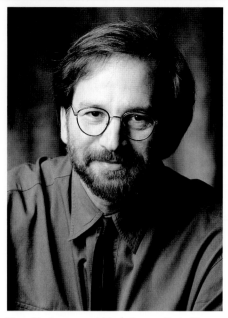

Tom Varisco opened his design studio in New Orleans in 1971.

An active figure in the New Orleans design community and past president of the New Orleans Art Directors & Designers Association, Tom Varisco has been profiled in New Orleans' Citybusiness, *Japan's* Idea *magazine,* Photo District News, *and* How *and* Communication Arts *magazines. He is a past member of the Louisiana Task Force on Design and is currently a member of the American Institute of Graphic Arts. Tom is also a member of the Visual Arts faculty for graphic design at Loyola University.*

His work has won many awards in New Orleans and on the regional and national levels. In January of 1993, Tom designed the official logo for the Clinton administration inauguration celebration on the mall.

A recent project now being implemented is the new signage program for the Port of New Orleans.

In the last 23 years, Tom has had the opportunity to work with some of New Orleans' largest corporations, numerous medium-size businesses, and major nonprofit organizations.

When I started Tom Varisco Designs in 1971, I was scared to death. Everyone told me that there was no way I'd succeed in New Orleans on my own. Too small a market ... which was true. This city is certainly no major market for advertising or graphic design. It's a raging market for tourism. Soon there will be the largest land-based casino and a new sports arena. Tourism doesn't just drive the economy—it is the economy.

About the quality of work produced here: It has improved markedly over the past ten years. I feel fortunate to have moved here when I did, to have seen the changes taking place. The work we produced in the 1970s was pretty dismal, but because New Orleans is such a small market, a few of us had the opportunity to work on many diverse projects. Early on, I was able to try my hand at producing and directing on video. I don't think I would have gotten that chance in a larger market—I certainly didn't get it in Houston, where I spent my first two years as a professional before moving here.

It has been my choice that I remain in New Orleans and as a one-man studio. I have always brought in other talent depending upon the size of the project and the budget. But I've shied away from the responsibility of full-time employees. However, I am seriously considering expanding. So who knows?

Like almost every other designer, I also considered moving to New York. Manhattan is seductive, but the life-style in New Orleans is hard to beat. The humor here is also very refreshing. I think we in the Deep South don't take things (including ourselves) as seriously as people in other regions of the country do. Maybe it's a defense mechanism, given the "quality" of government and education we have—whatever. I just feel comfortable here.

As for clients, I've never been very good at cold calls. Most of my work is for repeat clients. New clients come from referrals from existing or former clients. I've never worked on more than 15 projects simultaneously.

Although the majority of my income has always come from commercial clients, early in my career one third of what I made came from art-directing political campaigns. I've worked on about 50 campaigns, ranging from gubernatorial races to school board elections. I have always enjoyed the adrenaline generated by politicals. The work produced usually gets an immediate reaction and there is an obvious goal in sight, an unavoidable deadline. Because of a prominent political writer and strategist named Rusty Cantelli, I was given a chance to co-produce and sometimes

direct the video messages of the candidates. Nowadays, I still participate in some campaigns, but not nearly as many as I once did.

Before moving to my present address a few minutes from the French Quarter, I lived on Bourbon Street for nine years. My intention has always been to live in the same space in which I work. Maybe in that way I can fool myself into thinking what I do isn't work after all. My studio set-up is quite simple: a drawing table, many reference books, a few supplies, and no computer... yet. But I am being tutored by a fellow designer, so perhaps soon I too will be able to set type with the best of them. While I'm occupying myself with this new challenge, I do employ the services of others who are quite proficient on this new electronic tool.

Because of the computer, work is produced more quickly, and I find myself handling more jobs. I'm not sure I'm making more money than I made a few years back, but I am working harder. Almost every designer I've spoken with has this same lament.

Typically, this is how I work with a client: Before the job begins, we have a discussion about the direction to take and what that might cost. I then send an estimate/agreement for the client to sign. The agreement usually asks for three payments—one third in advance, one third upon layout approval, and the last payment upon approval of the final copy and laser proofs. I prefer that all support suppliers bill the client directly, but that policy can vary depending on the project.

It has never been my intention to surprise a client with hidden costs or unexpected final designs. I always try to include the client from the beginning so that he or she can get a better understanding of the process and see where we are going.

Depending upon the constraints of the particular project, the client usually sees a pencil sketch first, then a comprehensive layout. Next comes laser proofs with artwork in place before the disk goes to the printer. More often than not the client and I both see the random color proofs, and we both review the negatives. I also make it a practice to be present at all press checks.

There was an article recently in the AIGA newsletter about the devaluation of design. The article covered the aesthetics of particular schools of design and touched on the fierce competitiveness in the design market. It does appear that there are many more designers out there these days. Maybe it's easier to be a designer—just get a computer, and so on. For the past nine years, I've taught a senior design class at Loyola University here in New Orleans. Each year I get more than a few students who were initially fine arts majors but were discouraged from following that career because of the promise of money and glamour in graphic design. These students do not have a true appreciation of graphic design; they simply see it as another way to make a living. Money was never my main motivation when I attended the University of Southwestern Louisiana in Lafayette. We very rarely discussed money. Our primary goal was to produce excellent work. We thought the money would follow.

Today I stress to my students the same thing that was stressed to me when I was an undergraduate—concept is the most important aspect of design. I ask my students to read more and think independently. I encourage them to develop their own distinctive way of looking at life. Being well-read, being aware of the changing pop culture scene, and having a sense of humor should serve as an appropriate platform to propel them to produce better work. Then of course there are always those reference books and the ever-present computer. I do give my students one more bit of advice: Don't rely on the computer to solve all your problems.

A spread from a brochure intended to promote new business in New Orleans.

The cover of a folder to announce two new lines of belts with different "personalities."

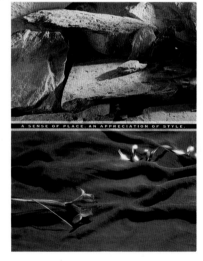

The cover of a folder promoting Blitch Architects.

An announcment for a one-month-old typesetting company who admitted to having initial problems.

Letterhead for a plastic surgeon with very "fortunate" initials.

A spread from a brochure, targeted to women only, for the Institute of Cosmetic and Plastic Surgery.

*A series of covers for
Tulanian, the alumni
publication of Tulane
University.*

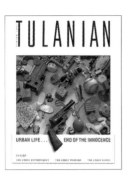

*A call for entries poster
for the Art Directors &
Designers Association.*

*A promotional piece
for a food stylist.*

*The cover of the 1993 annual report for Louisiana
Land and Exploration Company.*

*Logo for a television
show featuring the
head coach of the
Saints discussing the
plays and strategies
of the game played
the week before.*

*The official logo for the Clinton inauguration party
on the mall in Washington.*

Lee O. Warfield III is president of his own graphic design firm in Boca Raton, Florida, which specializes in annual reports, business-to-business and corporate communications, corporate and product identification, publication design, and sales promotion collateral. His work has won numerous awards and has been exhibited and published both nationally and internationally. In addition, he has lectured and taught graphic design in both the U.S. and Europe. Before founding his firm, Lee O. Warfield III, Inc., in 1986, Warfield had worked for a number of leading design firms around the country and was creative director of a major metropolitan daily newspaper. His career started in Washington, D.C., where he designed a number of annual reports, trade journals, and magazines, including Smithsonian.

Warfield has been very active in The American Institute of Graphic Arts and served as the first chairman of the Presidents Council, in addition to establishing the first chapter in Florida and serving as its president. He is an active member of the Christian Business Men's Committee, Greater Boca Raton Chamber of Commerce, Lucas Society, Maryland Institute Alumni Council, and TAT Foundation.

In 1971 Warfield graduated cum laude from The Maryland Institute, College of Art, with a B.F.A. degree in graphic design. He is a native Baltimorean and a member of a very old and distinguished Maryland family.

When I interviewed at Muir Cornelius Moore in New York, Richard Moore asked me, "What is the first thing you do when you're given a project?" My first thought was: "Nothing. I don't do anything." Panic took over! So my answer was: "I do nothing except just think a lot about the project and its problems and try to figure out what it will look like later." Moore told me afterward that he hired me because of my answer.

This approach to a project, combined with my basic design philosophy to keep things really simple and obvious, legible and easy to read, and right for the client and audience, provides the basic framework for all my work; and it has paid off. In this business, as in any kind of consulting business, the key is how you package yourself, do your paperwork and write proposals. It's how you write a letter to the client, the way you dress, the way you talk. But more importantly, it's the way you listen and work with clients on every level, regardless of personal feelings.

Frequently I meet with clients to discuss a specific project only to realize that what they really need is totally different from what they want. For example, one client wanted a newsletter but really needed a new name and identity. Asking some basic marketing questions helps to define those needs. "What are your strengths and weaknesses?" "What do you do better than the competition?" "What does your competition do better than you?"

All of my clients, regardless of size, appreciate our working relationship because they always know exactly where they stand. They know budgets will stay on target and schedules will be met. If a problem arises, they're made aware of it immediately and given alternatives, including costs for additional time and/or services. They never lose sight that their best interest is my best interest and that I care.

A quick response is possible largely due to a workable tracking and structuring system which is based on accurate record-keeping and documentation, utilizing letters of agreement, contracts/proposals, written estimates, and time sheets. The client is informed in writing, right from the beginning, the extent of the project, the services to be provided, and an itemized, detailed list of projected costs. There are no surprises, especially in billing. I've never known a designer to be fired over a layout the client didn't like; it's almost always over billing and lack of communication.

Primarily I work with two documents: a General Working Agreement and Project Proposal. Each serves a singular purpose, is written in concise and simple language, and is explained verbally in detail to the client. It is essential that both parties understand the other's procedures and expectations.

The General Working Agreement is a one-time document that is the umbrella for our entire business relationship and contains all the legal details, including responsibilities and potential liabilities for each of us. This document carefully defines terminology. For example, it is critical that the client understand such terms as "alteration" and "overtime." The agreement also contains an important guarantee for the client: that their money will not be spent without prior approval. Once signed, this document is filed away.

A Project Proposal that provides the contractual details of the services to be provided and their costs, including all necessary out-of-pocket expenses, is created for each new project. A comprehensive, realistic budget is very carefully prepared. It has never been my practice to "lowball" a project just to get a job. I explain to the client that the pricing reflects the time and service needed to do the job right.

There is an important inclusion in the proposal which states that the quoted price includes initial client alterations, providing they do not exceed a certain percentage of the estimated time and costs. Vendors also have agreed to price their services so they can absorb the first alterations, provided that they do not exceed 10 to 20 percent of the initial costs. This inclusion is intended to relieve the client's anxiety about numerous or unnecessary alteration charges. After producing the first issue of *The Ryder Resource,* my client at Ryder Truck Rental, Dave Dawson, stated, "That clause about revisions was a pure stroke of genius."

I have not fallen in love with the computer. That's not to say I don't respect it for its capabilities: speed and accuracy. In that sense, it's wonderful. However, designers have placed too much emphasis on and become too identified with it. This has hurt our profession. It limits the perception of who we are, what we are capable of doing, and what we should be doing as graphic designers. We are perceived more as a commodity, now, and less as professionals. The computer is only a tool; it cannot replace the human mind and the richness of life's experiences.

Here in South Florida, there is a tendency for companies to think they can simply buy the right software and have a secretary produce their projects in-house. I warn them that secretaries are not designers and are not knowledgeable about page layout, type fonts, specifications, or print production. Furthermore, I warn companies quick to hire a staff designer that it would be wise to consider the expense and continued need to generate additional projects to justify the position.

Paradoxically, the computer could bring about positive changes for our profession. It will force designers to work much more as pure consultants and with clients in a more abstract way, dealing with sales and marketing on a daily basis, as well as design. It is not my intent to just render a layout or produce something that may win a design award. It is my desire to be an invaluable resource for my clients and an integral part of the entire process—with or without the aid of a computer.

The computer has been beneficial to my business, but only in a very limited way. It has liberated my staff from the tedium of preparing camera-ready artwork and comps, but not much else. Consequently, more of my time and resources can be spent pursuing new business or further developing the business I already have.

My current business was started from scratch in a bedroom of my house. In the beginning my aspiration was to stay small and be the "Paul Rand" of South Florida. I have managed to build a respectable reputation as a designer, but it has been difficult to build a business alone.

Nothing is for certain, even with the best documentation, attorneys, accountants, and clients. There are so many uncontrollable variables to challenge every business: the state of the economy, a client's financial condition, mergers and acquisitions, changes in technology, legislation, competition, and—most often—a change in personnel. No matter how close a relationship with a client is, if the key contact leaves, that person's loyalty does not necessarily transfer to the successor.

I have made some costly mistakes along the way, like resting on my laurels and putting too many eggs in one basket. A major corporation was my primary client for a number of years, and our relationship appeared solid. The growth with them was so extensive that it consumed my time and energy to the detriment of my other business. Smaller clients slipped away, and new business was not aggressively pursued. This same client encouraged me to expand to accommodate their needs by renting expensive office space and hiring additional personnel. A year after doing so, my client pulled the plug. They comprised 80 percent of my business, and it was devastating to lose them. However, the biggest mistake I've made, to date, was starting out undercapitalized. I started my business with just $5.17 in the bank, and, believe me, it's hard to grow a business out of operating income.

From the very first project I do for a client, my goal is to build an ongoing relationship with that client. That is why it is imperative to keep selling to clients, even existing ones, by showing examples or telling of successes in person or on the telephone. Press releases are a useful tool, because they are successful, easy, and inexpensive. Visibility in the business community can also be valuable. Devoting just a few hours a month to the local Chamber of Commerce has been more beneficial to me for new business development than any design award ever has.

Entering this profession in 1971, I had a chip on my shoulder; and my goal was to be rich and famous. When I began my own business in 1986, the chip had long since fallen, and my goal was to do some good work, have a comfortable life, exercise as much control over my work and life as possible, and retire. These goals haven't changed, and I am still trying to achieve them today.

I learned everything by the seat of my pants—how to establish, operate, nurture, and expand my business. It is not my desire as a designer to sit all day at a drawing table or in front of a computer. The evolution of my business is like my life as a whole—a design in itself. It is a wonderful problem to solve and much more challenging and interesting than learning to sell the difference between pink and peach on a letterhead.

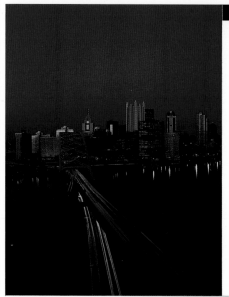

A cover and spread from The Ryder Resource, a quarterly magazine produced for Ryder Truck Rental, Inc., a subsidiary of Ryder System, Inc.

Poster announcing a dance competition sponsored by the Boca Raton Chapter of The National Society of Arts and Letters.

Cover of a sales promotion brochure for Florida Power and Light.

Relocation announcement for the office of Lee O. Warfield III, Inc. The illustration is a rebus and reads "O-pen."

Headache Treatment Center of Florida, a private medical practice specializing in the treatment of headaches.

The Harid Conservatory of Music, Inc., a private school of dance and music.

Quinby Skylur, Incorporated, a consulting firm providing services in human resources management.

Speech Recognition, the Power Personal Systems Division of IBM.

Yellow Airport Limousine Service, a service of Yellow Cab, providing a private driver and limousine or sedan.

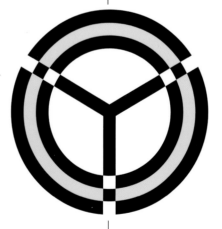

Welch Engineering, Limited, an aerospace controls and systems engineering company.

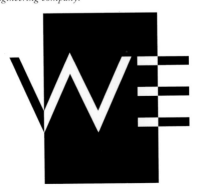

The Heart Institute of Kentucky, a private practice of cardiologists.

John Waters is president and design director of Waters Design Associates, Inc., a company providing identification planning, marketing communications, and digital media design services to corporate and institutional clients.

A native of North Carolina, John received his B.F.A. from the Virginia Commonwealth University and later studied at MIT, New York University, and the School of Visual Arts. He formed Waters Design in 1977, in New York City.

The firm's work has been widely represented in design and illustration annuals and has won numerous awards, most recently a gold award from New Media Invision—Multimedia '94, for an interactive program designed for the Wall Street Journal.

For eight years, John taught visual communications at Pratt Institute. He is president of the International Design by Electronics Association, a past board member of AIGA/NY, a member of the American Center for Design, and a frequent speaker at design seminars around the country.

The graphic design business has changed radically since I started this firm in 1977. In those days, all you needed to start a business was a T-square, a telephone, and a drawing board. And, of course, a client. Today, the only thing that remains, if you're lucky, is the client. The services, the way we provide them, and the tools required to create them have all changed.

Let's talk about the tools first. You cannot survive in business today without a computer, a fax, and a modem or E-mail. A beginning designer needs to know the basics of Quark, Illustrator, Free Hand, and Photoshop. And experience with MacroMind or another authoring program wouldn't hurt. These are the essentials. Understanding how they integrate with one another and how they influence the process and the product of communication is another matter.

When I taught visual communications at Pratt Institute in the early 1980s, faculty discussions would often revolve around how much time we should spend teaching technical skills—preparing mechanical art for offset printing, type specing and setting—versus analytical thinking and communication skills. I have always believed that thinking is the most important skill a designer has to offer and certainly what educators should focus on. Thinking is what we sell at Waters Design. However, technical skills—or, rather, technical knowledge—influences our thinking, whether we're trying to achieve a special duotone effect through traditional methods or resolving a color output issue on a digital printer. Our knowledge of printing processes, ink, and paper characteristics, or digital file characteristics, will influence the decisions and recommendations we make in much the same way as our knowledge of communications theories, marketing concepts, or the psychology of color.

The graphic design business has always been a complex business. It involves two different but complementary components which are inextricably bound together: the creative/conceptual side and the communications/production side. There is, of course, a third side, finance, but we'll get to that in a moment. The link between concept and production, between what is envisioned and the way it is expressed is the heart of design. This link is also why the business has gotten even more complex in recent years. Not only do we have to keep up with the new tools of production, and the old tools still in use, but we have to be aware of their influence on the communications process.

The options for methods of communicating are enormous now. Do we think about this next marketing project as a printed brochure, a series of direct mail pieces, a video, or an interactive digital presentation? Do we consider taking it on line with a BBS, or the Internet, or some combination of all the above ? Of course I am exaggerating, but not by much. All these channels are available today, and any of them may be appropriate. For a small firm to stay abreast of the information required to work in all of these media is practically impossible.

Waters Design is not a large office. We have a full-time staff of ten people. But, if I counted the network—just the "sneaker" network—of writers, photographers, musicians, video artists, and programmers that we work with, the number would be over 60. By keeping the firm small we are able to hold our overhead down, yet with our resources we offer a broad range of design services.

We refer to the firm as a multidiscipline shop because we do so many different things, from corporate identity and annual report design for Fortune 500 companies to the design of silk scarves for the Metropolitan Opera. The services we provide fall into three broad areas: Identification Planning, which includes visual audits, image analysis, and identity systems; Marketing Communications, which covers annual reports, capabilities brochures, promotional campaigns, and literature systems; and Digital Media, our newest area, which includes the design of interactive presentations for marketing or training and computer systems consulting.

I am often asked how we made the transition from print media to the new digital media. First, we started with computers over ten years ago. I bought my first computer in 1983. Then in '85 I bought a dedicated work station called Lightspeed. Since then we have continuously added work stations, upgraded hardware and software, and taken numerous training courses. It's a constant learning process. But the real reason we are able to work in new media is that we don't put media first. Strategic design thinking always comes first.

The basic skills required for designing for new media are no different from those needed for old media. The ability to analyze and synthesize in creating new forms of expression is not media dependent. The outcome, however, will certainly be influenced by the limitations of the media.

If the design of a poster, magazine, brochure, or package is viewed as the creation of an experience for the receiver, then designing the new media counterparts for these items will be the process of creating a vastly enriched experience—for the receiver and the designer. With the addition of music, voice, and motion, the "context" aspect of communication is expanded. This broadens the collaborative possibilities for designers. And we like to work in a collaborative environment. This way we are able to provide our clients much better results at lower cost.

Our billing rates are based on our cost, and, although we may charge different rates for different people, we don't necessarily charge different rates for different activities. We have a varying multiple, based on salary cost and all overhead, which is about 3.6, and we use that multiple to determine each employee's billing rate. For example, let's say an employee is costing me $30 an hour: $30 × 3.6 = $108 an hour, which would be that person's billing rate. It doesn't matter whether that employee is designing, setting type, or preparing files for the printer.

The rates in the office range from $80 to $250 per hour. We always provide detailed estimates in advance and often quote the expected rates. Sometimes these turn into fixed fees for a given project over a specified time, or we will establish a monthly retainer. This depends on the nature of the project. Outside costs that are billed through the firm are marked up 20 percent. But we offer our client the option of having these costs billed directly, in which case the invoice is made out to the client but sent to us first for approval.

We are very concerned about the quality of our work and tend to put more time into projects than we should to ensure the quality. This can be dangerous with fixed fees, because we end up eating this time. To monitor our hours we have daily time sheets turned in by each designer. A weekly status report showing all current jobs—usually about 25—is reviewed at the Monday morning staff meeting. It compares actual hours to estimated and remaining hours. If there is a problem, we know about it quickly and have to decide how we can adjust. We've been using this system, which is all tracked on computers, for a number of years.

Financially, we've had good years and some not so good years. The years 1990 and '91 were not great. A lot of projects got put on the shelf for one reason or another, usually the state of the economy was blamed for budget cutbacks. But, by the second quarter of '93, things had turned around and since then we seem to be on a roll.

Much of our new business is in the digital arena, designing interactive computer-based communications materials. This is a whole new area of business that did not exist five years ago. Nearly 15 percent of our fee income this year will be derived from projects designed for use on computers. This will probably increase to 30 or 35 percent by next year. And I expect it will continue to grow as digital media becomes mainstream.

I think the future of the design business looks very bright. A whole new world of possibilities—in fact, necessities—for design will exist very soon, in nearly every business sector. These include converting current communications assets to the new media; creating new assets in the digital environment; coordinating the look and feel of messages in both environments; coordinating digital messages across a wide range of possible presentations. All of this will require a tremendous amount of screen, interface, navigation, icon, path, and button design.

Also, traditional media will not die any time soon. So the opportunities for designers will be enormous. The challenge is for graphic designers to get into new media and show what a difference design can make before production houses dominate the market. Ninety percent of what exists now is ugly, awkward, and frustrating to use. It begs for the grace, beauty, rhythm, and rhyme of design.

I believe, regardless of the changes in media, that graphic design will remain the vital connection between perception and language, the pivotal point between what is envisioned, the way it is expressed, and how it will be understood.

Two promotional brochures for high gloss web freesheets from International Paper.

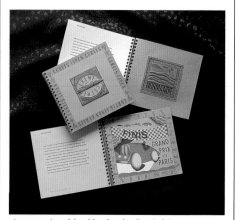

A promotional booklet for the Curtis Linen line of papers from James River Corp.

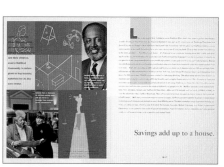

Identity program and key marketing brochure for Berger Mcgill, Inc., a fine lithographer.

Savings add up to a house.

Banks provide the capital that creates jobs.

Spreads from the NatWest Bank 1993 annual report.

Cover and spread from a marketing brochure for Merrill Lynch Asset Management.

The cover of Merck & Co., Inc. 1991 Centennial Book, a 200-page celebration of the first 100 years of accomplishments at Merck & Co.

An editorial spread from the 1990 annual report for GE Financial Services.

Title screen for The Premiere Advertising Vehicle, *an interactive/multimedia sales presentation for* The Wall Street Journal.

Title screen for The Affluent Investor, *an interactive/multimedia sales presentation for* The Wall Street Journal.

Craig Ziegler and Tim Thompson formed Graffito, a Baltimore-based graphic design studio, in 1985. Graffito was one of the first design firms to fully grasp the new computer technologies evolving within the field and successfully incorporate them into its design environment. The firm has won over 150 national and international awards and has had its work published in scores of design annuals including Print, Communication Arts, Graphis, How, AR100 and Type Directors Club.

With an educational background in graphic arts and a keen knowledge of the business of graphic design, Craig serves as a member of two State of Maryland university boards and as a member of the National Board of New Technology. He is the current president of the Baltimore chapter of the American Institute of Graphic Arts and regularly speaks at other AIGA chapters throughout the country.

As Senior Creative Director of Graffito, Tim oversees the creative arm of the studio. He is a graduate of the Maryland Institute College of Art.

In 1990, Craig and Tim joined forces with ETI, a New York exhibit design company, to form Active8, a communications firm which designs and produces computer-based multimedia and interactive presentations and exhibits for corporate and museum clients nationwide.

TT: We tried to create something new in Baltimore right from the start. We went after corporate work, for the most part, but corporate work with a twist. During my four years at Morgan State College, I was very critical of all the conservative and safe design work I saw everywhere. Everything looked alike to me, and it was all very boring. I just couldn't bring myself to work that way. So I said to myself, "Well, if I can't join them, then I'll have to beat them."

But, with such a simplistic philosophy, I have to say that I was pretty lucky to run into Craig. I remember him saying to me, "Just tell me what it is you want to do in the way of design, and I'll go out and sell it." And that was it in one sentence. I just said, "Okay, I know where I want to go."

CZ: At the time, we were both working for another design firm, and I already had built up a pretty large print-buying consulting business for myself. One day Tim and I said to each other, "Running a design business can't be that tough, provided you can start with a decent base of clients." So we decided to go for it.

TT: Craig did a real good job of pushing me out the door. I was dragging one foot behind the other because my situation seemed very stable.

CZ: We really didn't have any design clients to speak of, but we had an "attitude." Between the two of us, we managed to scrape together about $7,000. One of the first things we did was put together a business plan in which, with a lot of wishful thinking, we projected $350,000 in billings the first year.

TT: With this in hand, and using my house as collateral, we got a bank to lend us some money to get us started.

CZ: Incredibly, we managed to bill over $1 million our first year. We sold ourselves as the "mavericks" of our industry—and we performed. Because our style of design got people's attention, we were able to sell our work to Fortune 100 companies that usually bought only very conservative design.

TT: I guess that was good and bad. We did get cocky real fast.

CZ: We had always been sheltered from the business side of the design profession, as most designers are. So we were forced to learn by trial and error. In the early 1990s we began to run into some very serious problems. Because neither Tim nor I had ever really understood the business side of our business, and because we were too busy and trusting, one day we discovered that there was a major discrepancy between the amount of dollars we had versus the amount of dollars we should have had.

It turned out that an individual whom we trusted implicitly had seen an opportunity to take advantage of us. When we analyzed the situation, we realized our first mistake: We had given up the day-to-day operations of the company and passed them on. I had been focusing completely on bringing in new business—selling, selling, and continuing to sell. We had to learn a couple of critically important lessons the hard way. First, bank statements and all payroll records always have to come to the principals sealed, not open. The other lesson is that now our accountants come in every quarter or second quarter to check several different categories each time. It's not an audit, but it's very close to one. It costs us $4,000 to $5,000 a pop to do this, but, in retrospect, it's well worth it.

TT: This was a learning experience for both of us. I've been very fortunate to be teamed with Craig, but when this happened I realized that, because I saw myself as the "creative" guy in the partnership, as far as the business side was concerned, I had managed to put blinders on. I could say, "Well, damn it, Craig, you're supposed to be taking care of these kinds of things," but this incident made me look inside and say, "Damn it, Tim, you can't expect to be a principal in this business and not be aware of how things work."

The silver lining in this disaster was that the guy who had done this to us had been very negligent in billing for over a year, and, incredibly, we discovered $350,000 that had never been billed! Our clients were truly amazing. As long as we could prove that we had actually done the work, almost all of them paid their bills, and most paid quickly.

CZ: But the recession really took the wind out of our sails too, and for a while we thought we'd made a huge mistake. Had we just been lucky the last couple of years? Had we gone overboard with the technology? Had we made the transition to the Mac too soon and invested too much? Everything started piling up, including a lot of debt we had taken on as we moved into more sophisticated technologies.

TT: It was costing us about $120,000 to $125,000 a month just to keep the doors open, and we realized we would have to slide this all back. At the time we had an office in Philadelphia which was an unmanaged operation, but we began to realize that our clients really wanted to come to Baltimore to see the bells and whistles. All we needed in Philadelphia were some account reps. Today it costs us less than $50,000 a month to keep our doors open there.

CZ: We sat down with our counsel and worked out some new budgets and parameters. Today, we don't necessarily measure our profits and losses on a single job. We do it by quarters. So there still may be jobs that we lose money on. But, if that's the case, the job should give us a piece for our portfolio, or at least we should have taken the job knowing that we expect to put more into it than the budget calls for. If not, the reason we're losing money on the job has to be identified. If the client has made errors, we have to identify those errors and decide if we can charge them back to the client.

And it all comes back to sales, too. We realized we still had a strong group. We didn't lose that, but we had lost some of our edge in sales. So we either had to downscale drastically, or go out and find clients to fill the void. I knew I was selling Tim's creativity, so my approach was to find out where his head was, and I would try to diversify the products that he applied his thinking to. One day, he'd be doing an annual report. The next day, he'd be doing a packaging line, and the next day a menu. That philosophy worked. In addition, we deliberately set out to develop a strong self-marketing piece. It contains no fluff, and it's very clear as to our capabilities and what we've managed to accomplish for different industries.

TT: In the beginning, our edge in technology was all we talked about around here, as far as sales go. We knew that, eventually, this was going to fall away somewhat, and in the long run we really had to rely on a progressive design group that would appeal strongly to clients.

CZ: Because of our initial identification with the technology, both inside and outside, a lot of people had tagged us as a "passing fad" that would fall away sooner or later. They started saying, "Well, what's the basis for Graffito's success? Just some bells and whistles." But it really never was. It was always our design. We're designers, and we know that the computer is strictly a production tool. We also realized that the technology created a lot of competitors for us: one- and two-person operations; students with Macs working out of their basements—and some of them are damn good. We just felt that, to survive in the '90s, we had to diversify our products, our markets, our services, and, of course, our clients.

And so, in 1988–89, Active8 was conceived. It adds a new dimension to our work. Our "out of the box" thinking sets the stage for interactive and three-dimensional communication environments. Our philosophy is to "captivate, educate, and entertain" as a means to improve our clients' communication activities. We've invested significantly in people and technology to again be "mavericks" in multimedia presentations, interactive exhibits, custom-designed sales, and trade show and executive briefing-center environments. And we tie the components together in integrated marketing programs to leverage the dollars a client spends by "repurposing" the communication tools across media, across programs, and across venues.

TT: The gestation period for Active8 was immense, though. The first year was spent almost exclusively educating our clients. The second year was getting them to put multimedia into their budgets. It's a tough sell, and our pitch changed and evolved. We discovered that our first presentation was so powerful that it just blew potential clients out of their seats. They were looking at projects from Epcot Center and the Smithsonian and saying to themselves, "Well, what the hell am I going to do with that?" So nothing much was happening in the way of sales. What we learned from this is that we have to sell communications skills, not technology.

CZ: I feel we are now beginning to create a name for ourselves. We find that most of our clients are now coming to us, which makes for a stronger, more productive relationship. It's not us trying to fit a round peg into a square hole. The people we're talking to these days—CEOs and presidents—only want to know, "How are you going to impact my bottom line?"

TT: I think we're a little devious. Craig is excellent at that. We package it as bottom-line stuff, and clients love it and understand it, but our objective is still to create terrific design.

Graphic designers are now being pushed to discover other media. It's exciting, but it's also nerve-wracking, because you never know how it's going to translate. I'm just now getting comfortable with the process of thinking in 2-D initially and then laying ideas out into other dimensions.

CZ: I think the biggest difference with the formation of Active8, though, is that it's a bigger pool of people, different creative types like film editors and producers and animators—different walks of life. That is incredibly exciting to me, because we get to collaborate.

TT: That's a big word around here. We do a lot of collaboration. When anyone asks who did a piece, you don't hear, "Tim Thompson." You hear, "Graffito did it."

CZ: When we're tired of running this operation, we would like Graffito and Active8 to go on living. We're trying to create a company that is set up to survive, and to do this requires two things: common sense and us working together. That's the beauty behind it.

someWhere toDay

*Tabloid-size annual
report for American
Red Cross, chronicling
a day in the life of the
organization.*

*AIGA/Baltimore First
Annual Regional Show
Call for Entries packet.*

*MCI sales marketing
promotional poster.*

*Capabilities brochure featuring a vacuum-formed
plastic cover manufactured by the client, Apogee
Designs, Ltd.*

*Lightspeed capabilities brochure and kit folder pro-
moting new design software through the production
of the actual pieces.*

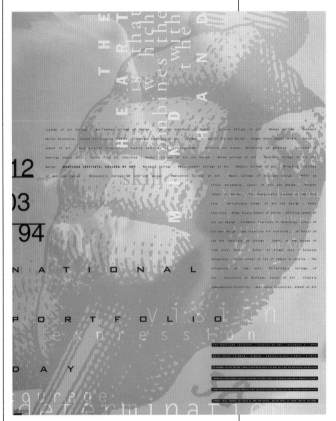

Poster/mailer for the Maryland Institute College of Art's Portfolio Day sent to art teachers and counselors around the country.

Graffito self-promotion mini-kit folder with inserts of work.

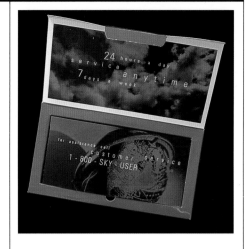

Packaging, housing pager, batteries, and customer welcome kit for SkyTel SkyPager.

Media guide for ESPN: a spiral-bound brochure with pockets for programming and research information.

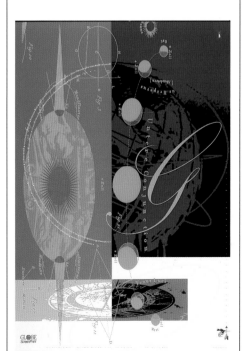

Promotional calendar for Globe Screen Printers, incorporating glow-in-the-dark silkscreen inks.

Index